THE LIFE OF MICHELANGELO

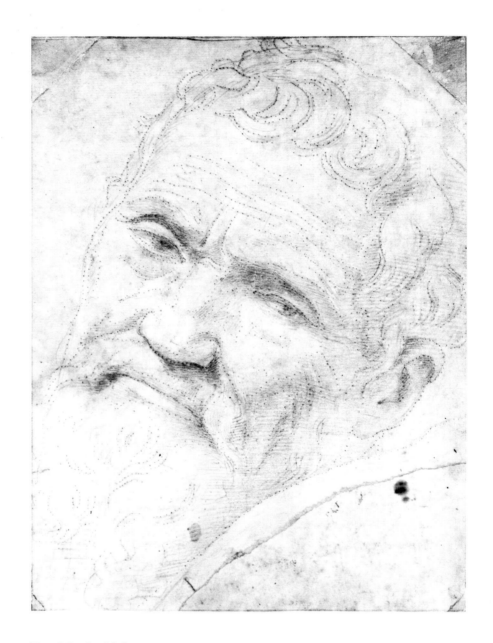

Daniele da Volterra
MICHELANGELO

THE LIFE OF MICHEL-ANGELO

BY ASCANIO CONDIVI

TRANSLATED BY ALICE SEDGWICK WOHL

EDITED BY HELLMUT WOHL

LOUISIANA STATE UNIVERSITY PRESS
BATON ROUGE

ISBN 0-8071-0164-8

Library of Congress Catalog Card Number 74-27197

Manufactured in the United States of America
Designed by Albert Crochet. Set in Linotype Electra
by Typoservice Corporation, Indianapolis, Indiana
Printed by Colonial Press, Incorporated, Clinton, Massachusetts

Grateful acknowledgment is made for permission to quote from the following:

Leon Battista Alberti, *On Painting and On Sculpture*, ed. and trans. Cecil
 Grayson, © 1972 by Phaidon Press, Ltd., London

J. J. Pollitt, *The Art of Greece, 1400–31 B.C.: Sources and Documents*,
 © 1965 by Prentice-Hall, Inc., Englewood Cliffs, N.J.

Dante Alighieri, *The Divine Comedy: Inferno*, trans. Charles S. Singleton,
 © 1970 by Princeton University Press, Princeton, N.J.

Dante Alighieri, *The Divine Comedy: Purgatorio*, trans. Charles S. Singleton,
 © 1973 by Princeton University Press, Princeton, N.J.

Robert N. Linscott (ed.), *Complete Poems and Selected Letters of Michelangelo*,
 trans. Creighton Gilbert, Random House, Inc., New York, © 1963 by
 Robert N. Linscott

E. H. Ramsden (ed.), *The Letters of Michelangelo*, trans. E. H. Ramsden,
 Stanford University Press, Stanford, Calif., © 1963 by E. H. Ramsden

Frontispiece photograph courtesy Teylers Stichting, Haarlem

TO MARGA
amica di virtute e gentilezza

CONTENTS

ILLUSTRATIONS

PLATES

FIGURES

INTRODUCTION

Amid the artists, men of letters, prelates, and diplomats of mid-sixteenth-century Rome Ascanio Condivi was a very minor figure. He was born about 1525 in Ripatransone, a few miles inland from the Adriatic coast of Italy roughly halfway between Ancona and Pescara. In his early or mid-twenties, sometime before 1550, he went to Rome where he became a pupil of Michelangelo's and lived in his house. In 1554 he returned to his native city to paint an altarpiece *The Mysteries of the Virgin* for the local church of S. Domenico. He was not a successful artist—the only painting generally attributed to him besides the altarpiece at Ripatransone is an undistinguished and unfinished *Madonna and Child with Saints* in the Casa Buonarroti in Florence from a cartoon by Michelangelo—and after he left Michelangelo he seems to have been active chiefly in business and civic affairs. In the second edition of his *Lives of the Artists* Giorgio Vasari claims that while Condivi was Michelangelo's pupil he worked hard but produced nothing and that after he had labored on one painting for several years Michelangelo took pity on him and helped him with it, but to little avail. In 1556 Condivi married Porzia Caro, the daughter of Michelangelo's friend Annibale Caro, and in 1565, a year after Michelangelo's death, he was elected to the Florentine Academy, no doubt in recognition of the contribution he had made with his *Life of Michelangelo* to the great man's memory. He then dropped out of sight. It is recorded that in December, 1574, while trying to ford a stream, he drowned.

In spite of Condivi's insignificance in his own right, or perhaps because of it—because he was able to a remarkable degree to be the voice of his master—his biography of Michelangelo is, next to the artist's letters and poems, our strongest source for Michelangelo's life. Completed eleven years

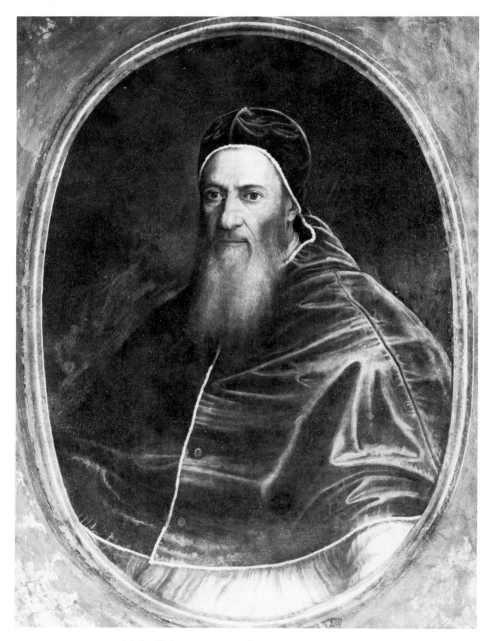

PLATE 1 Scipio Pulzone, *Pope Julius III*, Palazzo Spada, Rome
Photo courtesy Fratelli Alinari, Florence

before Michelangelo's death and dedicated to Pope Julius III (Pl. 1), whom Michelangelo was then serving as architect for the rebuilding of St. Peter's, it was published as *Vita di Michelagnolo Buonarroti raccolta per Ascanio Condivi da la Ripa Transone* (Rome, 1553). The original edition appeared in two printings, the second with a number of minor variations and three important insertions: one alluding to several writers of the time (see p. 93), another dealing with Michelangelo and Julius III (see p. 95), and a third recording Michelangelo's criticism of Albrecht Dürer's theory of proportions (see p. 99). All differences between the first and second printings are identified in the notes.

There have been eight subsequent Italian editions. Only two, both using the second printing of 1553, have contributed substantially to our understanding of the text. The first, and the first to appear after 1553, is *Vita di Michelangelo Buonarroti pittore scultore architetto e gentiluomo fiorentino pubblicata mentre viveva dal suo scolare Ascanio Condivi* (Florence, 1746), edited by Antonio Francesco Gori. It has excellent commentaries by Gori himself, Domenico Maria Manni, and (in French) Pierre Mariette and a supplement by the Florentine architect and sculptor Girolamo Ticciati tracing Michelangelo's career from 1553 until his death in 1564. This edition was reprinted in the early nineteenth century, without the supplement by Ticciati and with the addition of notes of little value by Giovanni Gherardo Rossi, as *Vita di Michelangelo Buonarroti scritta da Ascanio Condivi suo discepolo* (Pisa, 1823).

The exemplary modern presentation of Condivi's text, which the translator and the editor used alongside the two printings of 1553 as the basis for this English version, is in Carl Frey (ed.), *Le Vite di Michelangelo Buonarroti scritte da Giorgio Vasari e da Ascanio Condivi con aggiunte e note* (Berlin, 1887), containing an introduction in which Frey convincingly states the case for regarding Condivi as the principal source for Michelangelo's life; the texts of Condivi and of both the 1550 and 1568 editions of Vasari's biography of Michelangelo; the passages from all the biographies in the two editions of Vasari's *Vite* in which Michelangelo is mentioned;[1] and the earliest biographical account of Michelangelo, the short *Michaelis Angeli Vita* written in Latin by Paolo Giovio about 1527. The text of the most recent

edition in Italian, produced by Emma S. Barelli (ed.), *Ascanio Condivi, Vita di Michelangelo Buonarroti* (Milan, 1964), is not up to the standard set by Frey and is accompanied by notes that are both excessive and not always reliable.

Among the eight German editions of Condivi the earliest and best is R. Eitelberger von Edelberg (ed.), *Das Leben des Michelangelo Buonarroti geschrieben von seinem Schüler Ascanio Condivi*, trans. Rudolph Valdeck, Quellenschriften für Kunstgeschichte und Kunsttechnik des Mittelalters und der Renaissance, VI (Vienna, 1874). It includes translations of the supplement by Ticciati and of the funeral oration delivered by Benedetto Varchi at Michelangelo's obsequies in S. Lorenzo, as well as an instructive comparison of the sections on Michelangelo in the two editions of Vasari with reference to Vasari's reliance on Condivi in the edition of 1568.

Condivi's *Life of Michelangelo* has previously been translated into English with notes by Charles Holroyd in his *Michael Angelo Buonarroti* (2nd ed.; London, 1911) and without commentary by Herbert Horne, *The Life of Michelangelo Buonarroti Collected by Ascanio Condivi da La Ripa Transone* (Boston, 1904), and S. Elizabeth Hall (trans.), *The Sonnets of Michelangelo Buonarroti* (London, 1905). It seems appropriate in the year of the five-hundredth anniversary of Michelangelo's birth to replace these earlier editions, which have gone out of print and of which only Holroyd's is occasionally found in libraries, with a new English text and commentary incorporating the results of Michelangelo studies of the past two generations.[2]

The composition and publication of Condivi's work were largely if not wholly provoked by the legends and untruths in Vasari's life of Michelangelo in the first edition of the *Vite*. Although Condivi does not mention Vasari by name, it is to him that he refers when declaring in his preface to the reader that "there have been some who, writing about this rare man, through not having (as I believe) frequented him as I have, on the one hand have said things about him which never were so, and on the other hand they have left out many things which are most noteworthy."

Michelangelo must have been profoundly disappointed and irritated by the inventions of things "which never were so," the omissions, and the impersonal tone of Vasari's biography of 1550. A veiled and ambiguously

stated indication of his reaction took the form of the implication in a sonnet, which he dedicated to Vasari after having received from him a copy of the *Vite*, that its author was a better writer than painter. In view of Michelangelo's low opinion of Vasari's painting, this was hardly a compliment:

> If you had with your pen or with your color
> Given nature an equal in your art,
> And indeed cut her glory down in part,
> Handing us back her beauty lovelier,
>
> You now, however, with a worthier labor,
> Have settled down with learned hand to write,
> And steal her glory's one remaining part
> That you still lacked, by giving life to others.

Michelangelo's more substantial response to Vasari's *Vite* of 1550 was the biography by Condivi, which Condivi compiled, as he writes in the reader's preface, "with long patience from the living oracle of his speech." In effect, and by the testimony of Condivi in further passages throughout his text, the work that he composed is Michelangelo's autobiography—the first by a major Italian artist since Lorenzo Ghiberti's second *Commentario* a century earlier and preceding by five years the autobiography of Benvenuto Cellini. It is as Michelangelo's autobiography that Condivi's text commands its strength, and it is for this reason that Vasari's life of Michelangelo in the second edition of the *Vite*, though it incorporates and repeats much of what Condivi says, is no substitute for it.

For the biography of 1550 Vasari seems to have had little if any information from Michelangelo himself. Principal sources were members of the Medici family, the heirs of Michelangelo's first and only master Domenico Ghirlandaio, colleagues and other contemporaries in Michelangelo's circle in Rome, and the very cursory *Life of Michelangelo* by Paolo Giovio, who among Michelangelo's works mentions only the *Sleeping Eros*, the *David*, and the Sistine Ceiling. Vasari's purpose in writing the *Vite* was primarily didactic and propagandistic: to chart the rise of the arts in Italy from their rebirth through Giotto to their perfection in Vasari's own time; to point out the best masters whom his contemporaries should imitate; and to commemorate the leadership in the ascent of the arts in Italy of the Medici,

who were his employers. Although Vasari had very clear ideas about the development of Italian art as a whole, he ignored the evolution of individual artists. Aside from his belief in artistic progress, he was indifferent to the motivations and circumstances leading to the creation of works of art. And he was equally unconcerned about the historical accuracy or plausibility of his many biographical anecdotes.

One among many examples of Vasari's nonchalance in this respect in the 1550 edition of his *Vite* is the account he gives of Michelangelo's flight from Rome in 1506. The real causes for it were the refusal of Julius II to reimburse Michelangelo for expenses he had incurred in connection with the pope's tomb and the pontiff's loss of interest in the tomb project in favor of the rebuilding of St. Peter's. As Vasari tells it, Michelangelo left Rome because one of his assistants on the Sistine Ceiling, contrary to orders, had allowed Julius to inspect the progress of the work. For Michelangelo his flight from Rome was a traumatic event. He described it in two emotionally charged letters—hurriedly in May, 1506, a month after the incident, and in vivid detail thirty-six years later, in the autumn of 1542. From these letters it is clear that the reason the episode of the flight had such importance for him was that it marked the beginning of what Condivi aptly calls the "tragedy" of the Julius Tomb, the work which Michelangelo most passionately wanted to complete but was forced by circumstances, forty years after it had been begun, to terminate in an abortive, drastically curtailed form. Vasari, after describing the *Moses*, devotes one sentence to the saga of the tomb in his edition of 1550: "This tomb was subsequently discovered at the time of Paul III and was finished through the liberality of Duke Francesco Maria of Urbino." Condivi tells the story, insofar as he was able to grasp and record what his master said to him, as Michelangelo remembered it and wanted the world to remember it.

But Condivi's text also bears its stamp as Michelangelo's autobiography on another level than in its exposition of what Michelangelo considered "most noteworthy" in his career. Condivi did not seem to be aware—at least he did not express his awareness—of the complexities and contradictions in his master's character. As Edgar Wind says, he "was never baffled by Michelangelo's cryptic manner."[3] Michelangelo's "terrible sensuousness" (the phrase

is Max Beckmann's), his vulnerability, his torments of conscience, his un-flinching discernment of existential truth—these are recorded in his works and poems. They rarely show in his letters or conversations, and they escaped or were beyond Condivi's comprehension. Yet, Condivi's text, in the manner of autobiographies, offers a number of keys not found elsewhere to Michelangelo's personality. I shall confine myself to one example: Condivi's report that Michelangelo attributed the "gratification" he derived from "the chisel" to the milk of his wet nurse, whose father and husband were both stone-masons. "For it is known," Condivi paraphrases his master, "that the nurse's milk is so powerful in us that often, by altering the temperature of the body which has one propensity, it may introduce another, quite different from the natural one."[4]

The interest of Michelangelo's speculation on the origin of his inclination for sculpture lies not only in his reference to the ancient myth of the trans-formative power of woman's milk—whether she be mother, nurse, or al-legorical personification—but even more in his intimation that through her milk his wet nurse transmitted to him "a propensity . . . quite different from the natural one" with which he was born. As a sculptor, he implies, he was not the child of his father and mother, but of his wet nurse; he had been reborn, set apart from his natural heritage, and invested with a creative power that was his alone. The story goes far to illuminate several facets of Michelangelo's character and thought: the ambivalence—painfully conscientious filial love, respect, and concern interspersed with outbursts of bitterness, accusations, and self-pity—in his letters to his father, an ambivalence which erupts into revenge in Condivi's account of the humiliation of Michelangelo's father by Lorenzo the Magnificent; Michelangelo's belief that he was destined by nature to be a sculptor—Condivi says of *The Battle of the Centaurs* that whenever Michelangelo "sees it again, he realizes what a great wrong he committed against nature by not promptly pursuing the art of sculpture"; his reluctance to undertake painting and architecture on the grounds that they were "not his art"; his insistence that as a sculptor and artist he was accountable to no one but himself; his inability to collaborate with others and his suspicion and intolerance of potential rivals; and finally his conception of art, specifically of sculpture, as a dialogue between his soul and himself.

It has been rightly pointed out that Condivi is unreliable in questions of fact and detail; that his attitude toward Michelangelo was one of naïve adulation; that he omits many of Michelangelo's works and supplies scanty or no information about Michelangelo's relationships with those who were most important in his personal life, such as Tommaso Cavalieri, Luigi del Riccio, Donato Giannotti, and Vittoria Colonna; that he was as obtuse to the inflections in meaning of what Michelangelo told him as he was incapable of grasping Michelangelo's character; and that by the standards of Italian men of letters of the time his learning was extremely modest, which he himself acknowledges in admitting that he does not know "what Plato says on the subject" of love.

In judging Condivi, however, we should not forget that he was confined not merely by his own limitations, but to an even greater extent by what Michelangelo chose to confide to him, by the literary constraints of his time, by his concern that those "who are incapable of understanding the love of beauty except as lascivious and indecent" should not "think and speak ill" of Michelangelo, and by his evident wish to please and flatter his master. We should also keep in mind the chasm that separated the ambitious but un-talented pupil-servant-biographer, recently arrived from the provinces, from the aged "prince of the art of *disegno*," the idol of Italy, lonely, beleaguered, in failing health, harrowed by self-loathing, and in fear for the salvation of his soul, but undaunted and still at the height of his powers of mind, eye, and hand.

If Michelangelo wished Condivi to set down those things by which he most wanted to be remembered—his devotion to the memory of Lorenzo the Magnificent; the "tragedy" of the Julius Tomb; the program of the Sistine Ceiling; the reverence in which he was held by the five popes whom he served; his frustration at not being able to do what he wanted because of the unceas-ing demands made on him by these same pontiffs—his motivations, as in all autobiographies, were also of the nature of confession and self-justification, which appears clearly, for example, in the contexts to which I have just alluded, as well as in the story of the wet nurse and the account of the flight from Rome. Yet in an epoch before Freud, even if it harbored Montaigne, the acknowledgment of personal feelings did not find its way into literary

forms other than those either kept secret from the world or intended only for the eyes of those to whom they were specifically addressed. Many of Michelangelo's poems fall into these latter categories and speak with a force that directly touches the heart and wholly transcends the conventions of the age. Condivi's text, however, with its dedication to Pope Julius III, was aimed at the public at large, particularly, it would seem, at Michelangelo's critics and detractors. By recording "the living oracle of his speech" with unquestioning loyalty and earnestness it admirably served this purpose.

We owe our interest in Condivi's *Life of Michelangelo*, and much more besides, to Erik Erikson, in whose seminar on autobiography at Harvard University in the fall of 1968 the editor became aware of the need for a new English edition. In the translation of the text we had the help and companionship of Margaret Scolari Barr. For assistance in the preparation of the notes the editor is indebted to the members of his fall, 1974, graduate seminar on Michelangelo at Boston University: Babette Bohn, Thomas Boras, Sheila Dugan, Charles Giuliano, Marcienne Herr, Jeffrey Jarvis, Marguerite Shaw, and Lucy Der Manuelian Sidman. For support and advice we are grateful to Frances Frenaye Lanza, Elizabeth McKee Purdy, Leslie Phillabaum, and Charles Seymour, Jr. Our thanks also go to Marie Carmichael for her scrutiny and sensitivity in seeing the manuscript through publication, to Michael Rinehart and Richard Hunnewell for help in procuring photographs, and to Eileen Heaney for her patience in typing the manuscript. The section in the translated text concerning the Sistine Ceiling was published in Charles Seymour, Jr. (ed.), *Michelangelo: The Sistine Chapel Ceiling* (New York and London, 1972), 113–21, and appears here in slightly revised form.

The editor has omitted bibliographical references in the notes, since source citations would have swelled them to a length disproportionate to their purpose, which is to provide only the information that seemed essential for an intelligible reading of Condivi's text. The illustrations, except for portraits of Michelangelo and his principal patrons, have been restricted to what appeared helpful and illuminating in following the narrative and do not attempt to be representative of Michelangelo's work beyond the context of Condivi's biography. The Bibliographical Note discusses the works used

most heavily in the preparation of this edition and selected titles dealing with Michelangelo's life, work, and thought.

A number of terms and expressions used by Condivi have no appropriate English equivalents. They have been left in Italian and are explained either in the notes or in the Glossary. We debated for some time whether to adopt this procedure for the terms *storia* and *istoria*. But, since Condivi, unlike Alberti a century earlier, uses them fairly indiscriminately, we decided to translate them as *narrative, narrative content, narrative scene,* or *story,* depending on the context. Condivi's style is maladroit, especially in its use of pronouns. In the interest of clarity these have at times been replaced in the translation by nouns or proper names. Condivi also has the habit of changing the subject in the middle of a sentence, and whenever feasible this has been rectified. In regard to the text as a whole, the translator has attempted to render the facture and tone of the original as faithfully as possible within the limits of English grammar and usage.

<div align="right">HELLMUT WOHL</div>

THE LIFE OF MICHELANGELO

HOLY FATHER:

Unworthy servant and of so low estate as I am, I would not presume to appear before Your Holiness if my unworthiness and lowliness had not first been dispensed and invited by you yourself when you so condescended to me as to have me admitted to your presence and, in words consistent with your benevolence and greatness, deigned to give me courage and hope beyond my deserts and my condition. A truly apostolic act, by virtue of which I feel myself to have become more than I am; and I have followed my studies and the teaching of the master and my idol, as Your Holiness encouraged me to do, with such great fervor that I have labored and hope to bear fruit which, if not now, will at some time perhaps be deserving of the favor and my devotion to you forever, so do I dedicate to you in succession all the ciple of one Michelangelo Buonarroti: one the prince of Christianity, the other the prince of the art of *disegno*. And, to prove to Your Beatitude what your benevolence has wrought in me, just as I have dedicated my purpose **and my devotion to you forever, so do I dedicate** to you in succession all the works which I shall bring forth, and especially this one, of the life of Michelangelo, with the thought that they must be pleasing to you, as you are pleased by the *virtù* and excellence of the man whom Your Holiness yourself proposed that I imitate. This is as much as it behooves me to tell about him. Greater things remain which he has produced; these will be published subsequently for their nobility of expression and in order to establish their art and to the glory of Your Holiness, who favors art and the artist. Meanwhile I entreat you not to be offended that I am offering you these poor firstfruits, with which I bow down in deep humility at your most holy feet.

Your Beatitude's most unworthy servant,

ASCANIO CONDIVI

1

TO THE READER:

From the hour in which the Lord God by His singular beneficence made me worthy not merely of the presence (which I would hardly have hoped to enter), but of the love, the conversation, and the close companionship of Michelangelo Buonarroti, the unique sculptor and painter, I, being conscious of such a blessing and devoted to his profession and his goodness, applied myself with all attention and study to the observation and collection not only of the precepts he imparted to me about art, but of his sayings, actions, and habits, together with everything in his whole life which seemed to me to warrant wonder or imitation or praise, with the intention even then of writing about it at some time; both to render him some gratitude for my infinite obligations to him and to benefit still others with the advice and example of such a man: knowing how much our age and the age to come owe him for the great degree of enlightenment received from his work, a degree which is easy to recognize by looking at the work of others who flourished before him. I find, then, that I have made two collections of material to do with him, one pertaining to his art, the other to his life.[1] And, though both continue partly to multiply and partly to be digested, a circumstance has arisen such that for a twofold reason I am forced to hasten, indeed to precipitate, that of the life. First, because there have been some who, writing about this rare man, through not having (as I believe) frequented him as I have, on the one hand have said things about him which never were so, and on the other hand they have left out many things which are most noteworthy.[2] Furthermore, because certain others, to whom I have accorded and entrusted these labors of mine, have appropriated them in such a way that they propose to gain honor thereby as if they were their own. Therefore, to make up for the deficiency of the former and forestall the

3

injury of the latter, I have resolved to bring them forth immature as they are. And as for the method with which I have set them down, since my studies pertained to painting rather than writing and since the aforesaid reasons deprive me of the time to attend to it myself or to have others help me as I had planned, I shall be readily forgiven for it by my reasonable readers; indeed I will not trouble to apologize for the method, because I am not seeking praise for it. And, if none should come to me, I content myself that it is the method not of a good writer but of a diligent and faithful collector of these things, asserting that I collected them honestly, that I drew them skillfully and with long patience from the living oracle of his speech, and that recently I have compared and confirmed them with the evidence of trustworthy writings and men. But clumsy though I may be as a writer, I hope to be praised at least for this, that with the part now being published I have contributed as best I can to the fame of my master and, with the part which remains for me to do, to the preservation of a great treasure of our art. For the benefit of art, I will communicate the rest to the world later, more deliberately than I have done this part. Let us turn now to his life.

THE LIFE OF
MICHELANGELO

Michelangelo Buonarroti, the unique painter and sculptor, was descended from the counts of Canossa, a family from the region of Reggio which was noble and illustrious as much for its own merits and antiquity as for its connections with imperial blood. For Beatrice, the sister of Henry II, was given in marriage to Count Bonifazio of Canossa, then lord of Mantua, whose issue was the Countess Matilda, a woman of rare and singular prudence and devoutness. After the death of her husband Gottifredo, her holdings in Italy, besides Mantua, included Lucca, Parma, and Reggio and that part of Tuscany which nowadays is called the patrimony of St. Peter. And having done many memorable deeds during her lifetime, when she died she was buried outside of Mantua in the Badia of S. Benedetto which she had built and liberally endowed.[3]

From this family, then, a certain Messer Simone, who came to Florence in 1250 as *podestà*, merited by his *virtù* to be made a citizen of that place and head of a *sestiere*, because the city, which today is divided into quarters, was then divided into six parts.[4] And, as the Guelph party was ruling in Florence, he, who had been Ghibelline, became a Guelph because of the many benefits he had received from that party, changing the color of his coat of arms so that where formerly it was gules, a dog rampant with a bone in his mouth, argent, it became azure, a dog, or; and he was later granted by the *signoria* five lilies, gules, in a *rastrello* and likewise the crest with two bull's horns, one or, the other azure, as may be seen to this day painted on their old escutcheons. The old coat of arms of Messer Simone can be seen in the Palazzo del Podestà, where he had it carved in marble, as is the custom of most who hold that office.[5]

The reason why the family changed the name in Florence and instead of

5

Canossa came to be called Buonarroti was this: that as this name of Buonarroto had been in their house almost always through the ages, up to the time of Michelangelo, who had a brother also called Buonarroto, and as many of these Buonarroti had been *signori*, that is, members of the supreme magistracy of that republic, and most notably his said brother, who was one of that number at the time when Pope Leo was in Florence, as can be seen in the annals of this city, this name, carried on by many of them, became the surname of the whole family; and all the more readily since the custom of Florence in the *squitini* and other nominations is to add after the proper name of the citizen that of the father, the grandfather, the great-grandfather, and sometimes of those even farther back. So that from the many Buonarroti thus perpetuated and from that Simone who was the first of the family in that city, those who were of the house of Canossa came to be called de' Buonarroti Simoni; and so they are called today. In recent time, when Pope Leo X (Pl. 2) went to Florence, besides the many privileges which he granted to the house of Buonarroti, he also added to their coat of arms the ball, azure, of the arms of the Medici, with three lilies, or.[6]

Such was the family, then, of which Michelangelo was born. His father was called Lodovico di Leonardo Buonarroti Simoni, a good and religious man, rather more old-fashioned than not; who, while he was *podestà* of Chiusi and Caprese in the Casentino, had this son in the year of our salvation 1474, on the sixth of March, four hours before daybreak, on a Monday.[7] A fine birth, certainly, and one which showed already how great the boy was to be and how great his genius; because the fact of having received Mercury and Venus in the second house, the house ruled by Jupiter, and with benign aspect, promised what later followed: that such a birth must be of a noble and lofty genius, destined to succeed universally in any undertaking, but principally in those arts which delight the senses, such as painting, sculpture, and architecture.[8] When his term of office was over, the father returned to Florence and gave the child to a wet nurse in a village called Settignano, within three miles of the city, where the family still has property, which was among the first things that Messer Simone da Canossa bought in that country. The wet nurse was the daughter of a stonemason and was also married to a stonemason. For this reason Michelangelo is wont to say,

perhaps facetiously or perhaps even in earnest, that it is no wonder that the chisel has given him so much gratification, for it is known that the nurse's milk is so powerful in us that often, by altering the temperature of the body which has one propensity, it may introduce another, quite different from the natural one.[9]

PLATE 2 Giulio Romano, *Pope Leo X*,
Devonshire Collection, Chatsworth
By permission of Trustees of the Chatsworth Settlement

and every other part, and he would render them in his painting, so that by bringing it to that perfection of which he was capable, from that time he excited the admiration of the world and, as I have said, a certain envy in Ghirlandaio.[12] This became still more evident because one day when Michelangelo asked him for a sketchbook of his in which were painted shepherds with their sheep and dogs, landscapes, buildings, ruins and such things, he was not willing to lend it to him. And indeed he had the reputation of being a bit envious, because he showed a lack of courtesy not only toward Michelangelo, but also toward his own brother, whom he sent to France when he saw him getting ahead and inspiring great hope in himself, not so much in order to be helpful to him, as some said, but so that he himself could continue to be foremost in that art in Florence.[13] I wanted to mention this because I am told that Domenico's son attributes the excellence and *divinità* of Michelangelo to a great extent to his father's teaching, whereas he gave him no help whatever, although Michelangelo does not complain of this; indeed he praises Domenico both for his art and for his manners.[14] But this may be a slight digression; let us return to our story.

At that same time, another work of his aroused no less amazement, although it was spiced with a certain playfulness. Having been given a head to copy, he rendered it so precisely that, when he returned the copy to the owner in place of the original, at first the owner did not detect the deception, but discovered it only when the boy was telling a friend of his and laughing about it. Many wanted to compare the two, and they found no difference because, apart from the perfection of the copy, Michelangelo had used smoke to make it seem as old as the original. This gained him a considerable reputation.

Now that the boy was drawing one thing and then another at random, having no fixed place or course of study, it happened that one day he was taken by Granacci to the Medici Garden at S. Marco, which Lorenzo the Magnificent (Pl. 4), the father of Pope Leo and a man unique in all qualities of excellence, had adorned with figures and various ancient statues. When Michelangelo saw these works and had savored their beauty, he never again went to Domenico's workshop or anywhere else, but there he would stay all day, always doing something, as in the best school for such studies. One

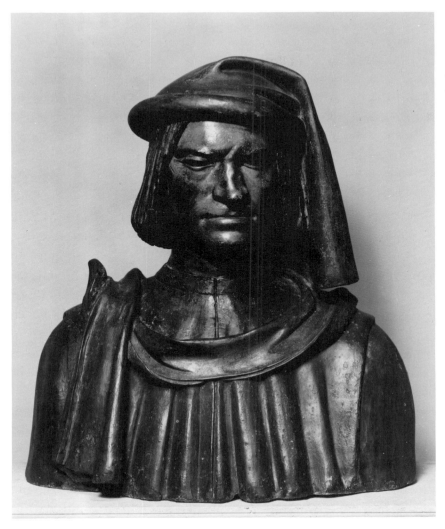

day, he was examining among these works the *Head of a Faun*, already old in
appearance, with a long beard and laughing countenance, though the mouth,
on account of its antiquity, could hardly be distinguished or recognized for
what it was; and, as he liked it inordinately, he decided to copy it in marble.[15]
And since Lorenzo the Magnificent was having the marble, or rather the
cut stonework, done there to ornament that very noble library which he and
his forebears had collected from all over the world (this building, which has

been neglected because of the death of Lorenzo and other misfortunes, was taken up again after many years by Pope Clement, but it was nevertheless left incomplete, so that the books are still in strongboxes),[16] as I was saying, these marbles were being worked, and Michelangelo got the workmen to give him a block and to provide him with tools. He set about copying the *Faun* with such care and study that in a few days he perfected it, supplying from his imagination all that was lacking in the ancient work, that is, the open mouth as of a man laughing, so that the hollow of the mouth and all the teeth could be seen. In the midst of this, the Magnificent, coming to see what point his works had reached, found the boy engaged in polishing the head and, approaching quite near, he was much amazed, considering first the excellence of the work and then the boy's age; and, although he did praise the work, nonetheless he joked with him as with a child and said, "Oh, you have made this *Faun* old and left him all his teeth. Don't you know that old men of that age are always missing a few?"

To Michelangelo it seemed a thousand years before the Magnificent went away so that he could correct the mistake; and, when he was alone, he removed an upper tooth from his old man, drilling the gum as if it had come out with the root, and the following day he awaited the Magnificent with eager longing. When he had come and noted the boy's goodness and simplicity, he laughed at him very much; but then, when he weighed in his mind the perfection of the thing and the age of the boy, he, who was the father of all *virtù*, resolved to help and encourage such great genius and to take him into his household; and, learning from him whose son he was, he said, "Inform your father that I would like to speak to him."

When Michelangelo had returned home, then, and delivered the message of the Magnificent, his father, who guessed why he was being summoned, was persuaded to go by the great efforts of Granacci and others; indeed, he complained that Granacci was leading his son astray, standing firm on this point: that he would never suffer his son to be a stonemason; and it was to no effect that Granacci explained to him how great a difference there was between a sculptor and a stonemason, and he argued about it at length. All the same, when he arrived in the presence of the Magnificent and was asked whether he would be willing to let him have his son for his own, the

father was unable to refuse; instead he answered, "Not only Michelangelo, but all of us, with our lives and our faculties, are at the disposition of Your Magnificence." And, when asked by the Magnificent what his occupation was, he replied, "I never practiced any profession; but I have always up to now lived on my slender income, attending to those few possessions left to me by my forebears, seeking not only to maintain them but to increase them as much as possible by my diligence." The Magnificent then said, "Well, see if there is not something in Florence that I may do for you, and make use of me, for I shall do for you the greatest favor in my power." And, after he dismissed the old man, he arranged that Michelangelo be given a good room in his house, providing him with all the conveniences he desired and treating him not otherwise than as a son, both in other ways and at his table, at which, as befitted such a man, personages of the highest nobility and of great affairs were seated every day. And as it was the custom that those who were present at the first sat down near the Magnificent, each according to his rank, without changing places no matter who should arrive later, it quite often happened that Michelangelo was seated above Lorenzo's sons and other distinguished people, the constant company in which that house flourished and abounded. By all of them Michelangelo was treated affectionately and encouraged in his honorable pursuit, but above all by the Magnificent, who would send for him many times a day and would show him his jewels, carnelians, medals, and similar things of great value, as he knew the boy had high intelligence and judgment.[17]

Michelangelo was between fifteen and sixteen years old when he went to live in the house of the Magnificent, and he stayed there until the latter's death, which was in 1492, about two years. During this time, when a position in the customs office fell vacant which no one but a citizen could hold, Michelangelo's father Lodovico came to see the Magnificent and in these words asked him for it: "Lorenzo, I don't know how to do anything but read and write. Now, as Marco Pucci's colleague in the customs is dead, I would like to take his place, as it seems to me that I could serve suitably in that office." The Magnificent clapped him on the shoulder and said, smiling, "You will always be poor," expecting that he would ask him for something greater. Then he added, "If you want to be in Marco's company,

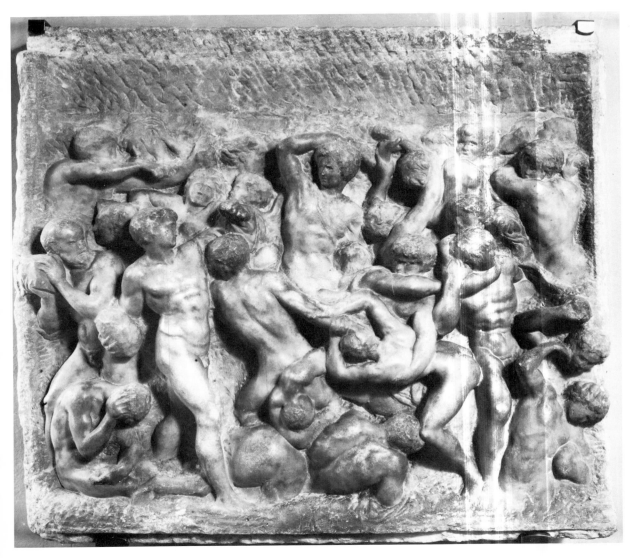

PLATE 5 Michelangelo, *The Battle of the Centaurs*, Casa Buonarroti, Florence
Photo courtesy Gabinetto Fotografico, Soprintendenza alle Gallerie, Florence

you may do so until something better is available." The position brought eight *scudi* a month, more or less. In the meanwhile, Michelangelo pursued his studies, every day showing the Magnificent some result of his efforts.

In the same house lived Poliziano, a most learned and clever man, as everyone knows and his writings fully testify.[18] Recognizing in Michelangelo

a superior spirit, he loved him very much and, although there was no need, he continually urged him on in his studies, always explaining things to him and providing him with subjects. Among these, one day he proposed to him the Rape of Deianira and the Battle of the Centaurs, telling the whole story one part at a time. Michelangelo set out to do it in marble in *mezzo-rilievo* (Pl. 5), and he succeeded so well that I recall hearing him say that, whenever he sees it again, he realizes what a great wrong he committed against nature by not promptly pursuing the art of sculpture, judging by that work how well he could succeed. Nor does he say this in order to boast, being a most modest man, but because he truly bewails having been so unfortunate that, through the fault of others, he sometimes spent ten or twelve years doing nothing, as will be seen below. This work of his can still be seen in his house in Florence, and the figures are about two *palmi* high.[19]

Hardly had he finished his work when Lorenzo the Magnificent departed this life. Michelangelo returned to his father's house, and he suffered such anguish over this death that for many days he was unable to do anything. But then he became himself again and bought a great block of marble which had lain many years exposed to the wind and the rain, and out of it he carved a *Hercules* four *braccia* high, which was later sent to France.[20]

While he was working on this statue, a great quantity of snow fell in Florence, and Piero de' Medici, Lorenzo's eldest son, who had taken his father's place but lacked the grace of his father, being young, wanted a statue of snow made in the middle of his courtyard.[21] He remembered Michelangelo, sent for him, and had him make the statue; and he wanted him to stay in his house as in his father's time, giving him the same room and having him as before, always at his table, where the same custom was maintained as in the father's lifetime, namely that whoever was seated first at table never moved from his place for anyone, however important, who might come in later. Lodovico, Michelangelo's father, who was by this time more friendly to his son, clothed him better and more worthily, as he saw that he was almost always in the company of distinguished men. Thus the young man remained with Piero for some months and was much cherished by him. There were two men of his household on whom Piero was wont to pride himself as being rare persons: one was Michelangelo, the other a

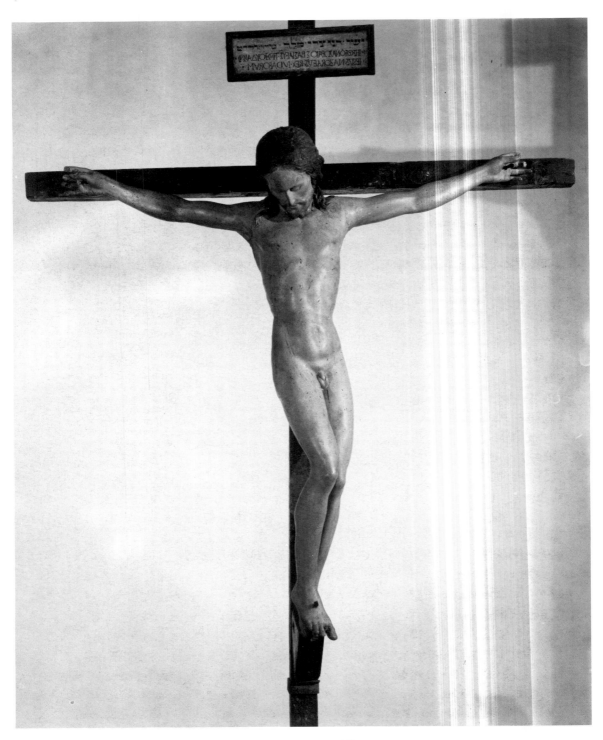

PLATE 6 Michelangelo, *Crucifix*, Casa Buonarroti, Florence
Photo courtesy Gabinetto Fotografico, Soprintendenza alle Gallerie, Florence

Spanish groom who, apart from the beauty of his body, which was marvelous, was so agile and strong and had such good wind that Piero on horseback at full gallop could not get a finger's length ahead of him.

At this time, Michelangelo, to oblige the prior of Sto. Spirito, a church greatly honored in the city of Florence, made a wooden *Crucifix* (Pl. 6), a little less than life-size, which still today is to be seen over the main altar of that church. He was very intimate with the prior, from whom he received much kindness and who provided him both with a room and with corpses for the study of anatomy, than which nothing could have given him greater pleasure. This was the first time that he applied himself to this study, and he pursued it as long as he had an opportunity.[22]

A certain man nicknamed Cardiere frequented Piero's house, who sang and improvised marvelously on the lyre and used to give pleasure to the Magnificent, who also played and so would practice the art almost every evening after dinner. This man, being a friend of Michelangelo's, confided to him a vision, which was this: that Lorenzo de' Medici had appeared to him with a black robe, all in rags over his nakedness, and had commanded him to tell his son that he would shortly be driven from his house, never to return again. Piero de' Medici was so insolent and intemperate that neither the goodness of his brother Giovanni the cardinal nor the courtesy and humaneness of Giuliano had as much power to keep him in Florence as those vices had to cause his expulsion.[23] Michelangelo urged Cardiere to inform Piero of this and to carry out Lorenzo's command; but Cardiere, fearing Piero's nature, kept it to himself. Another morning when Michelangelo was in the courtyard, who should appear but Cardiere, all terrified and suffering, and once again he tells him that Lorenzo appeared to him that night in the same garb as before and that, while he was awake and staring, he struck him a great buffet on the cheek because he had not communicated to Piero what he had seen. Michelangelo rebuked him then, and he was so persuasive that Cardiere, taking heart, set out on foot to go to Careggi, a Medici villa about three miles from the city. But, when he was almost halfway, he met Piero, who was on his way home, and, stopping him, he disclosed all that he had seen and heard. Piero laughed it off and, alerting his attendants, he made them mock him with a thousand jeers; and his chancellor, who later

became Cardinal Bibbiena,[24] said to Cardiere, "You are out of your mind. Who do you think Lorenzo loves more, is it his son or you? If it is his son, would he not appear to him rather than to anyone else if this were true?" Thus scorned, they let him go. When he was at home again and lamenting to Michelangelo, he spoke to him so convincingly of the vision that he, taking it for certain, left Florence two days later with two companions and went to Bologna and from there to Venice, fearing that, if Cardiere's prediction should come true, he would not be safe in Florence. But, a few days later, he ran out of money because he was paying for his companions and thought to return to Florence; and, when he reached Bologna, the following circumstance intervened.

There was in that country at the time of Messer Giovanni Bentivoglio a law to the effect that any foreigner entering Bologna should be stamped on the thumbnail with a seal in red wax.[25] And so, when Michelangelo inadvertently entered without the seal, he was taken together with his companions to the license office and fined fifty lire in *bolognini*; as he had no way of paying and was standing there in the office, one Messer Gianfrancesco Aldovrandi, a gentleman of Bologna who was one of the Sixteen at that time, noticed him there and, grasping the situation, had him set free, chiefly because he had found out that he was a sculptor.[26] And, when he invited him to his house, Michelangelo thanked him, excusing himself because he had with him two friends whom he did not want to leave, nor did he want to inflict their company on him. To which the gentleman replied, "I too will come with you and wander all over the world, if you will pay my way." When Michelangelo had been persuaded by these and other words, he excused himself to his friends and took leave of them, giving them what little money he had, and went to lodge with the gentleman. At this point, the Medici family with all their followers, who had been driven out of Florence, came on to Bologna and were lodged in the house of the Rossi; thus Cardiere's vision or diabolical delusion or divine prediction or powerful imagination, whatever it was, came true. This is truly remarkable and worth recording, and I have related it just as I heard it from Michelangelo himself.

From the death of Lorenzo the Magnificent to the exile of his sons,

some three years elapsed, so that Michelangelo must have been between the ages of twenty and twenty-one.[27] To avoid those first popular upheavals, waiting for the city of Florence to assume some order, he stayed on in Bologna with the aforesaid gentleman, who treated him with great honor, as he was delighted with his intelligence, and every evening he had him read from Dante or Petrarch and sometimes from Boccaccio, until he fell asleep. One day, as he was taking Michelangelo around Bologna, he led him to see the tomb of St. Dominic in the church dedicated to that saint, where two marble figures were missing, which were a *St. Petronius* and a *Kneeling Angel* with a candlestick in its hand. He asked Michelangelo if he felt equal to making them and, when he said yes, he arranged for the commission to be given to him and had him paid thirty ducats, eighteen for the *St. Petronius* and twelve for the *Angel*. The figures were three *palmi* in height and are still to be seen in that same place.[28] But then, as Michelangelo had suspicions of a Bolognese sculptor, who was complaining that Michelangelo had taken the commission away from him, to whom it had been promised first, and was threatening to cause him trouble, he returned to Florence, where things had by then more or less calmed down and he could live safely at home. He stayed a little more than a year with Messer Gianfrancesco Aldovrandi.

When Michelangelo was back in his native city, he set to work carving out of marble an *Eros*, six or seven years old, lying in the position of a man asleep. When Lorenzo di Pierfrancesco de' Medici, for whom Michelangelo had in the meanwhile made an *Infant St. John*, saw this figure, he thought it very beautiful and said to him, "If you would fix it so that it looked as if it had been buried, I would send it to Rome and it would pass for an ancient work, and you would sell it much better."[29] Upon hearing this, Michelangelo, to whom none of the ways of genius were obscure, reworked it immediately so that it looked as if it had been made many years earlier. Thus it was sent to Rome, and the cardinal of S. Giorgio bought it as an ancient work for two hundred ducats. However, the man who collected this money deceived both Lorenzo di Pierfrancesco and Michelangelo by writing to Florence that Michelangelo was to be paid thirty ducats, that that was the amount he had received for the *Eros*. But, in the meanwhile, it came to the ears of the

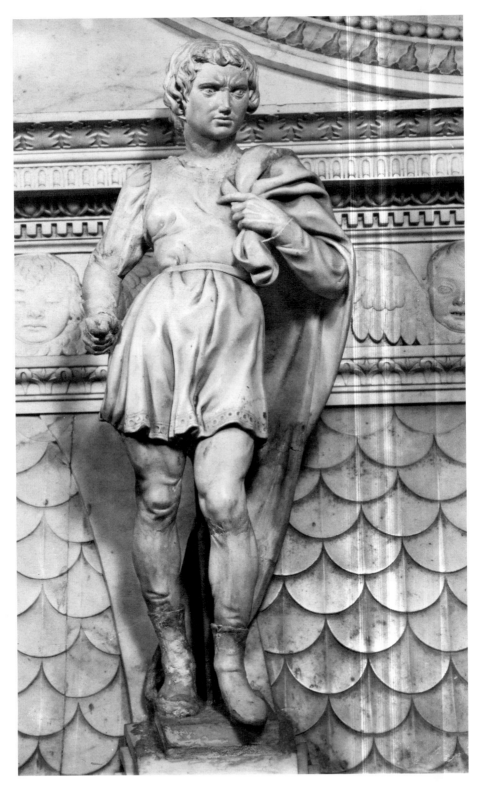

PLATE 7 Michelangelo, *St. Proculus,* tomb of St. Dominic,
S. Domenico, Bologna
Photo courtesy Fratelli Alinari, Florence

cardinal how the *putto* had been made in Florence and, as he was indignant at being cheated, he sent one of his gentlemen there. This man, pretending to seek a sculptor for certain works in Rome, was directed to Michelangelo's house after several others; and to throw light cautiously on what he wanted, when he saw the young man he asked if he would show him something. But as he had nothing to show, he picked up a pen, because the *lapis* was not in use at that time, and drew a hand for him with such skill that the gentleman was astonished.[30] Then he asked him if he had ever done any work in sculpture, and when Michelangelo answered yes, that he had done, amongst other things, an *Eros* of such and such a height and pose, the gentleman found out what he wanted to know. And, after describing what had happened, he promised Michelangelo that, if he were willing to go with him to Rome, he would help him to recover the difference and would set everything straight with his patron, whom he knew would be very pleased.

Thus Michelangelo, partly out of anger at being defrauded and partly out of a desire to see Rome, which the gentleman had so extolled to him as offering the widest field for everyone to demonstrate his ability, went along with him and lodged in his house, which was near the cardinal's palace. In the meanwhile, the cardinal, who had been advised by letter as to how the matter stood, had the man apprehended who had sold him the statue as an ancient work and, when he had gotten his money back, he gave him back the statue. It then passed, I do not know by what means, into the hands of the Duke Valentino and was given to the marchioness of Mantua and sent by her to Mantua, where it still is, in the house of those lords. Some were critical of the cardinal of S. Giorgio in this affair because, if the work was seen by all the artists in Rome and by them all equally it was judged very beautiful, it did not seem that he should be so offended by its being modern as to deprive himself of it for the sake of two hundred *scudi* when he was an affluent and very wealthy man. But, if he was incensed by having been deceived, he could have punished that man by making him refund to the master of the statue the remainder of the payment which he had already taken home. But no one suffered in this more than Michelangelo, who got no more out of it than what he had received in Florence.[31] And the fact that the cardinal of S. Giorgio had little understanding or enjoyment of

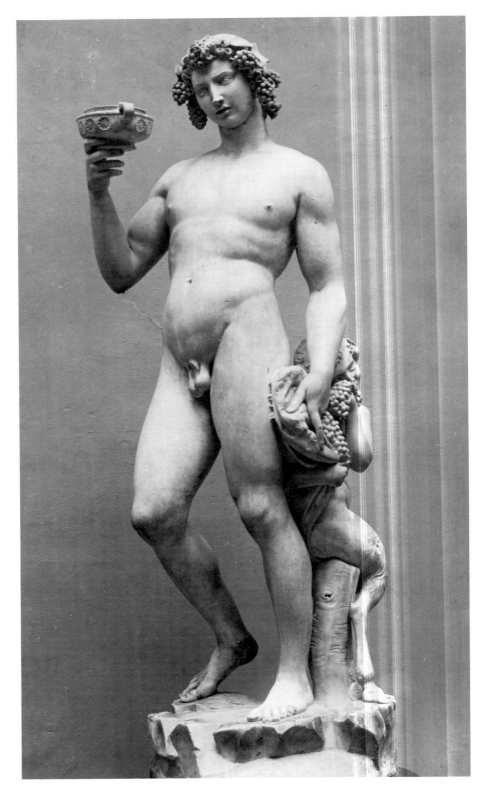

PLATE 8 Michelangelo, *Bacchus*, Bargello, Florence
Photo courtesy Fratelli Alinari, Florence

sculpture is made abundantly clear to us because in the whole time that Michelangelo stayed with him, which was about a year, he never worked on any commission whatever from the cardinal.

He did not, however, lack a connoisseur who did make use of him; for Messer Jacopo Galli, a Roman gentleman of fine intellect, had him make in his house a marble *Bacchus* ten *palmi* high (Pl. 8), whose form and ap-

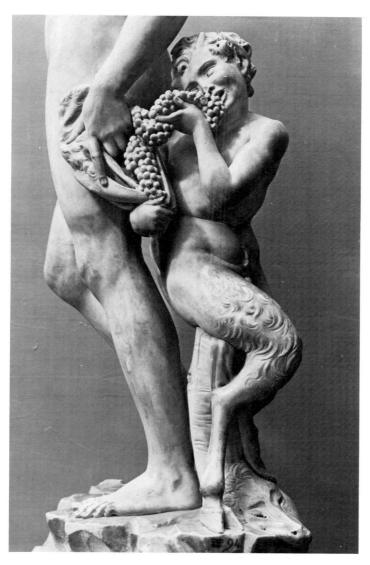

PLATE 9 Satyr and Flayed Leopardus, detail of *Bacchus*
Photo courtesy Fratelli Alinari, Florence

pearance correspond in every particular to the intention of the writers of antiquity: the mirthful face and sidelong, lascivious eyes of those too much possessed by the love of wine. He holds a cup in his right hand, as if about to drink, and gazes at it as if taking pleasure in that liquor which he invented; for this reason Michelangelo encircled the head with a garland of vine leaves. Over the left arm he has the skin of a tiger, which animal is dedicated to him because of its great delight in the grape; and Michelangelo made the skin instead of the animal to signify that he who lets himself be lured to that extent by the senses and by the craving for that fruit and its liquor ends by giving up his life to it. In the hand of this arm he holds a bunch of grapes which a merry and nimble little satyr (Pl. 9) at his feet is furtively eating; he appears to be about seven years old, and the *Bacchus* looks eighteen. It was also the wish of the said Messer Jacopo that he make an *Eros*; and both of these works are to be seen today in the house of Messers Giuliano and Paolo Galli, courteous and worthy gentlemen with whom Michelangelo has always maintained an intimate friendship.[32]

A little later, as a commission from the cardinal of S. Dionigi, known as Cardinal Rovano, he made out of one block of marble that marvelous statue of Our Lady which is nowadays in the chapel of the Madonna della Febbre (Pl. 10), although at first it was placed in the church of Sta. Petronilla, the chapel of the king of France, near the sacristy of St. Peter's. That church, which according to some was formerly a temple to Mars, was destroyed by Bramante for the sake of the design of the new church.[33] The Madonna is seated on the rock in which the cross was fixed, with her dead Son across her lap, of such great and rare beauty that no one sees it who is not moved to pity. It is an image truly worthy of that humanity with which the Son of God and so great a mother were endowed, even though there are some who object to the mother as being too young in relation to the Son. When I was discussing this one day with Michelangelo, he answered: "Don't you know that women who are chaste remain much fresher than those who are not? How much more so a virgin who was never touched by even the slightest lascivious desire which might alter her body? Indeed, I will go further and say that this freshness and flowering of youth, apart from being preserved in her in this natural way, may also conceivably have been given divine as-

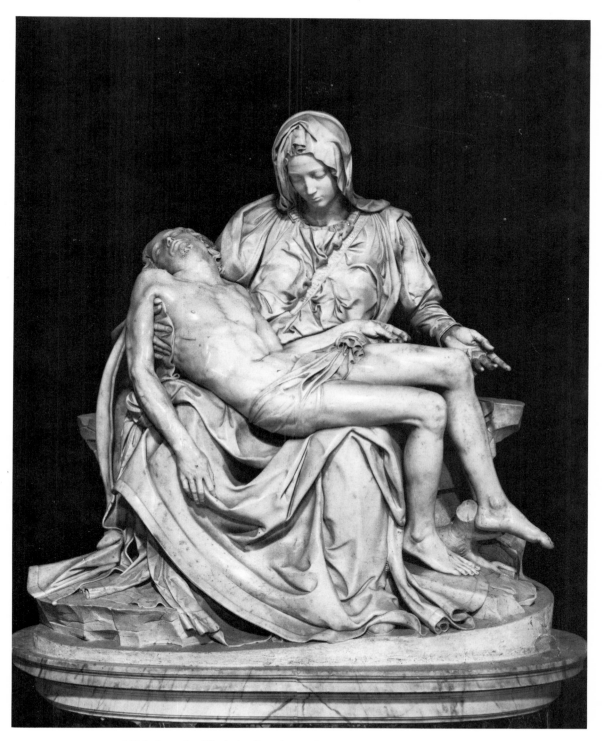

PLATE 10 Michelangelo, *Pietà*, St. Peter's Basilica, Rome
Photo courtesy Fratelli Alinari, Florence

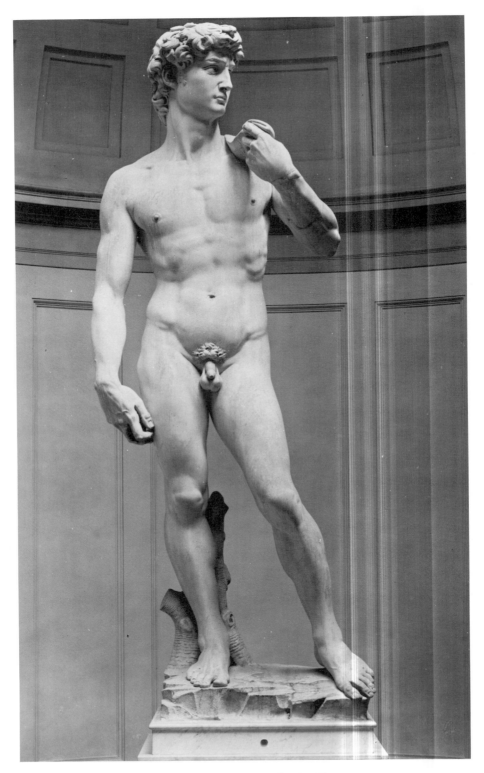

PLATE 11 Michelangelo, *David*, Accademia, Florence
Photo courtesy Fratelli Alinari, Florence

sistance in order to prove to the world the virginity and perpetual purity of the mother. This was not necessary with the Son, in fact rather the contrary, because in order to show that the Son of God truly assumed human form, as He did, and submitted to all that an ordinary man undergoes, except sin, there was no need for the divine to hold back the human, but it was necessary to let it follow its own course and order so that He would show exactly the age He was. Therefore you should not be surprised if, with this in mind, I made the Holy Virgin, mother of God, considerably younger in comparison with her Son than her age would ordinarily require, though I left the Son at His own age."[34] This consideration would be most worthy of any theologian and perhaps extraordinary coming from others, but not from him whom God and nature formed not only to do unique work with his hands but also to be a worthy recipient of the most sublime concepts, as can be recognized not only from this, but from very many of his thoughts and writings. Michelangelo could have been twenty-four or twenty-five years old when he did this work. Through it, he acquired great fame and reputation, so much that, already in the opinion of the world, he not only far surpassed any other man of his time, and of the time before him, but he even rivaled the ancients.

After he had done these things, he was forced to return to Florence to attend to his family affairs; there he stayed for some time and made that statue known to all as the *Gigante* (Pl. 11), which still today stands at the end of the balustrade in front of the door of the Palazzo della Signoria.[35] And it came about in this way: the *operai* of Sta. Maria del Fiore owned a block of marble nine *braccia* high, which had been brought from Carrara a hundred years earlier by an artist who, from what one could see, was not as experienced as he should have been; for, in order to transport it more conveniently and with less effort, he had roughed it out right at the quarry, but in such a way that neither he nor anyone else ever had the courage to lay a hand to it to carve a statue, not of that size or even much smaller. Since they were unable to get anything out of that block of marble which was likely to be good, one Andrea dal Monte a San Sovino had the idea that he might obtain it from them, and he asked them to make him a present of it, promising that, by adding certain pieces to it, he would carve a figure out of it.

But, before they decided to give it to him, they sent for Michelangelo and told him of Andrea's desire and opinion; and, when they perceived his confidence that he could carve something good from it, in the end they offered it to him. Michelangelo accepted it, and without adding any other pieces he extracted the aforesaid statue so exactly that the old rough surface of the marble still appears on the top of the head and on the base.[36] He has done the same in several other statues, such as the figure representing the *Contemplative Life* (Pl. 40) on the tomb of Pope Julius II: it is characteristic of great artists and of their mastery of the art. But in this statue it seemed all the more extraordinary because, apart from the fact that he did not add any pieces, it is also impossible (as Michelangelo is wont to say) or at least extremely difficult in making statues to correct the faults of the rough stage. He received four hundred ducats for this work and he accomplished it in eighteen months.

And so that there should be no material in the realm of sculpture to which he could not turn his hand, after the *Gigante*, at the request of his great friend Piero Soderini, Michelangelo cast a life-sized statue in bronze which was sent to France and likewise a *David* with Goliath below.[37] The one which is to be seen in the center of the courtyard of the Palazzo della Signoria is by the hand of Donatello, an outstanding man in the art of sculpture and much praised by Michelangelo except in one respect, that he lacked patience in polishing his works, so that, though they were admirably successful from a distance, they lost their reputation when seen from nearby.[38]

He also cast in bronze a *Madonna* with her little Son in her lap, which was sent to Flanders after he had been paid a hundred ducats for it by certain Flemish merchants, the Moscheroni, a very noble family in their own country. And in order not to abandon painting altogether, he did a *Madonna* on a round panel for Agnolo Doni, a Florentine citizen, for which he received seventy ducats.[39]

He remained for some time doing almost nothing in these arts, dedicating himself to the reading of poets and vernacular orators and to writing sonnets for his own pleasure until, after the death of Pope Alexander VI, he was called to Rome by Pope Julius II (Pl. 12), and he received a hundred

PLATE 12 Raphael, Julius II in *The Mass at Bolsena*,
Stanza d'Eliodoro, Vatican, Rome.
Photo courtesy Fratelli Alinari, Florence

ducats in Florence for his traveling expenses. Michelangelo must have been
twenty-nine at that time, because if we count from his birth, which was in
1474, as has been mentioned, to the aforesaid death of Alexander, which was
in 1503, we will find that twenty-nine years had elapsed. After he came to
Rome, then, many months passed before Julius II could decide in what way
to employ him. At last it entered his mind to have him make his tomb.[40]
And, when he saw the design, he liked it so much that he sent him at once
to Carrara to quarry the amount of marble required for the project, and he
had Alemanno Salviati in Florence pay him a thousand ducats for this pur-
pose.[41] He remained in those mountains for more than eight months, with
two helpers and a horse and no provision other than food. One day while
there, he was looking at the landscape, and he was seized with a wish to
carve, out of a mountain overlooking the sea, a colossus which would be visible
from afar to seafarers. He was attracted largely by the suitability of the rock,

which could be carved conveniently, and by the wish to emulate the ancients, who when they chanced to be in a place, perhaps for the same reasons as Michelangelo, either to escape idleness or for whatever other purpose, left behind them some sketched, imperfect traces which give very good proof of their skill.[42] And he would certainly have done it if he had had enough time or the project for which he had come had permitted. One day I heard him speak of this with great regret. Now, after he had quarried and selected what he thought were enough marbles and transported them to the coast, he left one of his men to attend to their loading, and he returned to Rome. And since he had stopped in Florence for several days, when he reached Rome he found that part of the marble had already arrived at Ripa; when the blocks had been unloaded there, he had them taken to the Piazza S. Pietro, behind Sta. Caterina, where he had his room near the Corridor.[43]

So great was the quantity of the blocks of marble that, when they were spread out in the piazza, they made other people marvel and rejoiced the pope, who conferred such great and boundless favors on Michelangelo that, when he had begun to work, he would go more and more often all the way to his house to see him, conversing with him there about the tomb and other matters no differently than he would have done with his own brother. And, in order to be able to go there more conveniently, he ordered a draw-bridge built between the Corridor and Michelangelo's room, whereby he could go in there secretly. As very often happens at court, the many great favors thus conferred gave rise to envy and, after envy, endless persecutions. Thus the architect Bramante, who was loved by the pope, made him change his plans by quoting what common people say, that it is bad luck for anyone to build his tomb during his lifetime, and other stories. Apart from envy, Bramante was prompted by the fear he had of the judgment of Michelangelo, who kept discovering many of Bramante's blunders. Because Bramante, who was as everyone knows a great spendthrift and given to every sort of pleasure, so that the funds provided him by the pope, however ample, did not suffice, tried to gain advantage in his buildings by making the walls of poor materials and inadequately strong and secure for their size and extensiveness. This is obvious for everyone to see in the building of St. Peter's in the Vatican, in the Belvedere Corridor, in the monastery of S. Pietro in Vincoli,

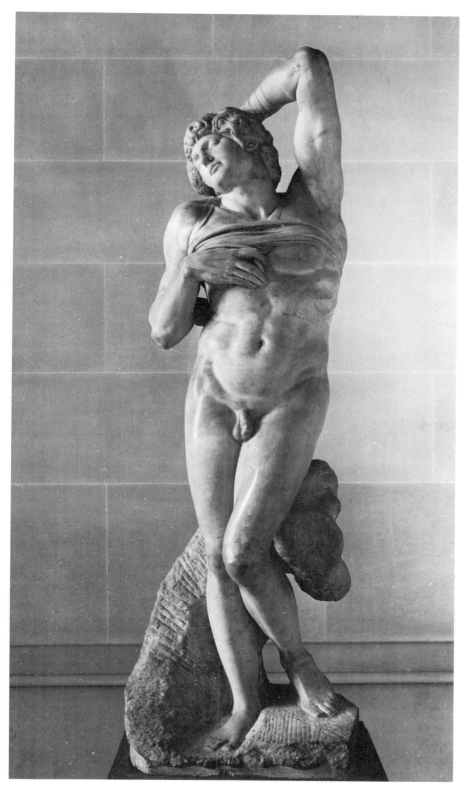

PLATE 13 Michelangelo, *Dying Slave*, Louvre, Paris
Photo courtesy Cliché Musées Nationaux, Paris

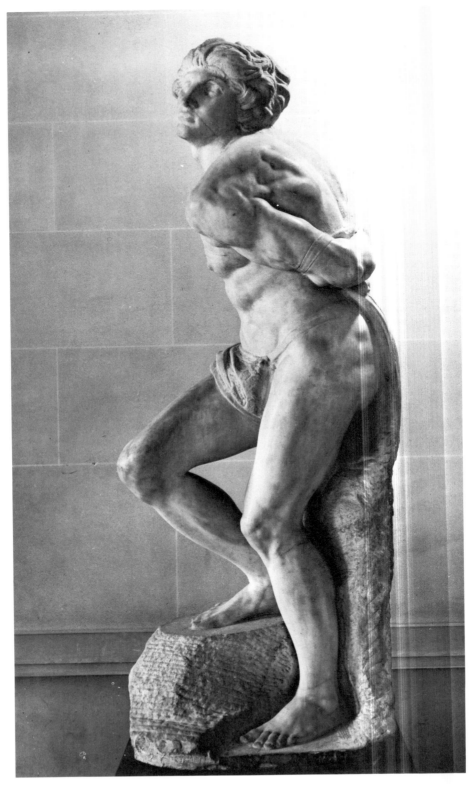

PLATE 14 Michelangelo, *Rebellious Slave*, Louvre, Paris
Photo courtesy Cliché Musées Nationaux, Paris

and in his other buildings, all of which have required new foundations and reinforcement with buttresses and retaining walls, as if they were falling or would shortly have fallen down. Now, because he did not doubt that Michelangelo recognized these misdeeds of his, he constantly sought to remove him from Rome, or at least to deprive him of the pope's favor and of the glory and reward he might acquire by his industry.[44] This happened to him in the case of this tomb; if it had been built according to his first design (be it said without envy), there is no doubt that in his art he would have prevailed over any other artist, however highly regarded, as he had ample scope in which to show his worth. And what he was going to do is indicated by his other works and by those two *Captives* (Pls. 13, 14) which he had already executed for the project; everyone who has seen them considers that no more deserving work has ever been done.[45]

And to give some idea of it, I will say briefly that this tomb was to have had four faces (Fig. 2): two were to have been eighteen *braccia* long to serve as the sides, and two of twelve *braccia* as head and foot, so that it came to a square and a half. All around the exterior there were niches for statues and between each niche and the next there were terms to which other statues were bound like captives, upon certain cubical bases which rose from the ground and projected outward.[46] These represented the liberal arts, such as painting, sculpture, and architecture, each with its attributes so that it could easily be recognized for what it was, signifying thereby that all the artistic virtues were prisoners of death together with Pope Julius, as they would never find another to favor and foster them as he did. Above these statues ran a cornice which bound the whole work together, on which level there were four large statues, one of which, namely the *Moses* (Pl. 38), appears in S. Pietro in Vincoli; and this will be discussed in its proper place. Continuing upward, the work terminated in a surface upon which there were two angels supporting a sarcophagus: one of them seemed to smile as if rejoicing that the soul of the pope had been received among the blessed spirits, the other to weep as if grieving that the world should be stripped of such a man. Through one end, the one which was at the upper side, one entered into a small chamber within the tomb resembling a *tempietto*, in the center of which was a marble chest where the body of the pope was to be placed;[47]

everything was executed with marvelous artistry. In short, the whole work involved more than forty statues, not counting the narrative scenes in bronze in *mezzo-rilievo*, all pertinent to the subject, in which the deeds of this great pope were to be seen.

When the pope had seen this design, he sent Michelangelo to St. Peter's to see where it could suitably be placed. The form of the church then was that of a cross, at the head of which Pope Nicholas V had begun to rebuild the choir, and it had already reached a height of three *braccia* aboveground when he died. It seemed to Michelangelo that this was a very appropriate place and, returning to the pope, he presented his opinion, adding that, if His Holiness thought so too, it was going to be necessary to raise the structure and roof it over. The pope asked him what would be the cost, to which Michelangelo answered, "A hundred thousand *scudi*." "Let it be two hundred thousand," said Julius. And after sending San Gallo, the architect, and Bramante to see the place, in the course of these arrangements the pope was inspired to build the whole church anew. Various designs were ordered, and Bramante's was accepted as more attractive and better conceived than the others (Fig. 9). Thus it was because of Michelangelo that the part of the building that was already begun was finished because, if this had not happened, perhaps it would still be as it was, and also that the pope conceived the desire to renovate the rest according to a new and more beautiful and more magnificent design.[48]

Now to return to our story. Michelangelo became aware of the pope's change of mind in this way: the pope had enjoined Michelangelo to go to him and no one else when he needed money, so that he would not have to turn here and there for it. It happened one day that the rest of the marbles which had remained at Carrara arrived at Ripa. Michelangelo had them unloaded and taken to St. Peter's and came to ask the pope for money, as he wanted to pay the fees for hiring, unloading, and transportation; but he found him busy and access to him more difficult. Therefore when he went home, in order not to inconvenience those poor men who were waiting to collect, he paid them all himself, expecting to have his money back, as he might get it readily from the pope. When he returned another morning and entered the antechamber for an audience, lo and behold, an equerry came

toward him saying, "Forgive me, but I have orders not to admit you." There was a bishop present, who when he overheard the equerry's words rebuked him, saying, "You must not realize who this man is?" "On the contrary, I do know him," answered the equerry, "but I am obliged to follow the orders of my superiors, without inquiring further." Michelangelo, to whom up to then no portiere had ever been drawn or door closed, seeing himself thus discarded, was angered by this turn of events and answered, "And you may tell the pope that from now on, if he wants me, he can look for me elsewhere." So when he returned home he gave orders to two servants that he had that, when they had sold all the household furniture and collected the money, they were to follow him to Florence. He boarded the stagecoach and at two in the morning he reached Poggibonsi, a castle in the domain of Florence, some eighteen or twenty miles from the city. Here, being in a safe place, he alighted. Shortly afterwards, five couriers arrived from Julius, with orders to bring him back wherever they should find him. But they had come upon him in a place where they could do him no violence and, as Michelangelo threatened to have them killed if they attempted anything, they resorted to entreaties; these being of no avail, they did get him to agree that at least he would answer the pope's letter, which they had presented to him, and that he would write specifically that they had caught up with him only in Florence, in order for the pope to understand that they had not been able to bring him back against his will. The tenor of the pope's letter was this: that, as soon as Michelangelo had seen the present letter, he was to return forthwith to Rome, under pain of his disfavor. To which Michelangelo answered briefly that he would never go back; that in return for his good and faithful service he did not deserve to be driven from the pope's presence like a villain; and that, since His Holiness no longer wished to pursue the tomb, he was freed from his obligation and did not wish to commit himself to anything else. When he had dated the letter as we said and dismissed the couriers, he went on to Florence where, in the three months that he stayed there, three briefs were sent to the *signoria*, full of threats, to the effect that they should send him back by fair means or foul.[49]

Piero Soderini, who was then *gonfaloniere* for life of that republic, had previously let him go to Rome against his will, as he was planning to employ

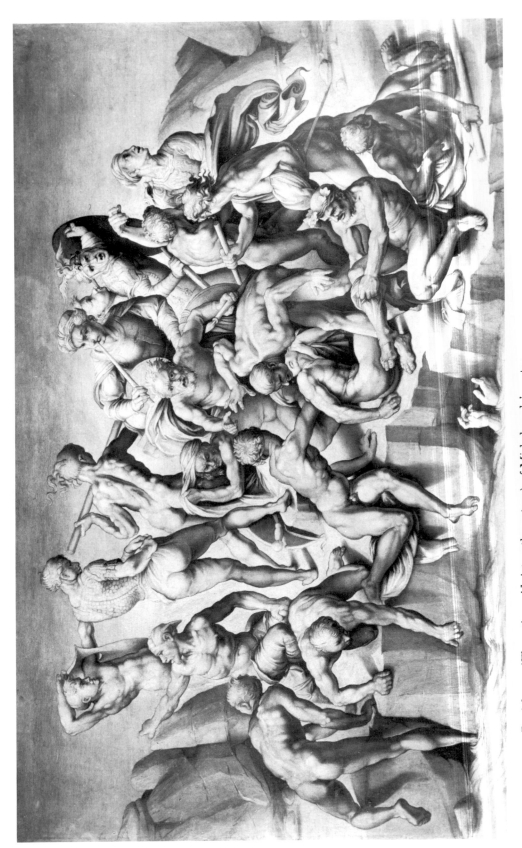

PLATE 15 Partial copy (Florentine mid-sixteenth century) of Michelangelo's cartoon for *The Battle of Cascina*, Lord Leicester Collection, Holkham Hall, Norfolk By permission of the earl of Leicester. Photo courtesy Courtauld Institute of Art

him in painting the Sala del Consiglio; thus when the first letter came he did not force Michelangelo to return, hoping that the pope's anger would pass; but, when the second and the third came, he sent for Michelangelo and said to him, "You have tried the pope as a king of France would not have done. However, he is not to be kept begging any longer. We do not want to go to war with him over you and place our state in jeopardy. Therefore, make ready to return." Then Michelangelo, seeing that it had come to this and fearing the wrath of the pope, thought of going away to the Levant, chiefly as the Turk sought after him with most generous promises through the intermediary of certain Franciscan friars, because he wanted to employ him in building a bridge from Constantinople to Pera and in other works.[50] But, when the *gonfaloniere* heard of this, he sent for him and dissuaded him from this idea, saying that he should prefer to die going to the pope than to live going to the Turk; and that anyway he should not be afraid of this because the pope was benevolent and was recalling him because he loved him and not in order to harm him; and that, if he was still afraid, the *signoria* would send him with the title of ambassador, because it is not customary to commit violence against public persons without its applying to those who send them. On account of these and other words, Michelangelo prepared to return.

But during this time that he stayed in Florence two things happened. One was that he finished that marvelous cartoon which he had begun for the Sala del Consiglio, in which he depicted the war between Florence and Pisa and the many and various incidents which took place in the course of it (Pl. 15). This artistically most skillful cartoon enlightened all who took brush in hand from that time forth. And I do not know by what misfortune it then went astray, for Michelangelo had left it in the Sala del Papa, a place in Florence at Sta. Maria Novella which goes by this name. However, some fragments are to be seen in various places, preserved with great care and as something sacred.[51] The other thing which happened was that Bologna was taken by Pope Julius, and he had gone there, and this acquisition had put him in very good spirits. This gave Michelangelo the courage to appear before him with more hope.

So he reached Bologna one morning and went to S. Petronio to hear

mass, and who should appear but the pope's equerries who, recognizing him, brought him before His Holiness, who was at table in the Palazzo de' Sedici. When he saw Michelangelo in his presence, he said to him with an angry look on his face, "You were supposed to come to us, and you have waited for us to come to you," meaning that His Holiness having come to Bologna, a place much closer to Florence than Rome was, was as if he had come to him. Michelangelo knelt down and loudly begged his forgiveness, pleading that he had erred not out of wickedness but out of indignation, as he could not bear to be turned away as he was. The pope remained with his head bowed and a disturbed expression on his face, answering nothing, when a monsignor, sent by Cardinal Soderini to exonerate and recommend Michelangelo, wanted to intervene and said, "Your Holiness must disregard his offense, because he offended through ignorance. Painters, outside of their art, are all like that." To which the pope answered angrily, "You are saying insulting things about him which we do not say. You are the ignoramus and the wretch, not he. Get out of my sight and go to the devil." And, when he did not go, he was pushed out (as Michelangelo tells it) with jabs by the pope's attendants. The pope, having thus vented most of his wrath upon the bishop, called Michelangelo closer, pardoned him, and enjoined him not to leave Bologna until he had given him another commission.[52]

Nor did the pope delay long before he sent for Michelangelo and said that he wanted him to portray him in a great bronze statue which he wanted to place on the façade of the church of S. Petronio. And, leaving a thousand ducats for this purpose in the bank of Messer Antonmaria da Lignano, he returned to Rome. In fact, before he left, Michelangelo had already made a clay model of the statue. And, since he was in doubt as to what to do with the left hand, having made the right hand in an attitude of benediction, he inquired of the pope, who had come to see the statue, whether he would like it if he made a book in that other hand. "What book," was the pope's response; "a sword: because I for my part know nothing of letters." And, joking about the forceful gesture of the right hand, he said smilingly to Michelangelo, "This statue of yours, is it giving the benediction or a malediction?" To which Michelangelo rejoined, "It is threatening this populace, Holy Father, if they are not prudent." But as I have said, when

Pope Julius returned to Rome, Michelangelo remained in Bologna, and he spent sixteen months finishing the statue and installing it where the pope had already ordered him to do so. Later, when the Bentivoglio reentered Bologna, this statue was thrown to the ground and destroyed in the fury of the populace. It was more than three times life-size.[53]

When Michelangelo had finished this work, he came on to Rome, where Pope Julius, still resolved not to do the tomb, was anxious to employ him. Then Bramante and other rivals of Michelangelo put it into the pope's head that he should have Michelangelo paint the vault of the chapel of Pope Sixtus IV (Pl. 16), which is in the palace, raising hopes that in this he would accomplish miracles. And they were doing this service with malice, in order to distract the pope from projects of sculpture, and because they took it for certain that either he would turn the pope against him by not accepting such an undertaking or, if he accepted it, he would prove considerably inferior to Raphael of Urbino, whom they plied with every favor out of hatred for Michelangelo, as it was their opinion that Michelangelo's principal art was the making of statues (as indeed it was). Michelangelo, who had not yet used colors and who realized that it was difficult to paint a vault, made every effort to get out of it, proposing Raphael and pleading that this was not his art and that he would not succeed; and he went on refusing to such an extent that the pope almost lost his temper. But, when he saw that the pope was determined, he embarked on that work which is to be seen today in the papal palace to the admiration and amazement of the world, which brought him so great a reputation that it set him above all envy.[54] Of this work I shall give a brief account.

The form of the vault is what is commonly called a barrel vault and its supports are lunettes, which are six along the length and two along the breadth, so that the whole vault amounts to two and a half squares.[55] In this space Michelangelo painted principally the Creation of the world, but he went on to embrace almost all the Old Testament (Pl. 17). And he divided this work in the following manner: starting from the brackets which support the horns of the lunettes, up to about a third of the arch of the vault, a flat wall is simulated (Fig. 7); rising to the top of it are some pilasters and bases simulating marble, which project outward from a plane resembling a parapet,

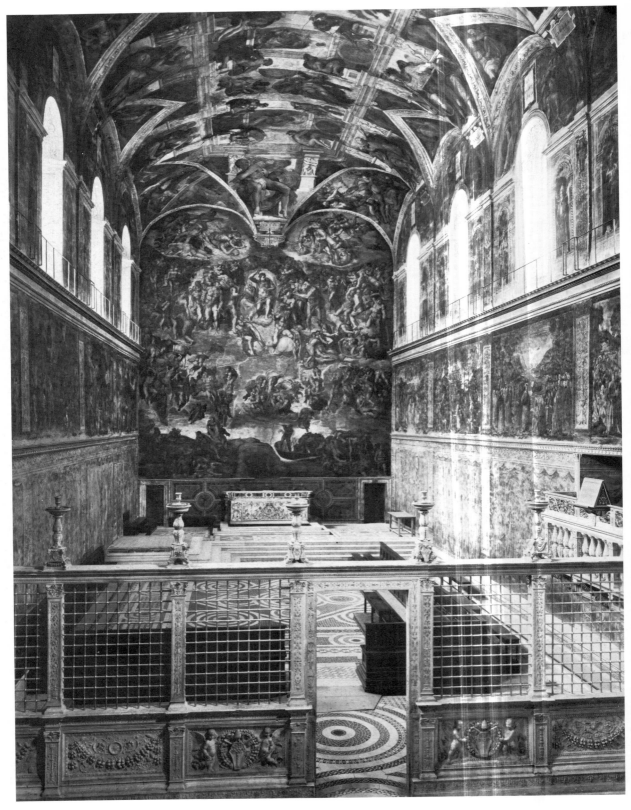

PLATE 16 Interior of the Sistine Chapel, Vatican, Rome
Photo courtesy Fratelli Alinari, Florence

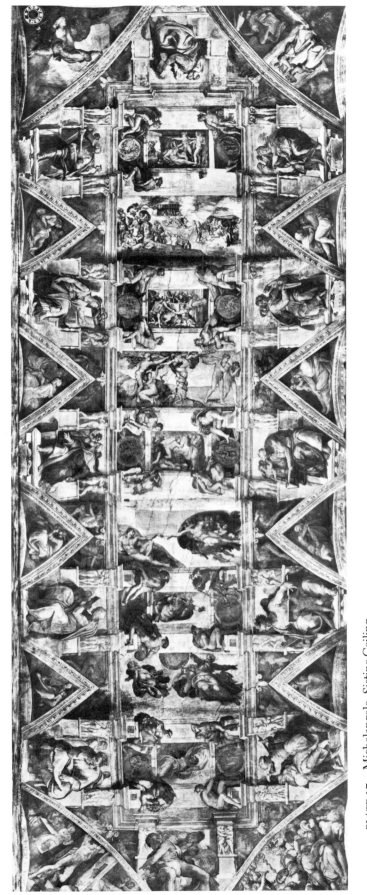

PLATE 17 Michelangelo, Sistine Ceiling
Photo courtesy Fratelli Alinari, Florence

with its corbels below and with other little pilasters above against the same plane, on which Prophets and Sibyls are seated. Springing from the arches of the lunettes, these first pilasters flank the brackets, excluding, however, a segment of the arches of the lunettes which is greater than the space contained between them. On the said bases are imitation figures of little nude children in various poses, which, like terms, support a cornice which surrounds the whole work, leaving the middle of the vault from head to foot like an open sky. This opening is divided into nine bands, because there are certain arches with moldings which rise from the cornice over the pilasters, traverse the highest part of the vault, and rejoin the cornice on the opposite side, leaving between the arches nine spaces, alternating large and small. In each of the small ones there are two strips of imitation marble which cross the space, so placed that the center comprises two parts to one part at each side where the medallions are situated, as will be mentioned in the proper place. And this he did to avoid the sense of surfeit which comes from sameness.

At the head of the chapel, then, in the first space, which is one of the smaller ones, God the Almighty is to be seen in the heavens, dividing light from darkness by the motion of His arms (Pl. 18).[56] In the second space is the creation of the two great lights, in which He appears with arms outstretched, with His right arm pointing toward the sun and His left toward the moon (Pl. 19). There are some little angels in His company, one of whom at His left side hides his face and draws close to his Creator as if to protect himself from the evil influence of the moon. In this same space, at the left side, God appears again, turning to create the grasses and the plants on earth, executed with such great artistry that, wherever you turn, He seems to follow you, showing His whole back down to the soles of His feet, a very beautiful thing, which demonstrates what foreshortening can do.[57] In the third space, the great God appears in the heavens, again with angels, and gazes upon the water, commanding them to bring forth all the species of creatures which that element sustains, just as in the second space He commanded the earth (Pl. 20). In the fourth is *The Creation of Man* (Pl. 21), where God is seen with arm and hand outstretched as if to impart to Adam the precepts as to what he must and must not do, while with the other arm

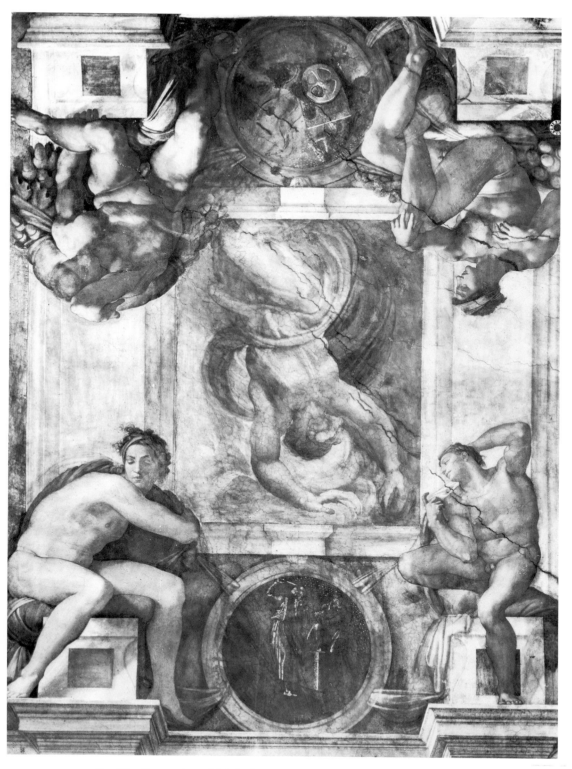

PLATE 18 *The Separation of Light from Darkness, Ignudi,* and medallion
with *The Sacrifice of Isaac*, Sistine Ceiling
Photo courtesy Fratelli Alinari, Florence

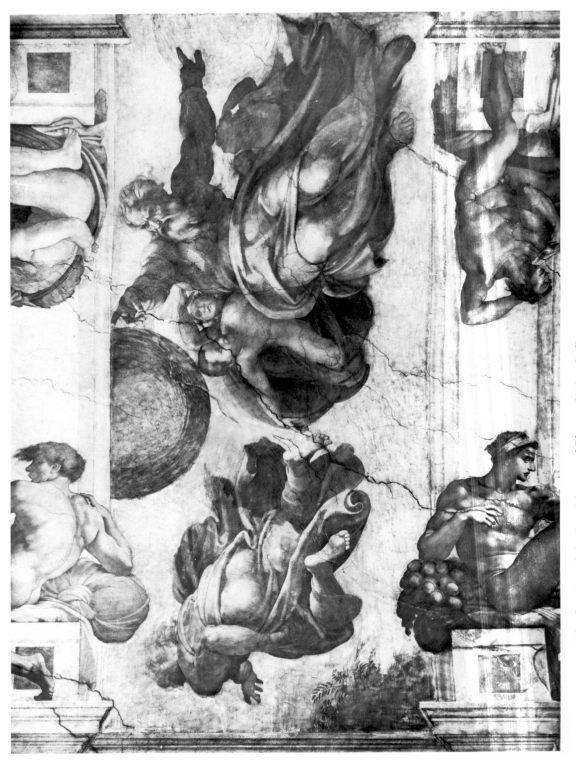

PLATE 19 *The Creation of the Sun, Moon, and Planets, Sistine Ceiling*
Photo courtesy Fratelli Alinari, Florence

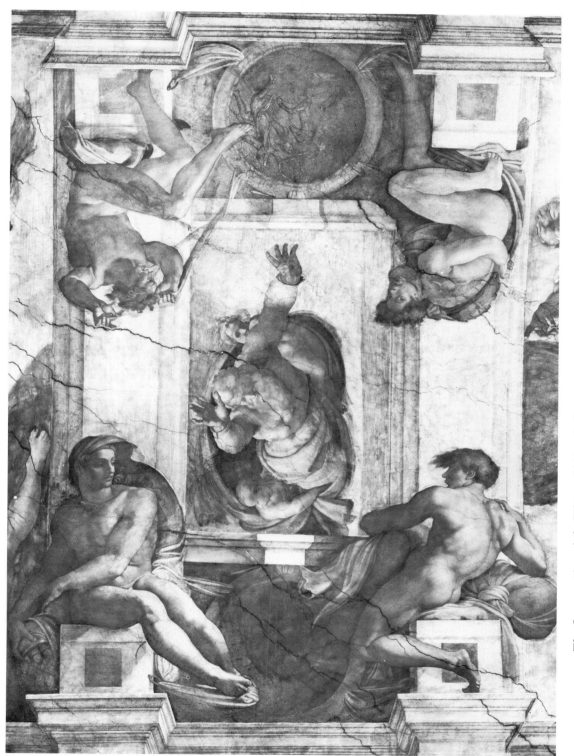

PLATE 20 *The Congregation of the Waters*, Sistine Ceiling
Photo courtesy Fratelli Alinari, Florence

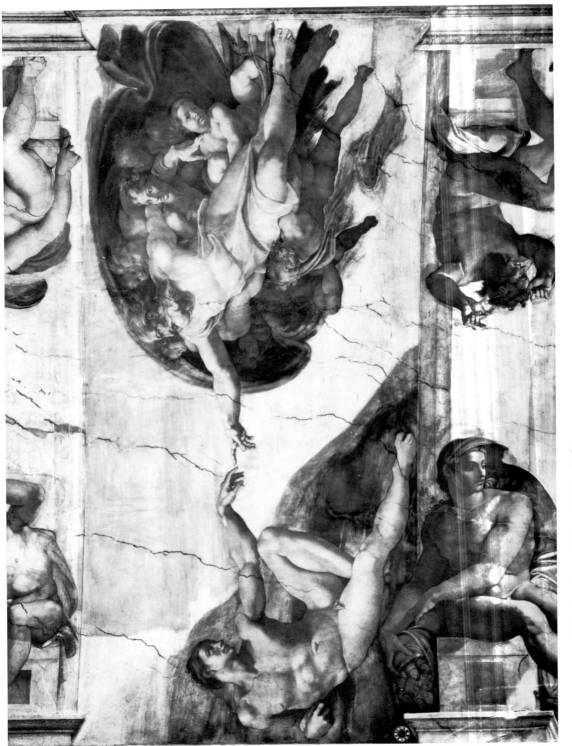

PLATE 21 *The Creation of Adam*, Sistine Ceiling
Photo courtesy Fratelli Alinari, Florence

He gathers His little angels around Him.[58] In the fifth is when He draws woman from Adam's rib and she, rising with hands joined and held out toward God and bowing in an attitude of meekness, seems to be thanking Him and He to be blessing her (Pl. 22). In the sixth is when the devil, his upper left in human form and the rest in that of a serpent, with his legs transformed into tails, coils around a tree and, pretending to reason with the man, persuades him to act against his Creator while to the woman he proffers the forbidden apple (Pl. 23). And the other part of the space shows them both, expelled by the angel, stricken with fear and grief, fleeing from the face of God.

In the seventh is the sacrifice of Abel and Cain (Pl. 24), the one pleasing and acceptable to God, the other abhorrent and rejected.[59] In the eighth is *The Flood*, in which Noah's ark can be seen in the distance, in the midst of the waters, with some figures who are clinging to it to be saved (Pl. 25). Nearer, in the same sea, there is a boat laden with various people, which, because it is overloaded and because of the frequent and violent shocks of the waves, its sail lost, bereft of all aid or human remedy, is already shipping water and going down. Here it is pitiful to see the human race perish so miserably in the waves. Likewise, nearer the eye, a mountaintop appears still above the waters, like an island, to which a multitude of men and women have retreated as they flee the rising waters; they express various emotions, but all pathetic and fearful, as they draw under a tent stretched over a tree for protection against the extraordinary rain; and, overhead, the wrath of God is represented with great artistry, pouring down upon them with waters, with thunder, and with lightning. There is another mountain peak at the right side, considerably nearer the eye, with a multitude ravaged by the same disaster, whose every detail would take a long time to describe; suffice it to say that they are all lifelike and awesome, as one might imagine in such a calamity. In the ninth, which is the last, is the story of Noah when he lay drunk on the ground with his privy parts exposed and was derided by his son Ham and covered by Shem and Japheth (Pl. 26).

Under the aforesaid cornice which terminates the wall and over the brackets on which the lunettes rest, between the pilasters are seated twelve large figures of Prophets and Sibyls (Pl. 27), all truly remarkable, as much

for their poses as for the richness and variety of their draperies.[60] But most remarkable of all is the prophet *Jonah* (Pl. 28), situated at the head of the vault, because, contrary to the curve of the vault and by means of the play of light and shadow, the torso which is foreshortened backward is in the part nearest the eye, and the legs which project forward are in the part which is farthest. A stupendous work, and one which proclaims the magnitude of this man's knowledge, in his handling of lines, in foreshortening, and in perspective. But in the spaces under the lunettes and also in the spaces above, which have the form of a triangle, the whole of the Genealogy is painted, or let us say the ancestry of the Savior, except for the corner triangles, which are joined together into one and form a double space (Fig. 8). In one of these, then, next to the wall of *The Last Judgment*, at the right-hand side, Haman appears, who was hung upon a cross at the command of King Ahasuerus; and this was because he, in his pride and arrogance, wanted to hang Mordecai, the uncle of Queen Esther, for not doing him honor and reverence as he passed by. In another is the story of the *Brazen Serpent* (Pl. 29), lofted by Moses on a staff, whereby the people of Israel, who had been wounded and tormented by live snakes, were healed when they looked upon it. Here Michelangelo has portrayed remarkable efforts of strength in those who are trying to rid themselves of the coils of those vipers. In the third corner, at the lower end, is Judith's revenge upon Holofernes. And, in the fourth, David's upon Goliath.[61] And this, in brief, is the entire narrative content.

But no less marvelous than this is that part which does not appertain to the narrative. These are certain *ignudi* which, seated on bases above the aforesaid cornice, support at either side the medallions already mentioned (Pl. 18), which simulate metal, on which, in the manner of reverses, various subjects are depicted, all related, however, to the principal narrative.[62] In all these things, in the beauty of the compartments, in the diversity of poses, in the contradiction of the contours of the vault, Michelangelo displayed consummate art. But, to relate the details of these and the other things would be an endless undertaking, and a volume would not suffice. Therefore I have passed over it briefly, wishing merely to cast a little light on the whole rather than to go into detail as to the parts.

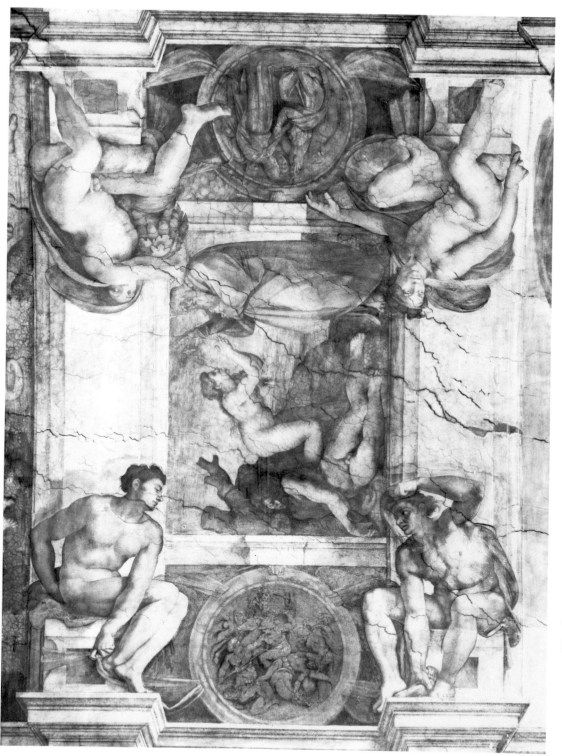

PLATE 22 *The Creation of Eve*, Sistine Ceiling
Photo courtesy Fratelli Alinari, Florence

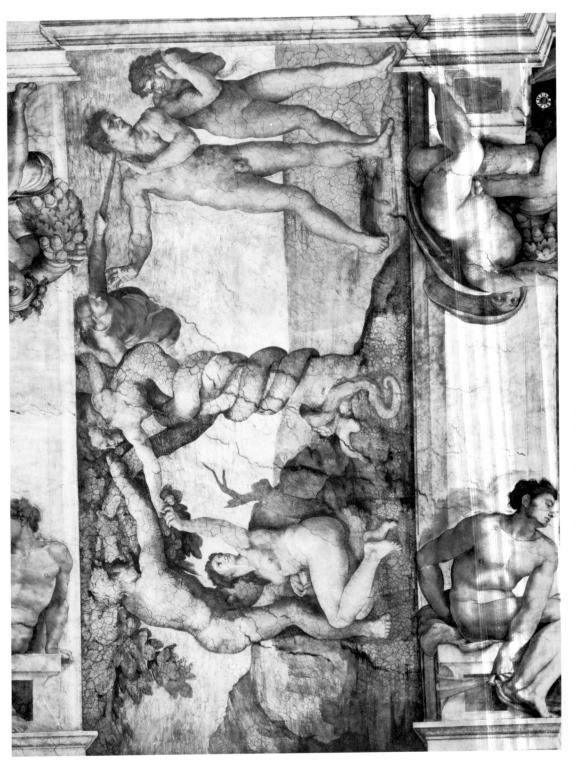

PLATE 23 *The Temptation and Expulsion*, Sistine Ceiling
Photo courtesy Fratelli Alinari, Florence

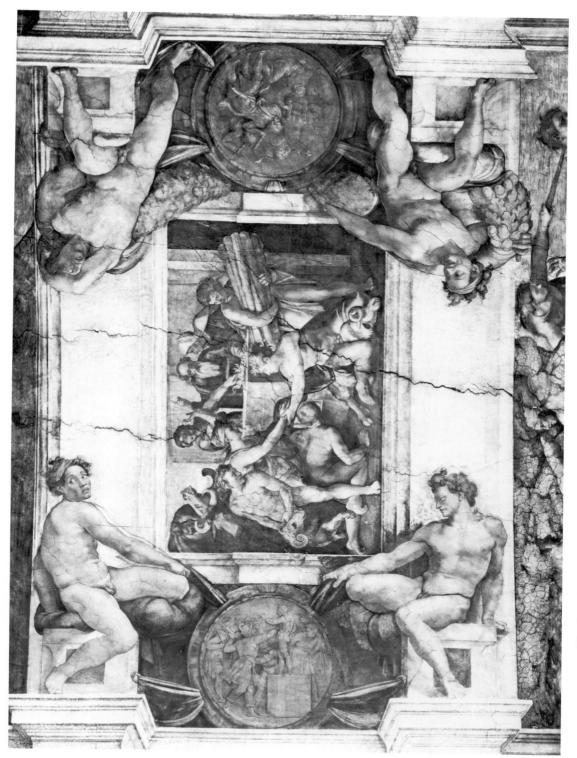

PLATE 24 *The Sacrifice of Noah*, Sistine Ceiling
Photo courtesy Fratelli Alinari, Florence

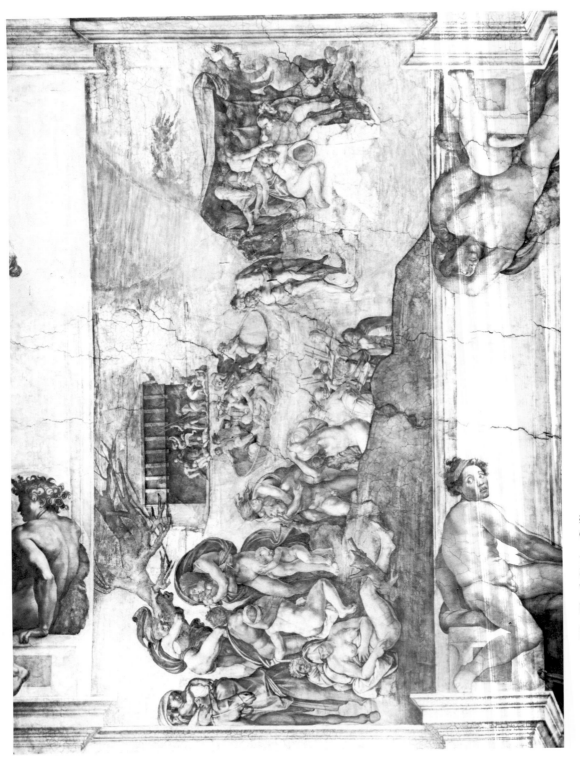

PLATE 25　*The Flood*, Sistine Ceiling
Photo courtesy Fratelli Alinari, Florence

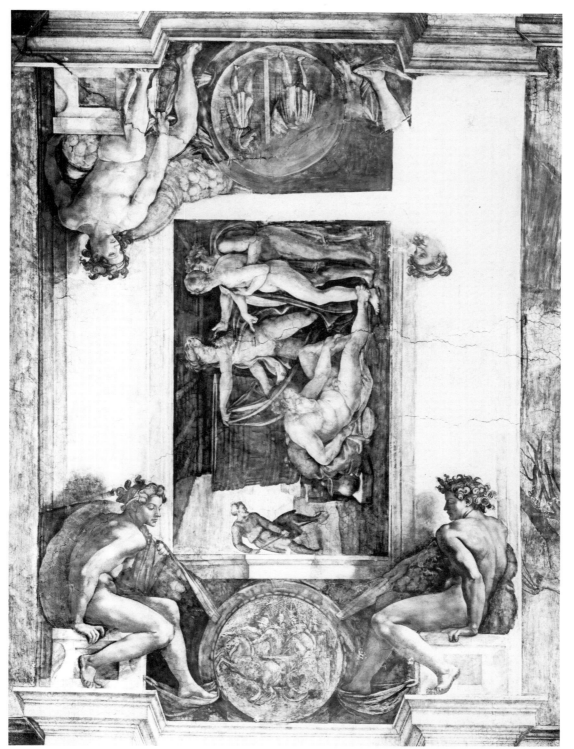

PLATE 26 *The Drunkenness of Noah,* Sistine Ceiling
Photo courtesy Fratelli Alinari, Florence

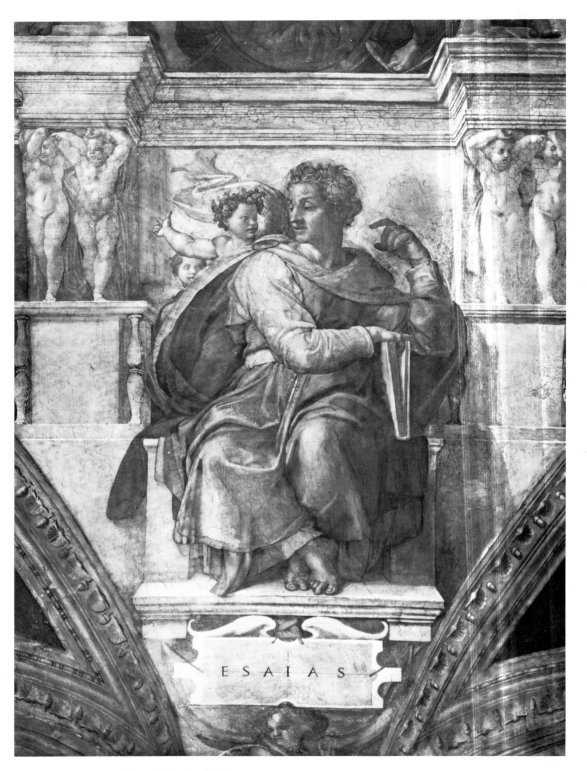

ESAIAS

PLATE 27 *Isaiah*, Sistine Ceiling
Photo courtesy Fratelli Alinari, Florence

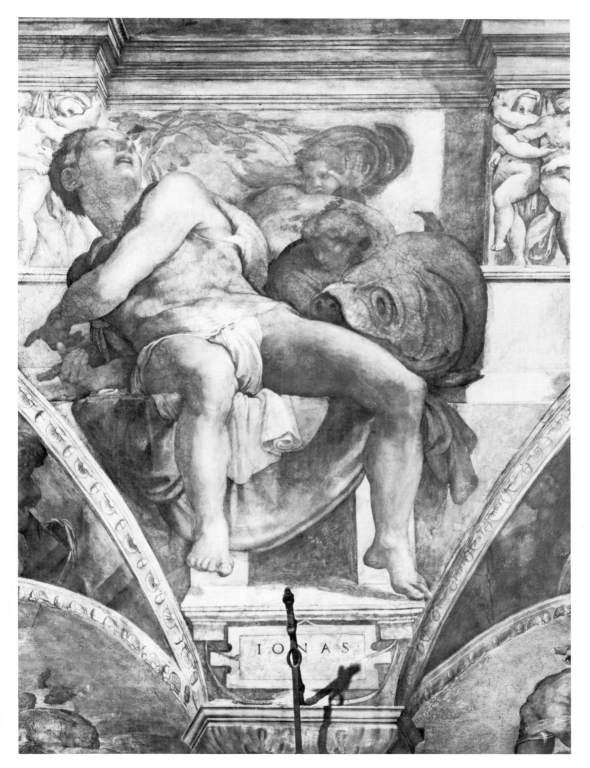

PLATE 28 *Jonah,* Sistine Ceiling
Photo courtesy Fratelli Alinari, Florence

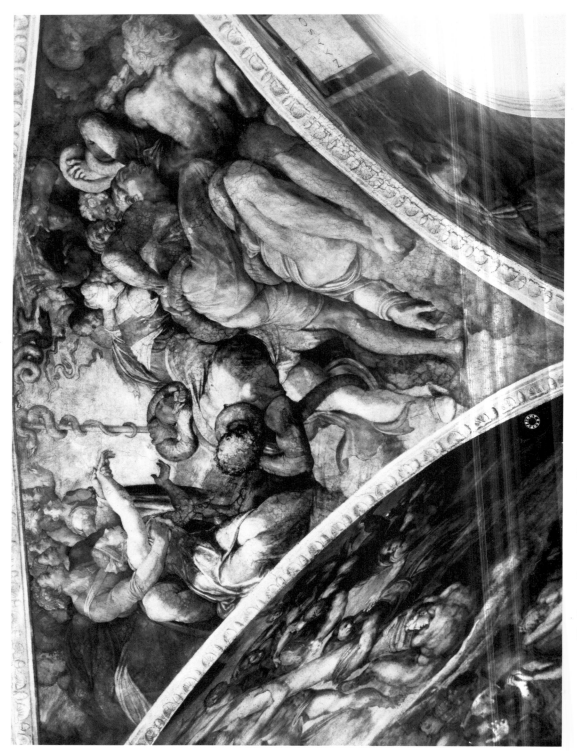

PLATE 29 *The Brazen Serpent*, Sistine Ceiling
Photo courtesy Fratelli Alinari, Florence

And, in the midst of all this, he was not without anxieties because, when he had begun the work and completed the picture of *The Flood*, it began to mildew so that the figures could barely be distinguished. Therefore Michelangelo, reckoning that this must be a sufficient excuse for him to escape such a burden, went to the pope and said to him, "Indeed I told Your Holiness that this is not my art; what I have done is spoiled. And if you do not believe it, send someone to see." The pope sent San Gallo, who, when he saw it, realized that Michelangelo had applied the plaster too wet, and consequently the dampness coming through produced that effect; and, when Michelangelo had been advised of this, he was forced to continue, and no excuse served.

While he was painting, Pope Julius often wanted to go and inspect the work; he would climb up by a ladder and Michelangelo would hold out a hand to him to help him up onto the scaffolding. And, being one who was by nature impetuous and impatient of waiting, as soon as the work was half done, that is from the door to midway on the vault, he wanted Michelangelo to uncover it while it was still incomplete and had not received the last touches. The opinion and the expectation which everyone had of Michelangelo brought all of Rome to see this thing, and the pope also went there before the dust raised by the dismantling of the scaffold had settled.[63]

After this work, when Raphael had seen the new and wonderful manner of painting, as he had a remarkable gift for imitation, he sought through Bramante to paint the rest himself.[64] This greatly disturbed Michelangelo, and before Pope Julius he gravely protested the wrong which Bramante was doing him; and in Bramante's presence he complained to the pope, unfolding to him all the persecutions he had received from Bramante; and next he exposed many of his deficiencies, and mainly that, in demolishing the old St. Peter's, Bramante was pulling down those marvelous columns which were in that temple, with no regard or concern for their being broken to pieces, when he could lower them gently and preserve them intact; and he explained that it was easy to put one brick on top of another, but that to make such a column was extremely difficult, and many other things which need not be told, so that, when the pope had heard of these derelictions, he wanted Michelangelo to continue, conferring upon him more favors than ever. He

finished this entire work in twenty months, without any help whatever, not even someone to grind his colors for him.[65] It is true that I have heard him say that it is not finished as he would have wanted, as he was hampered by the urgency of the pope, who asked him one day when he would finish that chapel, and when Michelangelo answered, "When I can," the pope, enraged, retorted, "You want me to have you thrown off the scaffolding." Hearing this, Michelangelo said to himself, "You shall not have me thrown off," and he removed himself and had the scaffolding taken down, and on All Saints' Day he revealed the work, which the pope, who went to the chapel that day, saw with immense satisfaction, and all Rome admired it and crowded to see it. What was lacking was the retouching of the work *a secco* with ultramarine and in a few places with gold, to give it a richer appearance. Julius, when the heat of his enthusiasm had subsided, really wanted Michelangelo to furnish these touches; but, when Michelangelo thought about the trouble it would give him to reassemble the scaffolding, he answered that what was lacking was nothing of importance. "It really ought to be retouched with gold," answered the pope, to whom Michelangelo responded with the familiarity which was his way with His Holiness, "I do not see that men wear gold." The pope said, "It will look poor." Michelangelo rejoined, "Those who are depicted there, they were poor too." So he remarked in jest, and so the work has remained.[66]

For this work and for all his expenses, Michelangelo received three thousand ducats, of which he was obliged to spend about twenty or twenty-five on colors, according to what I have heard him say. After he had accomplished this work, because he had spent such a long time painting with his eyes looking up at the vault, Michelangelo then could not see much when he looked down; so that, if he had to read a letter or other detailed things, he had to hold them with his arms up over his head. Nonetheless, after a while, he gradually grew accustomed to reading again with his eyes looking down. From this we may conceive how great were the attention and diligence with which he did this work.[67]

Many other things happened to him during the lifetime of Pope Julius, who loved him with all his heart and with more concern and jealousy for him than for anyone else whom he had around him. This can be inferred quite

clearly from what we have already written. Indeed, when the pope suspected one day that Michelangelo was annoyed, he sent someone at once to placate him. It happened in this way: Michelangelo, wishing to go to Florence for the feast of S. Giovanni, asked the pope for money. And, when the pope demanded when he would finish the chapel, Michelangelo answered in his usual way, "When I can." The pope, who was precipitate by nature, struck him with a staff which he had in his hand, saying, "When I can, when I can." However, after Michelangelo had gone home, he was making preparations to go without fail to Florence when Accursio, a young man much in favor, arrived from the pope and brought him five hundred ducats, placating him as best he could and making the pope's excuses. Michelangelo accepted the apology and went off to Florence. Thus it was evident that Julius had no greater concern for anything than for keeping this man with him; and he wanted to employ him not only during his lifetime but also after his death.

Thus, when he was approaching death, he commanded that Michelangelo was to be commissioned to finish that tomb which he had already begun, and the pope put his own nephew, Cardinal Aginense, in charge of it, with Cardinal Santi Quattro the Elder. But these men had him draw up a new design (Fig. 3), as the original seemed to them too great an undertaking.[68] So Michelangelo entered once again upon the tragedy of the tomb, which turned out no more happily for him than the first one; indeed, it turned out far worse, bringing him innumerable difficulties, disappointments, and anxieties, and worse yet, through the malice of certain men, it brought him disgrace of which he has barely rid himself after many years. Then Michelangelo began all over again to have the work done, with many master artisans brought from Florence, and Bernardo Bini, who was the *depositario*, dispensed money as it was needed.[69] But he did not get very far with it before he was interrupted, to his great distress, because Pope Leo (Pl. 2), who succeeded Julius, conceived a desire to decorate the façade of S. Lorenzo in Florence with sculpture and marble work. This church was built by the great Cosimo de' Medici and was all completely finished except for the façade at the front (Pl. 30). Pope Leo, then, when he decided to contribute this part, thought to employ Michelangelo; and, sending for him, he had him make a design, and finally he wanted him to go to Florence for this

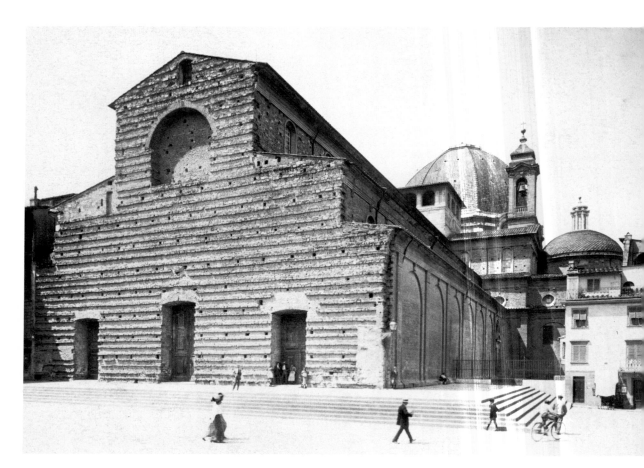

PLATE 30 S. Lorenzo, Florence
Photo courtesy Fratelli Alinari, Florence

purpose and take on that whole burden. Michelangelo, who had begun to
work on the tomb of Julius with great devotion, put up all the resistance he
could, alleging that he was under obligation to Cardinals Santi Quattro and
Aginense and could not fail them. But the pope, who had resolved upon this,
answered him, "Let me deal with them, for I shall see that they are satis-
fied." So he sent for them both and made them release Michelangelo to the
very great sorrow of both Michelangelo and the cardinals, particularly Agi-
nense who was, as we have said, the nephew of Pope Julius. However, Pope
Leo promised them that Michelangelo would work on the tomb in Florence
and that he did not want to obstruct it. So it came about that Michelangelo,
weeping, left the tomb and went away to Florence. When he had arrived
and organized all those things which were required for the façade (Pl. 31),

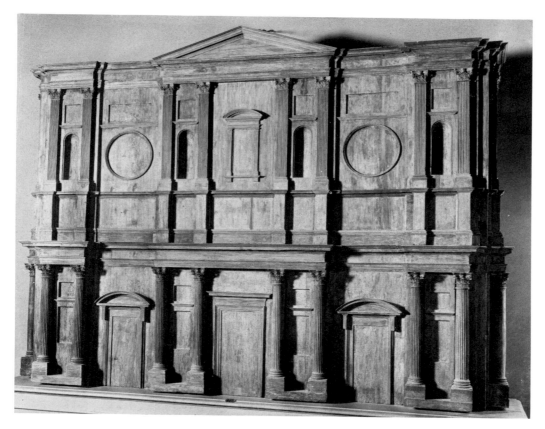

PLATE 31 Wooden model of Michelangelo's design for the façade
of S. Lorenzo, Casa Buonarroti, Florence
Photo courtesy Fratelli Alinari, Florence

he went on to Carrara to bring back the marbles, not only for the façade but also for the tomb, in the belief that he would be able to proceed with it, as he had been promised by the pope.[70]

In the meanwhile, word was sent to Pope Leo that in the mountains of Pietra Santa, a castle belonging to the Florentines, there were marbles of the same beauty and quality as those at Carrara and that, when this had been mentioned to Michelangelo, he had preferred to quarry the Carrara marbles rather than these others which were in the state of Florence, as he was a friend of the Marquis Alberigo and had come to an understanding with him.[71] The pope wrote to Michelangelo, ordering him to go to Pietra Santa to see whether the information written to him from Florence were true. When Michelangelo went there, he found marbles which were very difficult to work

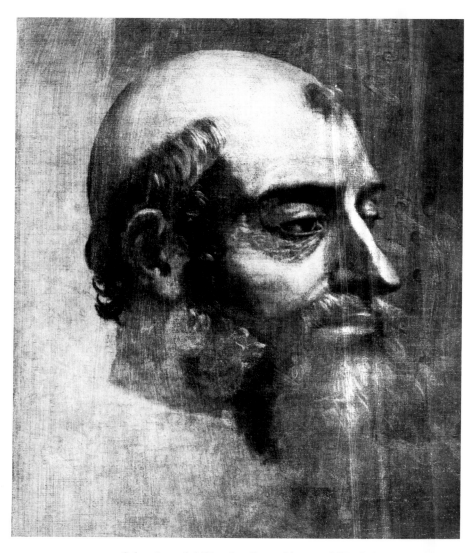

PLATE 32 Sebastiano del Piombo, *Pope Clement VII*, Galleria Nazionale, Museo di Capodimonte, Naples
Photo courtesy Fratelli Alinari, Florence

and not really suitable; and, even if they had been suitable, it was difficult and very expensive to transport them to the coast, as it was necessary to build a good many miles of road through the mountains with pickaxes, and on piles across the plain, which was marshy. When Michelangelo wrote this to the pope, he gave more credence to those who had written to him from Florence than to Michelangelo, and he ordered him to build the road. So, to

carry out the pope's wishes, he had the road built and by this means transported a great quantity of marbles to the coast. Amongst these were five columns of exact size, one of which he had transported to Florence, where it can be seen in Piazza S. Lorenzo; the other four, because the pope changed his mind and turned his thoughts elsewhere, are still lying on the beach.[72] But the marquis of Carrara, who thought that because Michelangelo was a Florentine citizen it had been his idea to quarry at Pietra Santa, became his enemy, and later he did not want him to return to Carrara for certain marbles which he had had quarried there. This was most detrimental to Michelangelo.

Now, when he had returned to Florence and found that, as we have already said, Pope Leo had completely lost interest, Michelangelo sorrowfully remained a long time without doing anything, after wasting much of his time up to then on first one thing and then another, to his great regret. Nonetheless, with certain marbles which he had, he began to proceed with the tomb in his own house. But, when Leo died and Hadrian VI was created pope, he was once again forced to interrupt the work, because people were making the accusation that he had received fully sixteen thousand *scudi* from Julius for that work and was not taking the trouble to execute it but was staying in Florence for his own pleasure.[73] When he was thus called to Rome in regard to this matter, the Cardinal de' Medici, who later became Clement VII (Pl. 32) and who at that time controlled the government of Florence, did not want him to go; and, to keep him occupied and to have some pretext, he set him to work on the vestibule of the Medici Library in S. Lorenzo and also on the sacristy with the tombs of his ancestors (Pl. 33), and he promised to satisfy the pope for him and to smooth everything out. So, as Hadrian did not live many months in the papacy and Clement succeeded him, for a time no word was said about the tomb of Julius.[74] But, when Michelangelo was advised that Francesco Maria, the duke of Urbino, nephew of the happy memory of Pope Julius, was making great complaints about him and even adding threats, he proceeded to Rome, where he discussed the matter with Pope Clement.[75] The pope advised him to have the duke's agents summoned to make an accounting with him of everything which he had received from Julius and everything he had done for him, knowing that, when Michelangelo's works were appraised, he would emerge a creditor rather

than a debtor. Michelangelo stayed there reluctantly for this matter, and, when some of his affairs were in order, he returned to Florence, mainly because he anticipated the ruin which descended on Rome shortly thereafter.

In the meanwhile, the house of Medici was banished from Florence for assuming greater authority than is tolerable to a free city and one which is ruled as a republic.[76] And, as the *signoria* had no doubt that the pope would do everything he could to reinstate the Medici, and they fully expected war, they turned their attention to fortifying the city; and they made Michelangelo commissioner general over this. Placed at the head of this undertaking, then, apart from many other provisions he made for the whole city, he built fortifications around the mountain of S. Miniato, which stands above the city and surveys the surrounding countryside. If the enemy were to make themselves masters of that mountain, there is no doubt that they would become masters of the city as well. Thus this foresight made for the safety of the country and extreme detriment to the enemy; because, being high and elevated as I have said, it inflicted great harm upon the enemy, chiefly from the bell tower of the church, where there were two pieces of artillery which continually did great damage to the plain beyond. Even though Michelangelo had made that provision, he nevertheless remained on the mountain for any contingency that might arise. And, when he had been there already about six months, rumors arose among the soldiers of the city of I know not what treachery. When Michelangelo became aware of this, partly by himself and partly through the warnings of certain captains who were friends of his, he went to the *signoria* and revealed to them what he had heard and seen, pointing out to them the danger in which the city found itself and saying that there was still time for them to take measures if they wanted to. But, instead of being rewarded with gratitude, he was insulted and reproved for being faint-hearted and unduly suspicious. And the man who answered him thus would have done far better to lend him an ear because, when the house of Medici entered Florence, he had his head cut off, whereas he might perhaps have lived.

When Michelangelo perceived that little value was attached to his words and that the city was sure to be ruined, he used his authority to have a gate opened for him and he went out with two companions and proceeded to

Venice. And certainly the treason was not an idle story; but he who was handling the matter judged that it would pass off with less scandal if it were not revealed just then, and if in time the same effect were produced by his merely not doing his duty and hindering whoever might have wanted to do it. Michelangelo's departure caused an uproar in Florence, and he fell into deep disfavor with the ruling forces. Nonetheless he was called back with great entreaties and with appeals to his patriotism and with assertions that he should not abandon the task that he had taken upon himself and that things had not reached such an extreme as he had been given to understand, and many other things. Persuaded by these arguments and by the authority of the personages writing to him, and principally by love of his native land, when he had been given a safe-conduct for ten days from the day he was to arrive in Florence, he returned, but not without danger to his life.[77]

Upon reaching Florence, the first thing he did was to reinforce the bell tower of S. Miniato, which was all scarred by the continual battering of the enemy artillery and stood in danger of eventually crumbling with very harmful effect upon those within. The method of reinforcement was this: a large number of mattresses well stuffed with wool were taken and lowered by night with stout cords from the top to the bottom of the tower, so as to cover that part which might be hit. And, because the cornices of the tower projected, the mattresses hung more than six *palmi* out from the main wall of the bell tower, in such a way that, when the cannonballs did come, partly because of the distance from which they were fired, partly because of the interference of these mattresses, they did little or no damage, not even harming the mattresses because they yielded. In this way he maintained that tower during the whole time of the war, which lasted one year, without its ever being harmed, and it contributed greatly to the protection of the country and the discomfiture of the enemy. But then, when the enemy had entered the city by agreement and many citizens had been seized and killed, the *corte* was sent to Michelangelo's house to arrest him; and the rooms and all the chests, even the chimney and the privy, were opened. But Michelangelo, fearing what was to ensue, had fled to the house of a great friend of his, where he remained hidden for many days without anyone except the friend knowing that he was in the house, and he saved himself; because, when the furor had subsided,

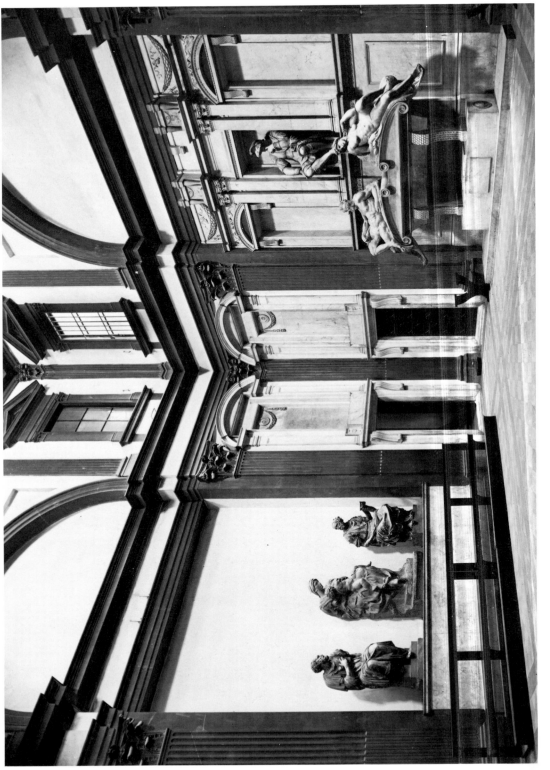

PLATE 33 Tomb of Lorenzo de' Medici, duke of Urbino, and *Madonna and Child*
flanked by *St. Cosmas* and *St. Damian*, Medici Chapel, S. Lorenzo, Florence
Photo courtesy Fratelli Alinari, Florence

Pope Clement wrote to Florence that Michelangelo was to be sought, and the pope's orders were that when he was found, if he were willing to continue the work he had already begun on the tombs, he should be treated with courtesy and allowed to go free. Learning of this, Michelangelo emerged and, although it had been some fifteen years since he had touched his tools, he set about that project with such diligence that, impelled more by fear than by love, in a few months he made all those statues which appear in the sacristy of S. Lorenzo (Pls. 33,34). It is true that none of them have received the final touches; however, they are all brought to such a stage that the excellence of the artist is very apparent, and the rough surfaces do not interfere with the perfection and the beauty of the work.[78]

The tombs are four, placed in a sacristy built for the purpose in the left side of the church, across from the Old Sacristy. And, although there was one conception and one form for them all, nevertheless the figures are all different and in different poses and attitudes. The tombs are placed in certain chapels and on their covers recline two great figures more than life-size, a man and a woman, representing Day and Night and, collectively, Time which consumes all. And, in order for his intent to be better understood, he gave to *Night*, which is made in the form of a woman of wondrous beauty, the owl and other pertinent symbols (Pl. 35), and to *Day* his symbols likewise. And to signify Time, he meant to carve a mouse, for which he left a little bit of marble on the work, but then he was prevented and did not do it; because this little creature is forever gnawing and consuming just as time devours all things. Then there are other statues which represent those for whom the tombs were built; and all of them, in conclusion, are more divine than human, but especially a *Madonna* with her little Son astride her thigh, about which I deem it better to be silent than to say little, so I shall forbear.[79] This blessing we owe to Pope Clement; if in his lifetime he had done nothing else that was praiseworthy, whereas indeed he did much, this would suffice to cancel his every fault since, through him, the world has so noble a work. And we owe him far more because, when Florence was taken, he showed the same respect for this man's *virtù* as Marcellus upon entering Syracuse showed for the *virtù* of Archimedes. Although in that case goodwill had no effect, in this case, by the grace of God, it did.[80] For all that, Michel-

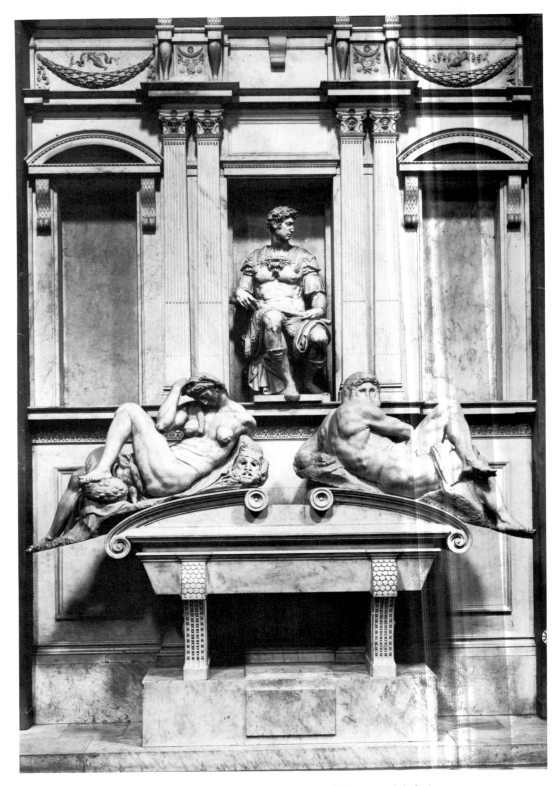

PLATE 34 Tomb of Giuliano de' Medici, duke of Nemours, Medici
Chapel, S. Lorenzo, Florence
Photo courtesy Fratelli Alinari, Florence

angelo lived in extreme fear, because he was deeply hated by Duke Alessandro, a fierce and vengeful young man, as everyone knows. And there is no doubt that, if it had not been for the respect shown by the pope, he would have gotten rid of Michelangelo. All the more so since, when the duke of Florence wanted to build that fortress which he built and had Signor Alessandro Vitelli summon Michelangelo to ride with him to see where it could conveniently be built, Michelangelo would not go, answering that he had no such orders from Pope Clement. This made the duke very angry; so that, both for this new reason and on account of the old ill will and the natural disposition of the duke, Michelangelo was justified in being afraid.[81] And it was certainly through the help of the Lord God that he did not happen to be in Florence at the time of Clement's death because, before the tombs had

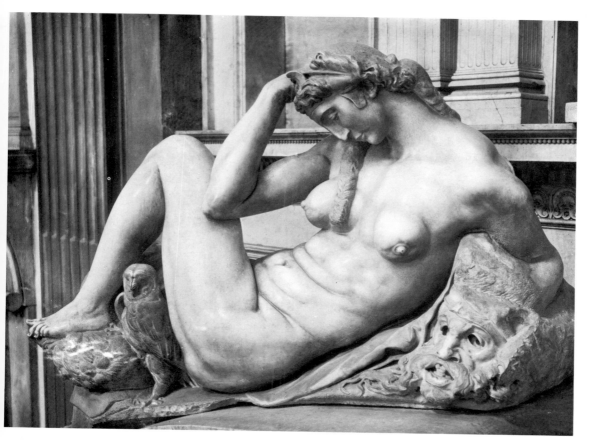

PLATE 35 Michelangelo, *Night*, tomb of Giuliano de' Medici
Photo courtesy Fratelli Alinari, Florence

been quite completed, the pope summoned him to Rome and received him joyfully. Clement respected this man as something sacred and would discuss both light and serious subjects with him with the same familiarity as he would have shown an equal. He endeavored to relieve him of the tomb of Julius so that he might remain permanently in Florence, not only to finish the works he had begun but also to undertake other works of no less merit.[82]

But, before I go on with this subject, I must write about another event in the life of this man, which I had inadvertently left out. This is that, after the violent departure of the Medici from Florence, the *signoria* suspected, as we have said above, that war was to come and planned to fortify the city; and, although they knew that Michelangelo was a man of supreme intelligence and ability for these undertakings, nevertheless, upon the advice of certain citizens who favored the Medici interests and who wanted craftily to prevent or prolong the fortification of the city, they wanted to send him to Ferrara on the pretext that he was to study the method used by Duke Alfonso to arm and fortify his city, knowing that His Excellency was very expert at this and most prudent in all other ways. The duke received Michelangelo with an expression of great joy on his face, both because of the greatness of the man and because his own son, Don Hercole, who is now the duke of that state, was captain of the Florentine *signoria*. He rode out in person with Michelangelo, and there was nothing relevant to the subject that he did not show him in the way of fortifications and artillery. Indeed, he opened all his storerooms to him, showing everything to him with his own hands, mainly some paintings and portraits of his forebears, by the hand of masters, and, considering the period in which they were painted, they were excellent. But, when Michelangelo had to leave, the duke said to him facetiously, "Michelangelo, you are my prisoner. If you want me to set you free, I want you to promise me to do something for me that is by your own hand, just as you like, sculpture or painting, whichever it may be." Michelangelo gave his promise and, when he returned to Florence, although he was very much occupied with fortifying the country, he nevertheless began a large easel painting representing the union of Leda and the Swan and, nearby, the bringing forth of the egg from which Castor and Pollux were born, according to what we read in myths of antiquity. Knowing this, when the duke heard

that the Medici had entered Florence, he was afraid of losing such a treasure in those upheavals and sent one of his men there at once. This man arrived at Michelangelo's house and, when he had seen the picture, he said, "Oh, this isn't much of anything." And when Michelangelo, who knew that everyone judges best that art which he practices, asked him what his profession was, he answered with a sneer, "I am a merchant." Perhaps he was disgusted by such a question and by not being recognized as a gentleman, and at the same time he was showing contempt for the industry of Florentine citizens, who for the most part have gone into trade, as if he were saying, "You ask me what my profession is; would you ever believe that I was a merchant?" Michelangelo, who understood the gentleman's words, said, "You will do bad business for your master; get out of my sight." In that way he dismissed the duke's messenger, and shortly thereafter he gave the painting to an apprentice of his who had asked him for help as he had two sisters to marry off. It was sent to France, where it still is, and King François bought it.[83]

Now to return to where I left off, Michelangelo had been summoned by Pope Clement to Rome, where he began to have trouble with the agents of the duke of Urbino over the tomb of Julius. Clement, who would have liked to employ him in Florence, tried every way to free him and, as his attorney, he provided him with one Messer Tommaso da Prato, who afterwards became *datario*. But Michelangelo, who was aware of Duke Alessandro's malevolent attitude toward him and was very afraid of it and who also had a love and reverence for the bones of Pope Julius and the illustrious della Rovere family, did everything possible to remain in Rome and busy himself with the tomb, all the more because he was being accused on all sides of having received fully sixteen thousand *scudi* from Pope Julius for the purpose, as we have said, and enjoying the money without fulfilling his obligation.[84] As he could not bear the infamy of this, being sensitive as to his honor, he wanted the matter to be cleared up; and, even though he was already old and the task most burdensome, he would not refuse to finish what he had begun. Thus, when they got down to the facts, and Michelangelo's adversaries did not show proof of payments which amounted to anything approaching that figure which had previously been bruited about, and, in fact, more than two-thirds was lacking of the whole payment agreed upon

at the outset with the two cardinals, Clement descried an excellent opportunity to extricate Michelangelo and to be free to employ him as he wished, so he sent for him and said, "Come now, you say that you want to build this tomb but that you want to know who is to pay you for the rest of it." Michelangelo, who knew what the pope wanted, that he would have liked to employ him in his own service, answered, "And if someone can be found to pay me?" To which Pope Clement said, "You are quite mad if you imagine that anyone is about to come forward who would offer you a penny." Thus, when Messer Tommaso, his attorney, appeared in court and made a proposal to this effect to the duke's agents, they began to look each other in the face and they concluded together that he should at least build a tomb for the amount that he had received. As Michelangelo felt that a good settlement had been reached, he willingly agreed, influenced largely by the authority of the elder Cardinal di Monte, who was both a favorite of Julius II and the uncle of Julius III, our pope at present, by the grace of God, and who intervened in this agreement.[85] The agreement was this: that Michelangelo was to build a tomb with a single façade and that he was to use those marbles which had already been worked on for the rectangular tomb, adapting them as best he could (Fig. 5). And thus he was under obligation to provide six statues by his own hand. Nevertheless, the concession was made to Pope Clement that he could employ Michelangelo in Florence, or wherever he pleased, for four months of the year, as His Holiness required this for the works in Florence. Such was the contract which was established between His Excellency the duke and Michelangelo.[86]

But here it must be known that, once all accounts had been cleared up, Michelangelo, in order to appear more indebted to the duke of Urbino and to give Pope Clement less assurance of sending him to Florence, where he in no way wished to go, made a secret agreement with the spokesman and agent of His Excellency that they should say that he had received several thousand *scudi* more than he really had received. Not only was this agreement made orally, but it was also put into the contract without his knowledge or consent, not when it was drawn up but when it was recorded, which greatly disturbed him. Nevertheless, the spokesman convinced him that this would not be to his detriment, as it did not matter whether the contract specified

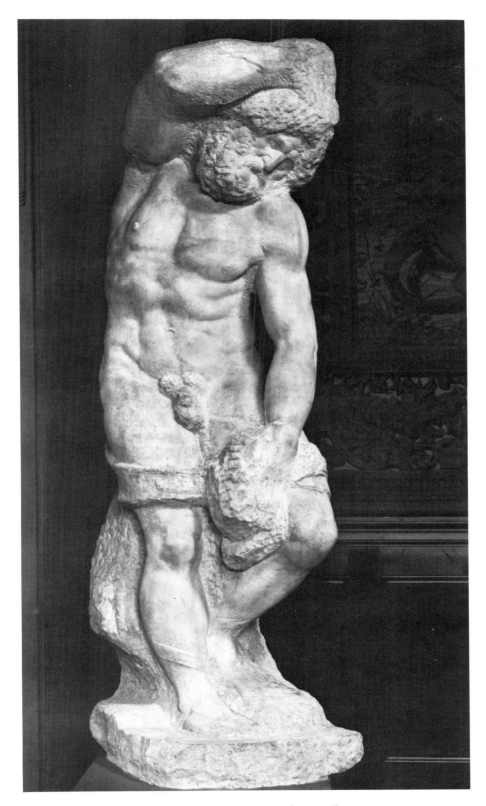

PLATE 36 Michelangelo, *Captive*, Accademia, Florence
Photo courtesy Fratelli Alinari, Florence

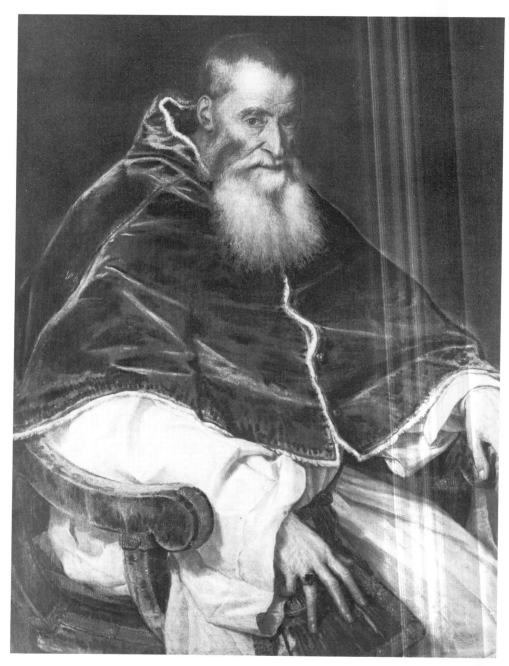

PLATE 37 Titian, *Pope Paul III*, Galleria Nazionale,
Museo di Capodimonte, Naples
Photo courtesy Fratelli Alinari, Florence

twenty thousand *scudi* more instead of one thousand, since they were in agreement that the tomb was to be reduced according to the amount of money actually received; and he added that no one but himself had any reason to inquire into these matters and that Michelangelo could be quite sure of him because of the understanding between them.[87] At this, Michelangelo calmed down, both because he thought he could rest assured of this and because he wanted this pretext to serve his aforesaid purpose with the pope. And in this way the matter subsided for the time being, although that was not the end of it because, after he had served the four months in Florence, when he returned to Rome the pope sought to employ him in something else and to have him paint the altar wall of the Sistine Chapel. And, as he was a man of good judgment and had thought over numerous possibilities for it, the pope in the end resolved to have him paint the Day of the Last Judgment, with the idea that the variety and magnitude of the subject ought to afford the scope for this man to demonstrate his powers and how much they could achieve (Pl. 42). Michelangelo, who was conscious of his obligation to the duke of Urbino, evaded this to the extent that he could but, since he could not free himself of it, he procrastinated and, while pretending to be at work, as he partly was, on the cartoon, he worked in secret on the statues that were to go on the tomb.[88]

In the meanwhile, Pope Clement died and Paul III was made pope (Pl. 37); he sent for Michelangelo and requested that he enter his service. Michelangelo, who suspected that he would be prevented from going on with that work, answered that he could not do so because he was bound under contract to the duke of Urbino until he had finished the work that he had in hand. The pope grew agitated and said, "For thirty years now I have had this wish and, now that I am Pope, can I not gratify it? Where is this contract? I want to tear it up." Seeing that it had come to this, Michelangelo was on the point of leaving Rome and going away to Genovese country to an abbey of the bishop of Aleria, a favorite of Julius' and very much Michelangelo's friend, to finish his work there, because the place was convenient to Carrara and he could transport the marbles easily owing to the accessibility of the sea.[89] He also thought of going away to Urbino, where he had previously planned to live, it being a quiet place and one where he hoped to be wel-

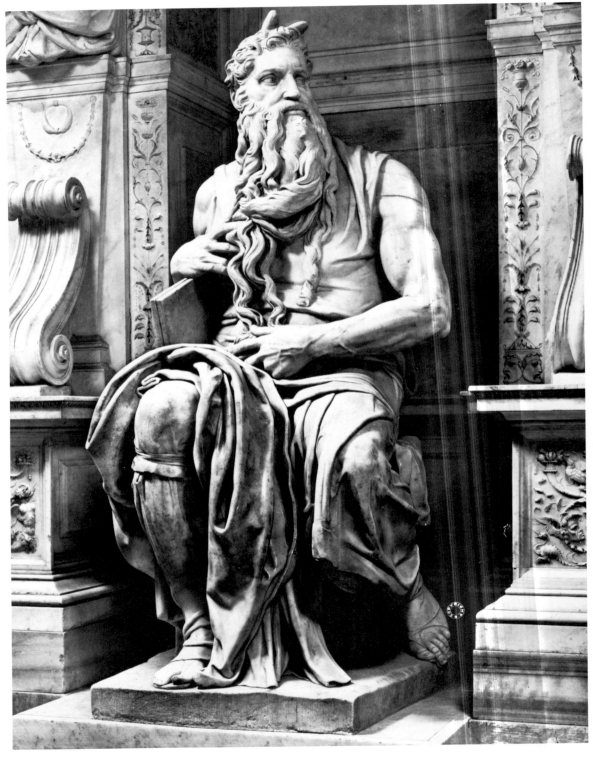

PLATE 38 Michelangelo, *Moses*, tomb of Julius II, S. Pietro in Vincoli, Rome
Photo courtesy Fratelli Alinari, Florence

comed for the sake of Julius' memory; and to this end he had sent one of his men there several months earlier to buy a house and some property; but fearing the power of the pope, as he had good reason to, he did not leave, and he was hoping to satisfy the pope with gentle words. But the pope, who remained firm in his resolve, came one day to see him at his house, accompanied by eight or ten cardinals, and he wanted to see the cartoon which Michelangelo had made in Clement's time for the altar wall of the Sistine Chapel, the statues which he had already done for the tomb, and everything in detail. When the most reverend cardinal of Mantua, who was present, saw there the *Moses* (Pl. 38) of which I have already written and will write more fully hereafter, he said, "This statue alone is sufficient to do honor to the tomb of Pope Julius." After Pope Paul had seen everything, he confronted him again with the request that he enter his service, and many cardinals were present, as well as the most reverend and most illustrious cardinal of Mantua already mentioned. And, finding that Michelangelo stood firm, he said, "I will see to it that the duke of Urbino contents himself with three statues by your hand and that the other three which remain to be done are given to others to do." In this way he arranged with the duke's agents for a new contract to be drawn up, which was confirmed by His Excellency the duke, who did not want to displease the pope in this matter. Thus Michelangelo, even though he could have avoided paying for the three statues, as he was freed from obligation on the strength of this contract, nonetheless preferred to pay the expense himself, and for these sculptures and for the rest of the tomb he deposited 1,580 ducats. So His Excellency's agents gave the statues out to be done, and the tragedy of the tomb and the tomb itself were finished.[90]

Today it may be seen in S. Pietro in Vincoli (Pl. 39), not conforming to the first design of four façades, but with one façade which is one of the shorter sides, not detached all around but standing against a wall, due to the obstructions described above. In truth, patched up and reworked as it is, it is still the most meritorious tomb to be found in Rome and perhaps elsewhere, if for no other reason, at least by virtue of the three statues there which are by the hand of the master. Marvelous among these is the one of *Moses* (Pl. 38), the leader and captain of the Jews, who is seated in the attitude of

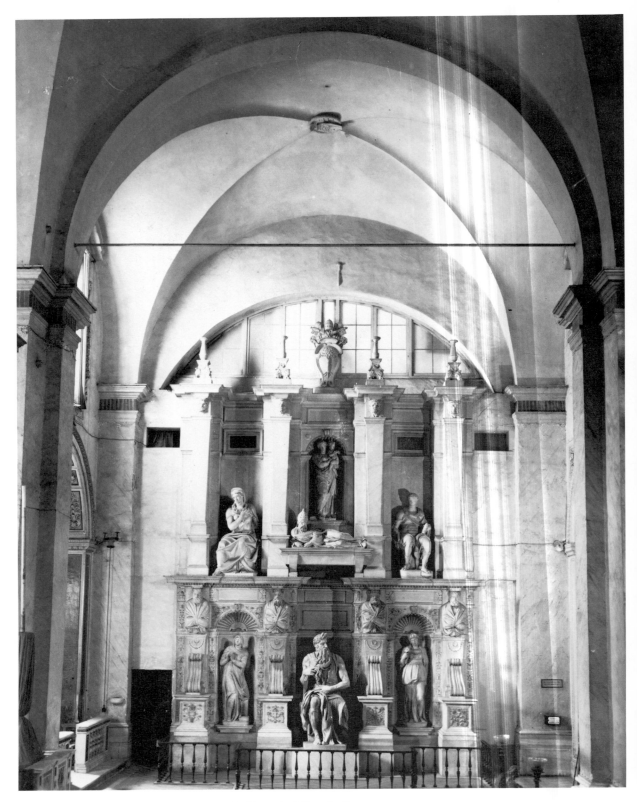

PLATE 39 Tomb of Julius II, S. Pietro in Vincoli, Rome
Photo courtesy Fratelli Alinari, Florence

a wise and pensive man, holding the tables of the law under his right arm and supporting his chin with his left hand like a person who is weary and full of cares; and long strands of beard pass through the fingers of this hand, which is something very beautiful to see. The face is full of animation and spirit, apt to inspire both love and terror, which was perhaps the truth. Following the customary descriptions, he has the two horns on his head, not far from the top of his forehead. He is attired in the style of antiquity, with toga and sandals and bare arms and everything else. It is a marvelous work and full of art, but all the more so in that the whole nude form is apparent under the beautiful draperies which cover him, and the robe does not detract from the beauty of the body; moreover, Michelangelo's observation of the human body is evident generally in all the clothed figures in his painting and sculpture. This statue is more than twice life-size. In a niche at the right hand of this sculpture there is another, which represents the *Contemplative Life* (Pl. 40), a woman of more than life-size, but of rare beauty, with one knee bent not on the ground but on a pedestal, with her face and both hands raised toward heaven, so that her whole being seems to emanate love. On the other side, that is at Moses' left hand, is the *Active Life* (Pl. 41), with a mirror in her right hand in which she examines herself attentively, meaning by this that our actions require consideration, and in her left hand is a garland of flowers. In this Michelangelo has followed Dante, whom he has always studied, who in his *Purgatorio* envisions an encounter in a field of flowers with the Countess Matilda, whom he interprets as the Active Life. The tomb in its entirety is nothing if not beautiful, and especially the way in which its elements are bound together by the cornice, which is incomparable.[91]

Now let this be enough said as to this work, though I even wonder whether it may not indeed have been too much and whether, instead of pleasing, it may not have bored the reader. Nevertheless, it seemed to me necessary to extirpate that harmful and false opinion which had taken root in men's minds, that he had received sixteen thousand *scudi* and was not willing to fulfill his obligation. Neither statement was true, because he only received from Julius for the tomb those thousand ducats which he spent in so many months of quarrying marbles at Carrara. And afterwards, how could he receive more money from him, if he changed his mind and no longer

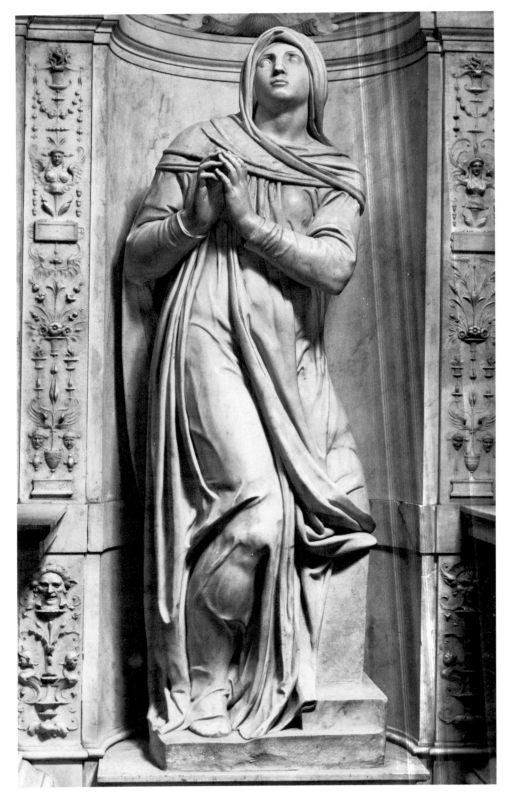

PLATE 40 Michelangelo, *The Contemplative Life*, tomb of Julius II
Photo courtesy Fratelli Alinari, Florence

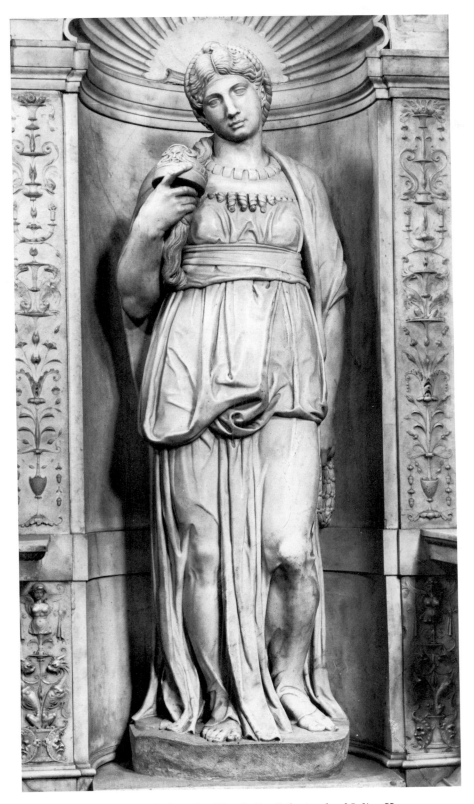

PLATE 41 Michelangelo, *The Active Life*, tomb of Julius II
Photo courtesy Fratelli Alinari, Florence

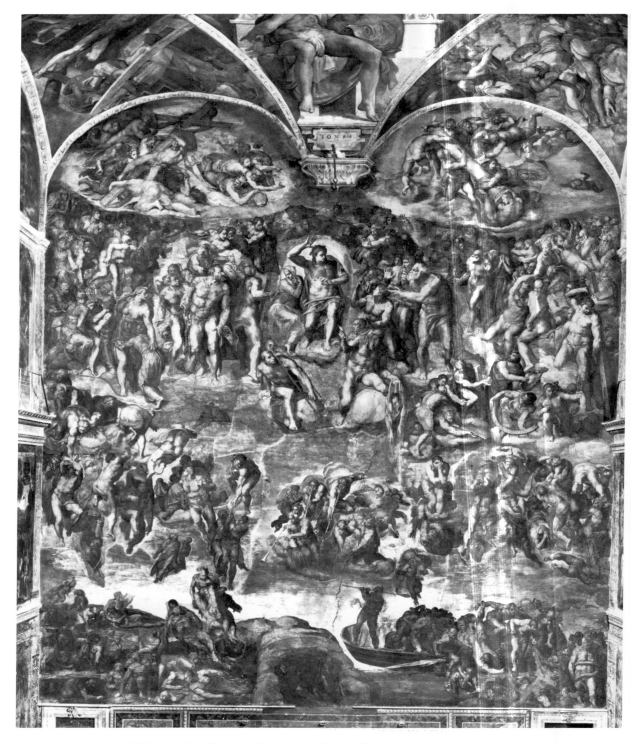

PLATE 42 Michelangelo, *The Last Judgment,* Sistine Chapel
Photo courtesy Fratelli Alinari, Florence

wished to discuss the tomb? As for the money that he received after the death of Pope Julius from the two cardinals who were executors of the will, he has in his possession a certificate by the hand of a notary, sent to him by Bernardo Bini, citizen of Florence, who was the *depositario* and paid out the money, which came to perhaps three thousand ducats. With all this, never was a man more eager about his work than Michelangelo was about this, both because he realized how great a reputation it would bring him and because of the memory he has always retained of the blessed soul of Pope Julius, for whose sake he has always honored and loved the della Rovere family and principally the dukes of Urbino for whom he put up a fight against two popes who wanted, as has been said, to take him away from that undertaking. And this is Michelangelo's complaint: that, in place of the gratitude that was his due, what he received for it was odium and disgrace.

But, to go back to Pope Paul, I want to say that, after the final agreement reached between His Excellency the duke and Michelangelo, the pope took him into his service and wanted him to carry out what he had already begun in Clement's time; and he had him paint the altar wall of the Sistine Chapel, which he had already prepared with rough plaster and closed off with boards from the floor to the vault. Because it had been Pope Clement's idea and begun in his time, Michelangelo did not put Paul's coat of arms in this work, although the pope had besought him to.[92] So great was Pope Paul's love and respect for Michelangelo that, even though he desired this, he nevertheless did not want ever to displease him.

In this work Michelangelo expressed all that the art of painting can do with the human figure, leaving out no attitude or gesture whatever (Pl. 42). The composition of the narrative is careful and well thought out, but to describe it is lengthy and perhaps not necessary as such a quantity and variety of copies have been printed and sent everywhere.[93] Nevertheless, for the sake of anyone who has not seen the original or had a copy come into his hands, we shall say briefly: that the whole is divided into sections, left and right, upper, lower, and central. In the central part of the air, near the earth, are the seven angels described by St. John in the Apocalypse, who with trumpets at their lips summon the dead to judgment from the four corners of the earth. Amongst these there are two other angels holding an open book

in which everyone reads and recognizes his past life, so that he must almost be his own judge. At the sound of these trumpets, the graves on earth are seen to open and the human race to issue forth in various and amazing attitudes (Pl. 43); although some, according to the prophecy of Ezekiel, have their skeletons merely reassembled, some have them half-clothed in flesh, and others, completely.[94] Some are naked, some are clad in the shrouds or winding-sheets in which they were wrapped when carried to the grave and which they are trying to struggle out of. Among these there are some who do not seem to be quite awake yet, and they stand looking up toward heaven as if in doubt as to whither divine justice may be calling them. Here it is delightful to see some human beings emerging with strain and effort from the earth, and some with outstretched arms taking flight toward heaven, some who have already begun to fly, who are aloft in the air, some higher, some lower, in various attitudes and postures. Above the angels with their trumpets is the Son of God in His majesty, with His arm and mighty right hand raised in the manner of a man who wrathfully damns the guilty and banishes them from His presence to eternal fire; and, with His left hand held out toward His right side, it seems as if He is gently gathering the righteous to Him. At His command, the angels appear between heaven and earth as executors of the divine judgment; at the right they hasten to the assistance of the elect whose flight might be impeded by evil spirits, and at the left side they rush to fling the wicked back to earth, who might have raised themselves already by their audacity. However, these sinners are dragged down by evil spirits, the proud by the hair, the lascivious by their pudenda, and each sinner correspondingly by the part of his body with which he sinned.[95]

Below these evildoers, we see Charon with his bark, exactly as Dante describes him in his *Inferno,* in the muddy waters of Acheron, raising his oar to strike any laggard soul (Pl. 44); and, as the bark touches the bank, all those souls can be seen vying to hurl themselves out, spurred by divine justice so that "fear," as the poet says, "is changed to desire." After receiving their sentence from Minos (Pl. 45), they are dragged by evil spirits into the depths of hell, where they display amazing attitudes of the grave and hopeless emotions which the place inspires.[96] In the central section, the blessed who are already resurrected form a circle or crown in the clouds of the

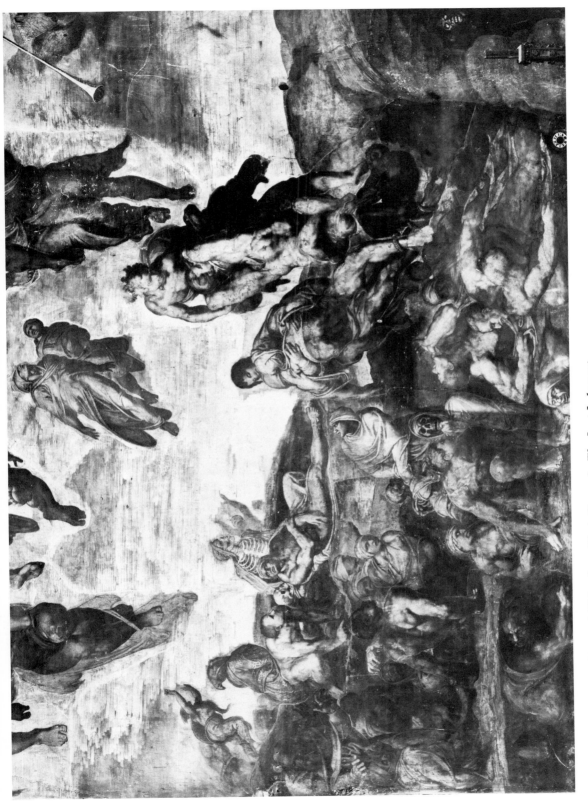

PLATE 43 The Damned Rising from Their Graves in *The Last Judgment*
Photo courtesy Fratelli Alinari, Florence

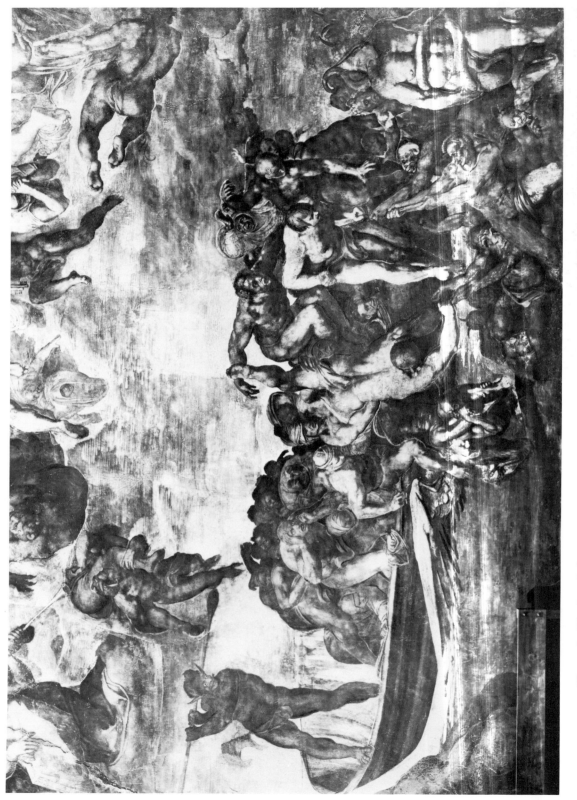

PLATE 44 Charon in *The Last Judgment*
Photo courtesy Fratelli Alinari, Florence

sky around the Son of God; but His mother, set apart and near her Son, slightly timid in appearance and almost as if uncertain of the wrath and mystery of God, draws as close as she can beneath her Son. After her are the Baptist and the Twelve Apostles and the Saints of the Lord, displaying to the terrible Judge that instrument whereby each of them, confessing His name, was deprived of life: St. Andrew the cross, St. Bartholomew his skin (Pl. 46),[97] St. Lawrence the grate, St. Sebastian the arrows, St. Blaise the iron combs, St. Catherine the wheel, and others other things by which we may recognize them. Above these, at the right and left sides in the upper section of the wall, groups of little angels appear in singular and lovely postures, presenting in heaven the cross of the Son of God, the sponge, the crown of thorns, the nails, and the column where He was flagellated, in order to confront the wicked with God's benefactions which they most ungratefully ignored and to comfort and give faith to the righteous. There are innumerable details which I am passing over in silence. Suffice it to say that, apart from the sublime composition of the narrative, we see represented here all that nature can do with the human body.

Finally, as Pope Paul had built a chapel on the same floor as the Sistine Chapel which has already been mentioned, he wanted to decorate it with memorials of Michelangelo, and he had him paint two large paintings on the side walls. In one of them is represented the story of St. Paul, when he was converted by the presence of Jesus Christ, in the other, *The Crucifixion of St. Peter*, both stupendous works, not only in the representation of the events in general but also in each figure in particular. And this is the last work of his in painting which has been seen to date; he finished it when he was seventy-five years old.[98]

Now he has in hand a work in marble which he is doing for his own pleasure; being a man who is full of ideas and energy, he naturally produces something every day. This is a group of four figures over life-size, consisting of a Christ deposed from the cross, whose dead body is sustained by His mother, as she slips her breast, arms, and knee under His body in a remarkable pose (Pl. 47). However, she is assisted from above by Nicodemus, who, erect and firm on his legs, with a display of vigorous strength supports the body under the arms; and from the left side she is assisted by one of the

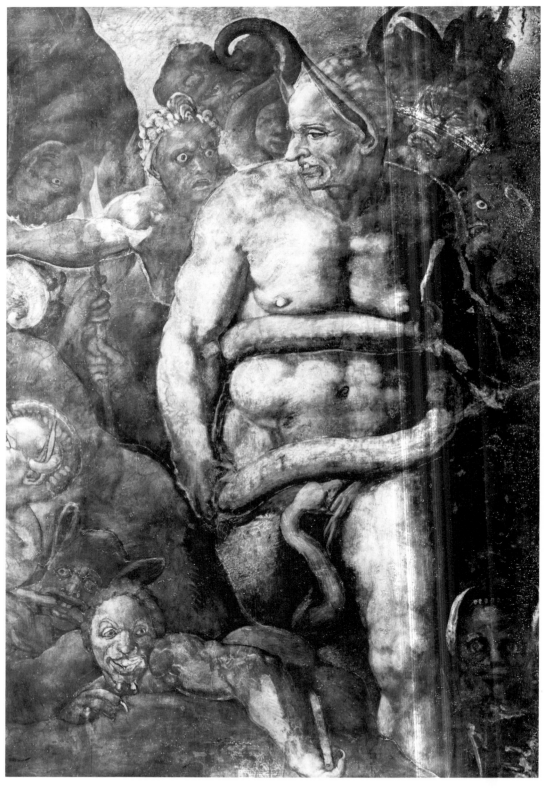

PLATE 45 Minos in *The Last Judgment*
Photo courtesy Fratelli Alinari, Florence

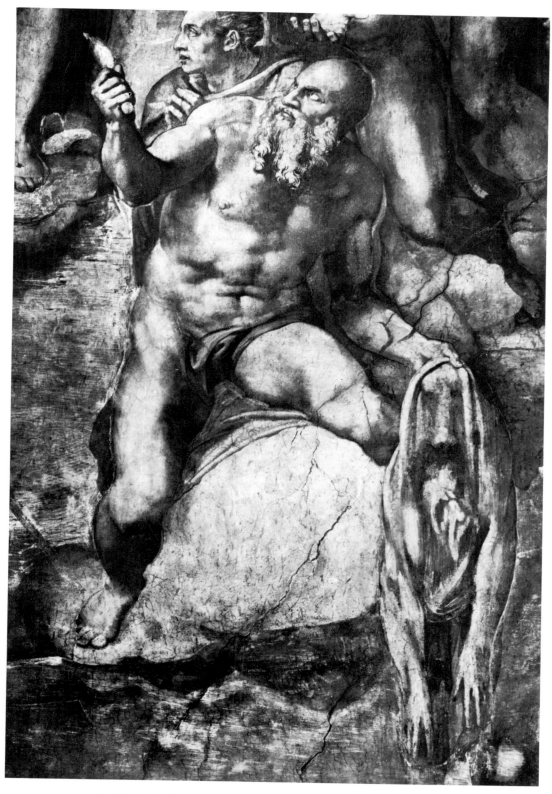

PLATE 46 St. Bartholomew in *The Last Judgment*
Photo courtesy Fratelli Alinari, Florence

Marys, who, although visibly deeply grieved, nevertheless does not fail in the task to which the mother, in her extreme sorrow, is not equal. The released Christ falls with all His limbs slackened, but in a very different position from the one Michelangelo did for the marchioness of Pescara (Pl. 48) or the one of the Madonna della Febbre (Pl. 10). It would be impossible to describe the beauty and the emotions shown in the grieving and sorrowful faces of the anguished mother and all the others; therefore let this suffice. I really mean to say that it is something rare and one of the more exacting works that he has done to date, chiefly because all the figures are perceived distinctly and the draperies of any one figure are not to be confused with those of the others.[99]

Michelangelo has done innumerable other things which I have not mentioned, such as the *Christ* in the Minerva, a *St. Matthew* in Florence which he began with the intention of doing Twelve Apostles to go in the twelve piers of the Duomo, cartoons for various works in painting, countless designs for public and private buildings including, lately, one for a bridge over the Grand Canal in Venice in a new and unexampled form and style, and many other things which are not to be seen and which would take time to describe; therefore I will end here.[100]

Michelangelo plans to donate this *Pietà* to some church and to have himself buried at the foot of the altar where it is placed.[101] May the Lord God in His goodness preserve him to us for a long time, for I do not doubt that his life and his works will end on the same day, as it is written of Isocrates.[102] My firm hope that he has many years of life ahead is founded both on his lively and robust old age and on the long life of his father, who reached the age of ninety-two without knowing what fever was and who died more from weakness than from illness, so that when he was dead, according to Michelangelo, he retained the same color in his face as he had when living and appeared to be sleeping rather than dead.[103] From boyhood Michelangelo has been a very hard worker, and to his natural gifts he has added learning, which he was determined to acquire not through the efforts and industry of others but from nature herself, which he set before himself as a true example. Thus there is no animal whose anatomy he would not dissect, and he worked on so many human anatomies that those who have spent their lives at it and

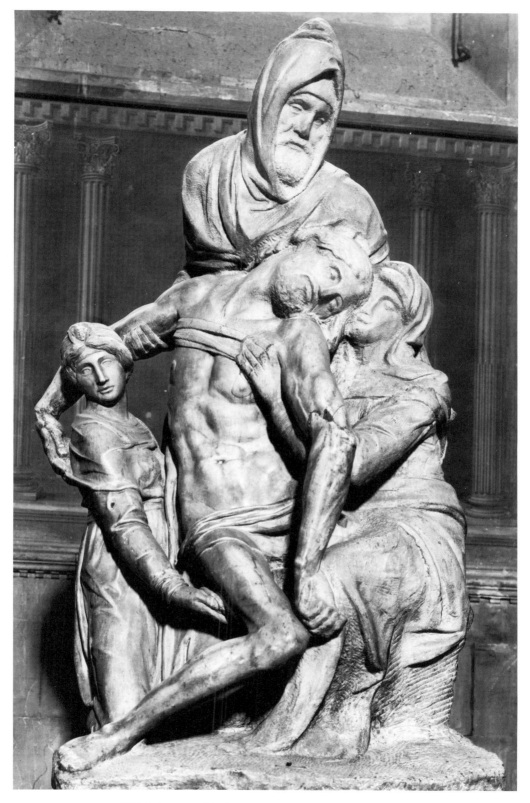

PLATE 47 Michelangelo, *Pietà*, Duomo, Florence
Photo courtesy Fratelli Alinari, Florence

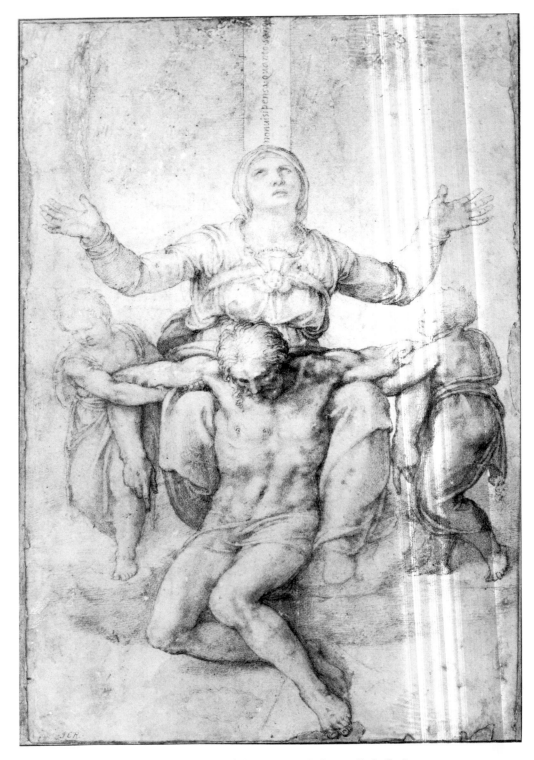

PLATE 48 Michelangelo, *Pietà* for Vittoria Colonna, Isabella Stewart
Gardner Museum, Boston
Photo courtesy Isabella Stewart Gardner Museum

made it their profession hardly know as much as he does. I am speaking of the knowledge which is necessary to the art of painting and sculpture and not of the other minutiae which anatomists observe. And that this is so is demonstrated by his figures, in which there is such a concentration of art and learning that they are almost impossible for any painter whatever to imitate.

I have always held the opinion that the efforts and endeavors of nature have a prescribed limit, imposed and ordained by God, which cannot be exceeded by ordinary *virtù*; and that this is true not only for painting and sculpture but universally for all the arts and sciences; and that nature concentrates this effort of hers in one man, who is to be the example and norm in that faculty, giving him first place so that, from then on, whoever wants to produce something in art which is worthy of being either read or looked at is subject to the necessity that it be either identical to the work already produced by that first man, or at least similar to it and following the same course; or, if not, the more it departs from the right way, the more inferior it will be. After Plato and Aristotle, how many philosophers have we seen who did not follow them and were held in esteem? How many orators after Demosthenes and Cicero? How many mathematicians since Euclid and Archimedes? How many doctors since Hippocrates and Galen or poets since Homer and Vergil? And if indeed there has been someone who has exerted himself in one of these branches of knowledge and whose great aptitude enabled him to reach first place by his own efforts, nevertheless, because he found it already occupied and because perfection is none other than what his predecessors demonstrated, he either abandoned the undertaking or with good judgment dedicated himself to the imitation of those predecessors as the archetype of perfection. In our time this has been noted in Bembo, in Sannazzaro, in Caro, in Guidiccione, in the marchioness of Pescara, and in other writers and devotees of Tuscan verse, who, although they were of supreme and singular talent, were nevertheless unable by themselves to produce anything better than what nature had demonstrated in Petrarch, and they devoted themselves to imitating him, but so felicitously that they have been judged worthy of being read and counted among the good writers.[104]

Now, to conclude these remarks of mine, I say that it seems to me that

in painting and sculpture, nature has been generous and liberal to Michelangelo with all her riches, so that I am not to be blamed for saying that his figures are almost inimitable. Nor do I think that I have permitted myself to be carried away because, disregarding the fact that to this day he is the only one to handle the chisel and the brush both equally well and that today no record remains of the painting of the ancients, we do have many examples of their statuary, and to whom should he defer? Certainly to no one, in the judgment of men concerned with the art, unless we follow the opinion of the herd, who blindly admire antiquity, despising the geniuses and industry of their own time; although I have yet to hear anyone say a word to the contrary, to such an extent has this man surpassed all envy. Raphael of Urbino, however anxious he might be to compete with Michelangelo, often had occasion to say that he thanked God that he was born in Michelangelo's time, as he copied from him a style which was quite different from the one he learned from his father, who was a painter, or from his master Perugino.[105] But what greater and clearer sign of this man's preeminence can there ever be than the competition among the princes of the world for his services? Because, apart from the four popes, Julius, Leo, Clement, and Paul, even the Grand Turk, the father of the one who now rules the empire, sent certain Franciscan friars to him, as I have said above, with letters entreating him to go and stay with him, and he ordered through letters of credit not only that the Gondi bank in Florence should disburse to Michelangelo the amount of money he might want for his traveling expenses, but also that when he had passed Cossa near Raguga, he should be accompanied from there to Constantinople by one of his nobles in a manner conveying the utmost respect.[106] François Valois, the king of France, sought him by many means, putting three thousand *scudi* at his disposal in Rome for his expenses whenever he might want to go.[107] Bruciolo was sent to Rome by the *signoria* of Venice to invite him to live in that city and to offer him a retainer of six hundred *scudi* a year, not committing him to anything, but simply so that he would honor that republic with his presence, with the condition that, if he were to do any work in their service, he should be paid in full as if he received no retainer from them.[108] These are not common, everyday occurrences; rather they are new and exceptional; and they are not wont to happen except

in cases of singular and preeminent *virtù*, such as Homer's, for whom many cities contended, each of them claiming and establishing him as its own.

The present pontiff, Julius III, has held him in no less esteem than all those mentioned above, being a prince of consummate judgment and a devotee and benefactor of all the *virtù* universally, but in particular he is most inclined toward painting, sculpture, and architecture, as is clearly confirmed by the works which His Holiness has commissioned in the palace and in the Belvedere and now in his Villa Giulia, a memorial and project worthy of a lofty and generous spirit such as his. This villa is filled with so many statues, ancient and modern, and with such a great variety of magnificent stones and precious columns, with stucco work and paintings and every other sort of ornament, that I am reserving myself to write about it at another time, as it requires a work to itself and it has not yet been perfected. Out of respect for Michelangelo's age, the pope has not employed him in doing this work.[109] He well knows and appreciates Michelangelo's greatness, but spares him any burden beyond what he takes upon himself, which consideration, in my opinion, does Michelangelo more honor than any of the other popes did. It is true that His Holiness almost always seeks Michelangelo's opinion and judgment as to the works of painting and architecture which he is constantly having done, and quite often he sends the artists right to his house to see him. It grieves me and grieves His Holiness as well that, because of a sort of natural shyness of his or shall we say respect or reverence, which some call pride, Michelangelo does not avail himself of the benevolence, kindness, and generous nature of a pope who is so great and so devoted to him. According to what I heard first from his chamberlain, the most reverend monsignor of Forlì, the pope has often remarked that, if it were possible, he would gladly give up some of his years and some of his own blood to add to Michelangelo's life, in order that the world not be deprived so soon of such a man.[110] Having myself also had access to His Holiness, I have with my own ears heard this remark from his lips and, furthermore, that if he outlives Michelangelo, as the natural course of life would seem to suggest, he wants to have him embalmed and kept near him so that his remains will be eternal like his works. This he said to Michelangelo himself in the presence of many people, at the very beginning of his pontificate. I do not

PLATE 49　Giorgio Vasari, *Paul III Directing the Rebuilding of St. Peter's*, 1546, Sala di Cento Giorni, Palazzo della Cancellaria, Rome
Photo courtesy Fratelli Alinari, Florence

know what could be more of an honor to Michelangelo than these words or a greater sign of the degree to which His Holiness values him.

The pope also manifested his esteem when, after the death of Pope Paul and his own election, he defended Michelangelo at the consistory in the presence of all the cardinals who were convened in Rome at the time and undertook to protect him against the deputies of the works at St. Peter's who, not because of any fault of his, as they said, but because of the fault of his administrators, wanted to abrogate or at least restrict the authority bestowed on Michelangelo by Pope Paul in a *motu proprio* decree, of which more will be said below. And he defended him in such a way that he not only confirmed the *motu proprio*, but he honored him with many expressions of respect and would not pay any further attention to the charges of the deputies or of any others.[111] Michelangelo realizes (as he has often told me) the affection and benevolence as well as the respect that His Holiness has for him; and, because he cannot reciprocate with his services and show his appreciation, the rest of his life gives him less satisfaction, as it seems to him useless and thankless to His Holiness. One thing does (as he is wont to say) afford him some comfort: that, knowing how undemanding His Holiness is, he therefore hopes to be forgiven and to have his goodwill accepted since he can give nothing else. However, he does not decline to place his life itself at the service of His Holiness, to the extent of his powers and his worth; and this I have from his own lips. Michelangelo did nevertheless make a design at the request of His Holiness for the façade of a palace which he had in mind to build in Rome; it is something unusual and new to whoever sees it, indebted to no style or rule either ancient or modern.[112] The same is true of many of his other works in Florence and in Rome, proving that architecture was not treated by the ancients so exhaustively that there is not room for new invention no less charming or beautiful.

Now, to return to the subject of anatomy, he gave up dissecting corpses because his long handling of them had so affected his stomach that he could neither eat nor drink salutarily. It is quite true that when he gave it up he was so learned and rich in knowledge of that science that he has often had it in mind to write a treatise, as a service to those who want to work in sculpture and painting, on all manner of human movements and

PLATE 50 St. Peter's from the Vatican Gardens, Rome
Photo courtesy Fratelli Alinari, Florence

appearances and on the bone structure, with a brilliant theory which he arrived at through long experience. And he would have done it had he not doubted his powers and whether they were adequate to treat the subject properly and in detail, as someone would who was trained in the sciences and in exposition. I know very well that, when he reads Albrecht Dürer, he finds his work very weak, seeing in his mind how much more beautiful and useful in the study of this subject his own conception would have been. And, to tell the truth, Albrecht discusses only the proportions and varieties of human bodies, for which no fixed rule can be given, and he forms his figures straight upright like poles; as to what was more important, the movements and gestures of human beings, he says not a word.[113] And, because by now Michelangelo has attained a grave and mature age and does not expect to be able to reveal this invention of his to the world in writing, he has disclosed everything to me with great devotion and in the most minute detail. He also began to discuss this with Messer Realdo Colombo, a very superior anatomist and surgeon and a particular friend of Michelangelo's and mine, who sent him for this purpose the corpse of a Moor, a most handsome young man and, insofar as one could say, most suitable; and it was placed in S. Agata where I was and still am living, because of its being a remote place. On this corpse Michelangelo showed me many rare and recondite things, perhaps never before understood, all of which I noted and hope one day to publish with the help of some learned man for the convenience and use of all who want to work in painting and sculpture.[114] But enough of this.

He dedicated himself to perspective and architecture with a degree of success which is demonstrated by his works.[115] Nor did Michelangelo content himself merely with the knowledge of the principal elements of architecture, but he also insisted on knowing everything which in any way pertained to that profession, such as how to make running knots, scaffolding or platforms, and that sort of thing, in which he became as proficient perhaps as those who have no other profession (Pl. 51). This became known at the time of Julius II in the following way. When Michelangelo was to paint the vault of the Sistine Chapel, the pope ordered Bramante to build the platform. For all that he was such an architect, he did not know how to proceed, and in several places on the vault he drilled holes from which he suspended the ropes which

PLATE 51 Piero di Cosimo, *The Building of a Palace*, 1520, John and Mable
Ringling Museum of Art, Sarasota
Photo courtesy John and Mable Ringling Museum of Art

were to hold the platform. When Michelangelo saw this, he laughed and asked Bramante what he was supposed to do when he got to those holes. Bramante, who had no defense, gave as his only answer that there was no other way of doing it. The matter was brought before the pope and, when Bramante gave the same answer, the pope turned to Michelangelo and said, "Since this won't do, go and build it yourself." Michelangelo dismantled the platform, and he recovered so many ropes from it that, when he gave them to a poor assistant of his, the proceeds enabled the man to marry off two of his daughters. Michelangelo built his platform without ropes in such a way and so well fitted and joined that the greater the weight upon it, the more secure it became. This opened Bramante's eyes and taught him how to build a platform, which was very useful to him later in the building of St. Peter's.

And, although in all these matters Michelangelo had no equal, he nonetheless never wanted to make architecture his profession. On the contrary, after the recent death of Antonio da San Gallo, the architect for the building of St. Peter's, when Pope Paul wanted to replace him with Michelangelo, he firmly refused the position, alleging that it was not his art; and he refused it in such a way that the pope was compelled to order him to take it, granting him a very extensive *motu proprio*, which was later confirmed by Pope Julius III, by the grace of God our present pontiff, as I have mentioned. Michelangelo has never wanted anything in return for this service of his, and he wanted a statement to that effect in the *motu proprio*. Thus, when the pope sent him a hundred *scudi* in gold one day by Messer Pier Giovanni, who was then master of the wardrobe to His Holiness and is now the bishop of Forlì, as if in payment of his month's stipend for the works, Michelangelo did not want to accept the money, and he sent it back, saying that this was not what they agreed between them. The pope was angry at this, according to what I was told also by Alessandro Ruffini, a Roman gentleman who was in attendance to His Holiness at the time; but not even on this account did Michelangelo change his mind.[116] Since he had accepted this charge, he made a new model, both because certain elements of the old one did not satisfy him in many respects and because it was such an undertaking that one could expect to see the last day of the world sooner than see St. Peter's finished. This model, which was praised and approved by the pope, is being

followed at present, to the great satisfaction of those people who have good judgment, even if there are some who do not approve of it.[117]

While he was young, then, Michelangelo dedicated himself not only to sculpture and painting but also to all those subjects that are pertinent or related to them; and this he did with such great application that for a time he all but withdrew from the company of men, frequenting only a very few. As a result he was considered arrogant by some and, by others, bizarre and eccentric, although he had neither one vice nor the other, but (as happens to many outstanding men) the love and continual practice of *virtù* made him solitary and afforded him such delight and fulfillment that the company of others not only failed to satisfy him but even distressed him, as if it distracted him from his meditation, whereas he was never (as the great Scipio used to say of himself) less alone than when he was alone.[118] He has, however, gladly retained the friendship of those from whose enlightened and learned conversation he could benefit and in whom there shone some ray of excellence: such as the most reverend and distinguished Monsignor Polo for his rare *virtù* and singular goodness; likewise my most reverend patron, Cardinal Crispo, because he found in him, apart from his many good qualities, an exceptional and outstanding sense of judgment; he is also very fond of the most reverend cardinal of Sta. Croce, a most serious and prudent man, of whom I have often heard him speak with the greatest respect; and of the most reverend Maffei, whose benevolence and erudition he has always proclaimed; and he loves and honors without exception all members of the house of Farnese, because of the living memory he has of Pope Paul, whom he remembers with the greatest reverence and mentions constantly as a good and saintly old man; and likewise the most reverend patriarch of Jerusalem, formerly the bishop of Cesena, whom he has long frequented with great familiarity, because he admires such a pure and generous nature as his. He also had a close friendship with my most reverend patron, Cardinal Ridolfi of happy memory, the refuge of all men of *virtù*. There are some others whom I am omitting in order not to be prolix: such as Monsignor Claudio Tolomei, Messer Lorenzo Ridolfi, Messer Donato Giannotti, Messer Lionardo Malespini, Lottino, Messer Tommaso Cavalieri, and other honored gentlemen on whom I will not expatiate. Recently he has become very fond of

Annibal Caro, and he tells me that he regrets not having frequented him sooner, as he has found him very much to his liking.[119]

In particular, he greatly loved the marchioness of Pescara, whose sublime spirit he was in love with, and she returned his love passionately. He still has many of her letters, filled with honest and most sweet love, and these letters sprang from her heart, just as he also wrote many many sonnets to her, full of intelligence and sweet desire. She often traveled to Rome from Viterbo and other places where she had gone for recreation and to spend the summer, prompted by no other reason than to see Michelangelo; and he in return bore her so much love that I remember hearing him say that his only regret was that, when he went to see her as she was departing this life, he did not kiss her forehead or her face as he kissed her hand. On account of her death he remained a long time in despair and as if out of his mind. At this lady's request, he made a nude figure of Christ when He is taken from the cross, which would fall as an abandoned corpse at the feet of His most holy mother, if it were not supported under the arms by two little angels (Pl. 48). But she, seated beneath the cross with a tearful and grieving countenance, raises both hands to heaven with open arms, with this utterance, which is inscribed on the stem of the cross: *Non vi si pensa quanto sangue costa.* The cross is similar to the one carried in procession by the Bianchi at the time of the plague of 1348, which was then placed in the church of Sta. Croce in Florence. For love of this lady, he also did a drawing of Jesus Christ on the cross (Pl. 52), not in the usual semblance of death, but alive, with His face upturned to the Father, and he seems to be saying, "Eli, Eli." Here we see that body not as an abandoned corpse falling, but as a living being, contorted and suffering in bitter torment.[120]

And just as he has greatly delighted in the conversation of learned men, so he has also derived great pleasure from reading the writers of both prose and poetry, amongst whom he has especially admired Dante, delighted by the remarkable genius of that man, whose work he knows almost entirely by heart, although perhaps he knows the work of Petrarch no less well. And he not only has enjoyed reading verse but sometimes has liked to compose it, as we may see by certain sonnets of his which give a fine example of his great powers of invention and discrimination. And Varchi has published certain discourses

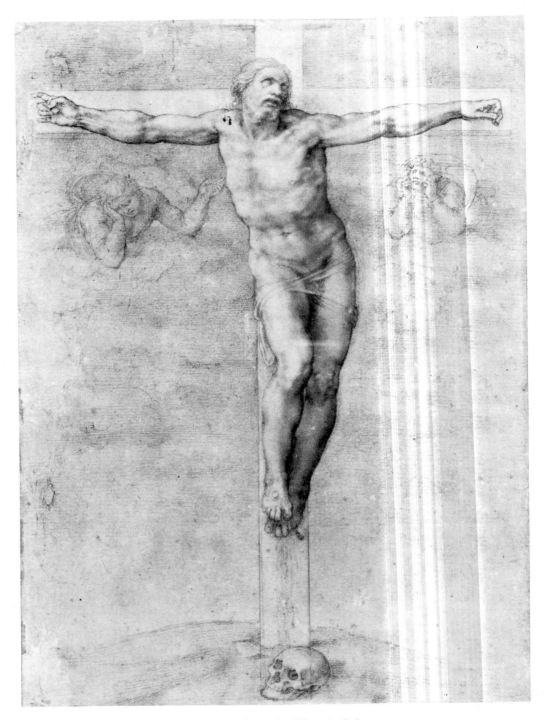

PLATE 52 Michelangelo, *Crucifixion* for Vittoria Colonna,
British Museum, London
Photo courtesy Trustees of the British Museum

and comments on some of them.[121] But Michelangelo has applied himself to poetry more for his own pleasure than as a profession, and he has always belittled himself and asserted his ignorance in these matters. He has likewise read the Holy Scriptures with great application and study, both the Old Testament and the New, as well as the writings of those who have studied them, such as Savonarola, for whom he has always had great affection and whose voice still lives in his memory.[122] He has also loved the beauty of the human body as one who knows it extremely well, and loved it in such a way as to inspire certain carnal men, who are incapable of understanding the love of beauty except as lascivious and indecent, to think and speak ill of him. It is as though Alcibiades, a very beautiful young man, had not been most chastely loved by Socrates, of whom he was wont to say that, when he lay down with him, he arose from his side as from the side of his father. I have often heard Michelangelo converse and discourse on the subject of love and have later heard from those who were present that what he said about love was no different than what we read in the writings of Plato. As for me, I do not know what Plato says on the subject, but I do know very well that, in all my long and intimate acquaintance with Michelangelo, I have never heard any but the most honorable words cross his lips, such as have the power to extinguish in the young any unseemly and unbridled desire which might spring up.[123] And that no foul thoughts could have arisen in his mind is evident also from the fact that he has loved not only human beauty but everything beautiful in general: a beautiful horse, a beautiful dog, a beautiful landscape, a beautiful plant, a beautiful mountain, a beautiful forest, and every place and thing which is beautiful and rare of its kind, admiring them all with marveling love and selecting beauty from nature as the bees gather honey from flowers, to use it later in his works. All those who have achieved some fame in painting have always done the same. In order to create a *Venus*, the ancient master was not content to consider a single maiden, but he wanted to contemplate many, and from each he took her most beautiful and perfect feature to use in his *Venus*.[124] And, in truth, anyone who thinks to arrive at some level in this art without this means (whereby true knowledge of theory can be acquired) is greatly deceiving himself.

Michelangelo has always been very abstemious in his way of life, taking

food more out of necessity than for pleasure, and especially while he had work in progress, when he would most often content himself with a piece of bread which he would eat while working. Indeed, for some time now he has been living more carefully, as befits his more than mature age. I have often heard him say, "Ascanio, however rich I may have been, I have always lived like a poor man." And just as he has eaten sparingly, so also he has done with little sleep, since sleep, according to him, has seldom done him good, for when he sleeps he almost always suffers from headaches; in fact, too much sleep gives him a bad stomach. While he was more robust, he often slept in his clothes and in the boots which he has always worn, partly because of the cramp from which he has suffered constantly and partly for other reasons; and he has sometimes gone so long without taking them off that then the skin came away like a snake's with the boots. He was never avaricious or concerned to accumulate money, being content with as much as he required to live decently; wherefore, although he has received requests for works by his hand from more and more noble and wealthy people, with most generous promises, he has seldom complied and, when he did, it was more out of friendship and goodwill than in the expectation of reward. He has given away many of his things, which would have brought him a vast amount of money if he had wanted to sell them, if it were only those two statues which he gave to his great friend Messer Roberto Strozzi.[125] Not only has he been generous with his work, but also with his purse he has often met the needs of some poor, deserving student of letters or of painting; to this I can bear witness, having seen him behave in this way toward myself. He was never jealous of the work of others, even in his own art, owing to good nature rather than any opinion he might have of himself. Indeed, he has always praised them all universally, even Raphael of Urbino, between whom and himself there was in the past some rivalry in painting, as I have written. I have merely heard him say that Raphael did not come by his art naturally, but through long study. Nor is it true, as many people charge, that he has been unwilling to teach; on the contrary, he has been glad to do so, and I have known it in my own case as he has disclosed to me every secret pertaining to his art. But, as misfortune would have it, the pupils he has come across either had little aptitude or, if they had aptitude, they did not

persevere but considered themselves masters after a few months of study with him. Also, even though he did this readily, he did not care to have it known, preferring good deeds to the appearance thereof.[126] It should further be known that he has always sought to instill his art in noble people, as the ancients used to do, and not in plebeians.

Michelangelo has a most retentive memory, so that, although he has painted all the thousands of figures that are to be seen, he has never made two alike or in the same pose. Indeed, I have heard him say that he never draws a line without remembering whether he has ever drawn it before and erasing it if it appears in public. He also has the most powerful faculty of imagination, which gives rise in the first place to the fact that he has not been very satisfied with his works and has always belittled them, feeling that his hand did not approach the idea which he formed in his mind. From the same origin, then, it proceeds that, as is the case with most people who devote themselves to a leisurely and contemplative life, he has been rather timid, except in righteous anger when some injury or breach of duty is done to him or to others, in which case he plucks up more courage than those who are considered courageous; then in other things he is extremely patient. Of his modesty, it would be impossible to say as much as it deserves, and the same is true for many other qualities and ways of his, which were also seasoned with charm and witticisms. So were the remarks he made in Bologna to a gentleman who, upon seeing the size and massiveness of the bronze statue which Michelangelo had done, inquired in wonderment, "Which do you think would be bigger, this statue or a team of oxen?" To which Michelangelo replied, "It depends which oxen you have in mind; if you mean some of the Bolognese oxen, oh, without a doubt they're bigger; if you mean some of ours from Florence, they are much smaller." Again, when Francia, who at that time in Bologna was considered an Apelles, saw this same statue and said, "This is beautiful material," Michelangelo, thinking that he was praising the metal and not the form, answered laughingly, "If this is beautiful material, I have Pope Julius to thank, who gave it to me, just as you have to thank the apothecaries who give you your colors." And on another occasion, seeing a young son of that same Francia, who was very handsome, he said, "My child, your father makes more beautiful live figures than painted ones."[127]

Michelangelo is well built; his body tends more to nerves and bones than to flesh and fat, healthy above all, both by nature and as a result of physical exercise and his continence with regard to intercourse and food, although he was sickly and delicate as a boy, and as a man he has had two illnesses.[128] But, for some years now, he has had great discomfort in urinating, an affliction which would have developed into a stone if it had not been relieved by the efforts and diligence of the aforesaid Messer Realdo. He has always had good color in his face, and his stature is as follows: he is of medium height, with broad shoulders, and the rest of his body is rather slight in proportion to his shoulders. The shape of that part of his head which shows frontally is rounded so that above the ears it forms a half circle plus a sixth (Pl. 53). Thus his temples project somewhat beyond his ears and his ears beyond his cheeks and the latter beyond the rest of his face, so that his head in proportion to the rest of his face can only be called large. The forehead seen from the front is square, the nose a bit flattened, not by nature but because when he was a boy a man called Torrigiano de' Torrigiani, a bestial and arrogant person, with a blow of his fist almost broke off the cartilage of Michelangelo's nose, so that he was carried home as if dead. However, that Torrigiano, who was banished from Florence for this, came to a bad end.[129] All the same, the nose, just as it is, is proportionate to the forehead and to the rest of the face. His lips are thin, but the lower one is slightly thicker so that seen in profile it projects a little. His chin goes well with the features already mentioned. The forehead in profile protrudes almost beyond the nose, which is just less than straight, except for a little lump in the middle. The eyebrows are scanty, the eyes might be called rather small, horn colored but changeable, with little flecks of yellow and blue. The ears are of a proper size; the hair is black and likewise the beard, except that, at his age of seventy-nine years, the hairs are plentifully streaked with white. The beard is forked, between four and five fingers long, and not very thick, as is partly visible in his portrait.[130]

I had many other things still to say, which I have omitted in my haste to publish this part which is written, since I understand that certain others wanted to gain honor for themselves from my efforts which I had entrusted to their hands; so that if it ever happens that someone else should want to undertake this work or to write the same biography, I offer to communicate

all my labors or to give them to him in writing in a spirit of loving kindness. I hope in a short time to publish some of Michelangelo's sonnets and madrigals, which I have collected over a long period from him and from others, and this I will do in order to prove to the world how great are his powers of invention and how many beautiful ideas spring from that divine spirit.[131] And with this, I make an end.

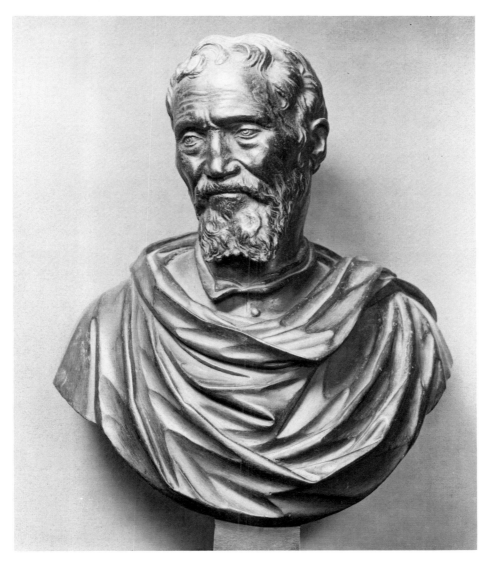

PLATE 53 After Daniele da Volterra, *Michelangelo*,
Casa Buonarroti, Florence
Photo courtesy Fratelli Alinari, Florence

APPENDIX 1

GENEALOGY OF THE MEDICI FAMILY

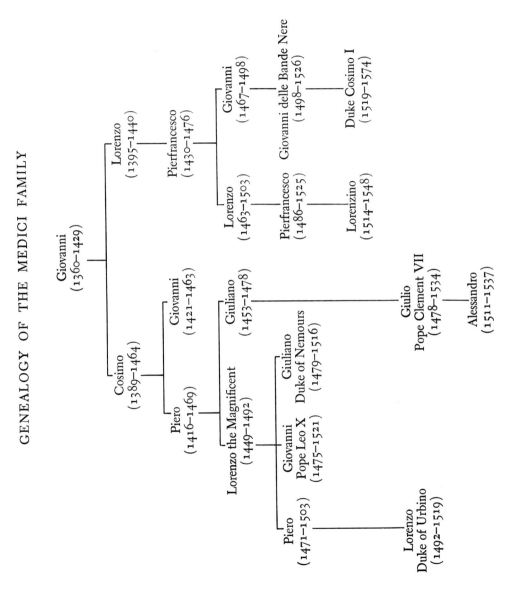

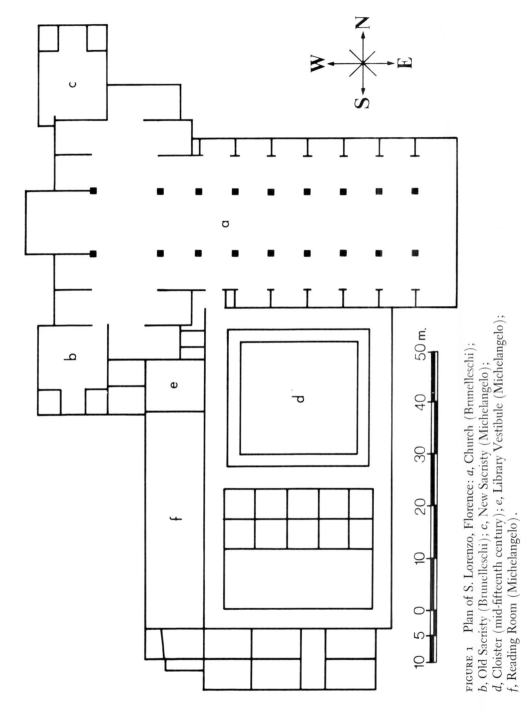

FIGURE 1 Plan of S. Lorenzo, Florence: *a*, Church (Brunelleschi);
b, Old Sacristy (Brunelleschi); *c*, New Sacristy (Michelangelo);
d, Cloister (mid-fifteenth century); *e*, Library Vestibule (Michelangelo);
f, Reading Room (Michelangelo).

APPENDIX 2

THE TOMB OF POPE JULIUS II

There are five designs for the pope's tomb: the original project of 1505 for a free-standing monument and the subsequent designs of 1513, 1516, 1532, and 1542 for a wall tomb. No contract for the first project has survived; for the other four Michelangelo signed contracts with the executors of Julius' estate.

No drawings or specifications have survived for the design conceived in 1505

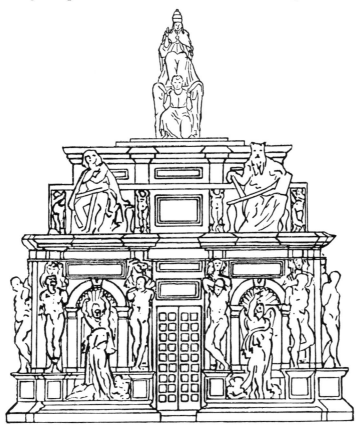

FIGURE 2 Reconstruction of Michelangelo's design of 1505
for the tomb of Julius II
Reproduced by permission from Herbert von Einem, *Michelangelo,*
© by Verlag W. Kohlhammer

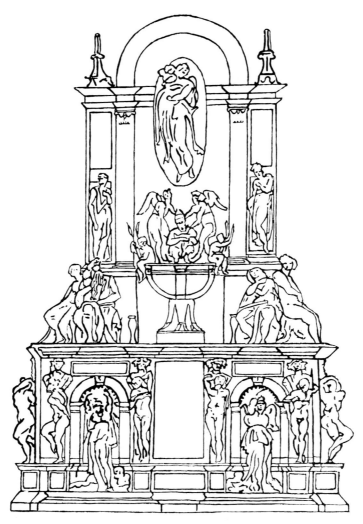

FIGURE 3 Reconstruction of Michelangelo's design of 1513
for the tomb of Julius II
Reproduced by permission from Herbert von Einem, *Michelangelo*,
© by Verlag W. Kohlhammer

and abandoned in 1506 in favor of the rebuilding of St. Peter's. Our knowledge
of the project rests almost entirely on Condivi's description (see p. 33), which was
repeated with minor emendations and variations in the 1568 edition of Vasari's
Vite. None of the statues or reliefs planned for this project were carried out
(Fig. 2).

The design of the 1513 project was recorded by Giacomo Rocchetti in a copy,

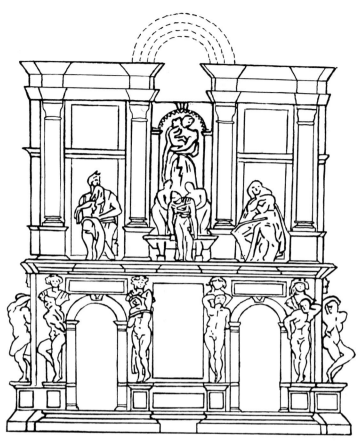

FIGURE 4 Reconstruction of Michelangelo's design of 1516
for the tomb of Julius II
Reproduced by permission from Herbert von Einem, *Michelangelo,*
© by Verlag W. Kohlhammer

formerly in Berlin, of a lost drawing by Michelangelo (Fig. 3). The first and second levels are substantially the same as in the project of 1505, but a twenty-five-foot-high frontispiece with a *Madonna and Child* in the center and four other figures was added to the upper story. The *Rebellious Slave* and the *Dying Slave* in the Louvre (Pls. 13, 14), on which Michelangelo worked in 1513, were to flank the left-hand niche, and the *Moses* (Pl. 38), begun in the summer of 1515 and left unfinished in 1516, was to be one of the figures on the upper level. The architectural work for the lower story of this project was almost completed by the stonemason Antonio da Pontassieve in 1513–1514 and was later used for the monument as installed in S. Pietro in Vincoli.

In the 1516 project (Fig. 4) the front of the lower story remained the same,

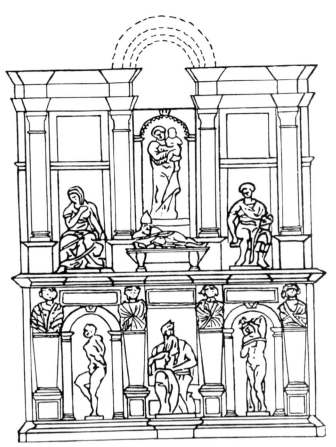

FIGURE 5 Reconstruction of Michelangelo's design of 1532
for the tomb of Julius II
Reproduced by permission from Herbert von Einem, *Michelangelo*,
© by Verlag W. Kohlhammer

and the two Louvre *Slaves* and the *Moses* were to stay where they had been planned
in the design of 1513. But the upper story was changed to a rectangular façade
fourteen feet in height, with applied columns on bases, and crowned by a cornice.
In the center there was to be a platform for the standing *Madonna* and the effigy
of the pope flanked by two angels. The seated figures at the sides were to be
set in niches.

By terms of the 1532 contract Michelangelo was to complete within three
years six statues—the *Madonna*, a Prophet, a Sibyl, and probably the two *Slaves*
in the Louvre and the *Moses*—and the architectural work as designed for the
project of 1516 (Fig. 5). The contract also specified that the tomb was to be
erected in S. Pietro in Vincoli, the titular church of Julius II. Vasari tells us that

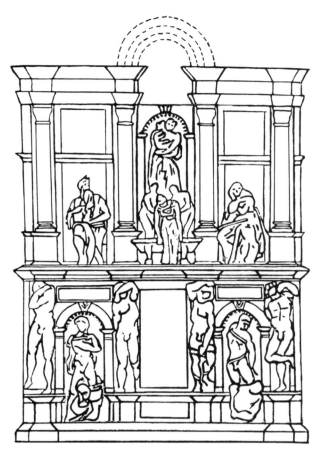

FIGURE 6 Reconstruction of Michelangelo's modified version of
his design of 1516 for the tomb of Julius II
Reproduced by permission from Herbert von Einem, *Michelangelo*,
© by Verlag W. Kohlhammer

when Michelangelo moved from Florence to Rome in 1534 he left in his studio
"a great number of statues." Among them were the *Victory* in the Palazzo della
Signoria and the four *Captives* in the Accademia (Pl. 36). They may have been
intended for a modified version of the design of 1516 (Fig. 6), in which the
Victory was to occupy one of the niches on the lower level and the *Captives*
were to be atlantes supporting the upper story.

The contract of 1542 revised the terms of the agreement of 1532 to the effect
that three of the six statues Michelangelo had promised to deliver were to be
finished by his pupil Raffaello da Montelupo. Before the fourth contract had been
signed, Michelangelo had decided to replace the two *Slaves* now in the Louvre
with the allegorical figures, the *Contemplative Life* and the *Active Life* (Pls. 40,

41), both of which he had begun by the summer of 1542. The architectural design of the tomb as it was installed in 1545 at S. Pietro in Vincoli (Pl. 39) follows the project of 1532, except that large volutes have been placed under the terms ending in busts of patriarchal figures that flank the lateral niches of the lower story. The recumbent effigy of the pope, which was not mentioned in the contracts of 1532 or 1542, is the work of Maso di Boscolo, a pupil of Andrea Sansovino's.

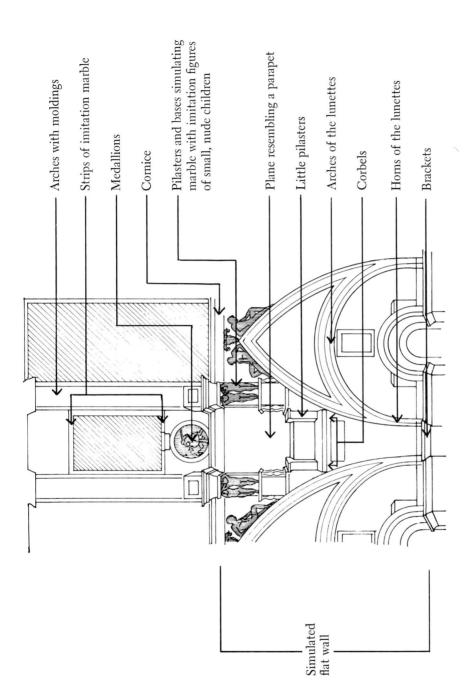

Arches with moldings

Strips of imitation marble

Medallions

Cornice

Pilasters and bases simulating marble with imitation figures of small, nude children

Plane resembling a parapet

Little pilasters

Arches of the lunettes

Corbels

Horns of the lunettes

Brackets

Simulated flat wall

FIGURE 7 Architectural organization of the Sistine Ceiling
Reproduced by permission from Sven Sandström, *Levels of Unreality:
Studies in Structure and Construction in Italian Mural Painting During
the Renaissance*, p. 185, © 1963 by Acta Universitatis Upsaliensis

119

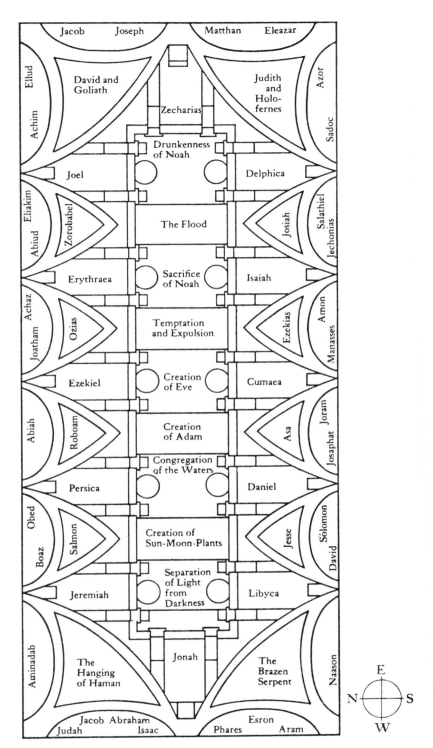

FIGURE 8 Schematic organization of the Sistine Ceiling
Adapted from Charles Seymour, Jr. (ed.), *Michelangelo:
The Sistine Chapel* © by W. W. Norton and Co.

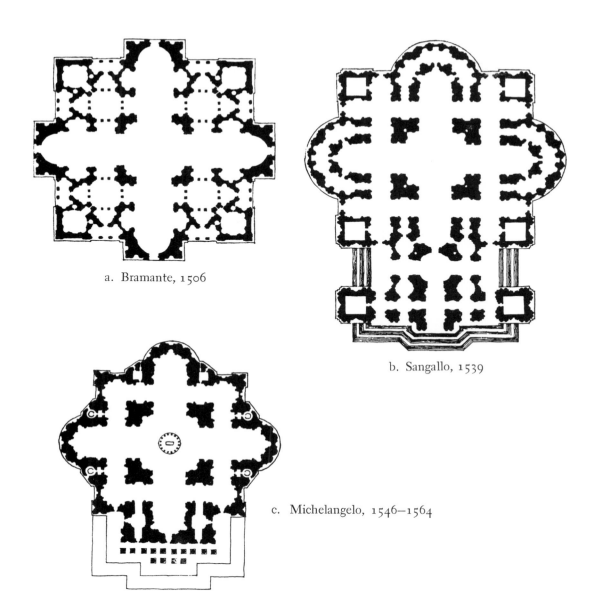

a. Bramante, 1506

b. Sangallo, 1539

c. Michelangelo, 1546–1564

FIGURE 9 Plans for the rebuilding of St. Peter's
Reproduced by permission from James S. Ackerman, *The Architecture
of Michelangelo*, Fig. 11, © 1961 by Viking Press, Inc.

121

NOTES

NOTES TO INTRODUCTION

1. The first edition of Vasari of 1550 has been neglected in favor of the enlarged second edition of 1568 and has never been translated from the Italian. The most satisfactory English version of the second edition is Gaston de Vere (trans.), *Lives of the Most Eminent Painters, Sculptors, and Architects by Giorgio Vasari* (10 vols; London, 1911–15). The first edition in its entirety was reprinted without commentary by Corrado Ricci (ed.), *Le Vite de' più eccellenti architetti, pittori et scultori italiani da Cimabue insino a' tempi nostri descritte in lingua toscana da Giorgio Vasari pittore Aretino* (4 vols; Rome, 1927). The standard annotated Italian version of the second edition is Gaetano Milanesi (ed.), *Le Vite de' più eccellenti pittori scultori e architettori scritte da Giorgio Vasari pittore Aretino* (9 vols; Florence, 1878–85). Both editions of Vasari's biography of Michelangelo are reprinted not only in the Frey book mentioned previously in the text, but also in Giorgio Vasari, *La Vita di Michelangelo nelle redazioni del 1550 e del 1568,* ed. Paola Barocchi (5 vols; Milan and Naples, 1962), I.

2. All editions of Condivi in all languages are listed and described in Ernst Steinmann and Rudolf Wittkower (eds.), *Michelangelo Bibliographie, 1510–1926* (Leipzig, 1927), and Luitpold Dussler (ed.), *Michelangelo Bibliographie, 1926–1970* (Wiesbaden, 1974).

3. Edgar Wind, *Pagan Mysteries in the Renaissance* (London, 1958), 153.

4. For an orthodox psychoanalytic interpretation of this passage, see Gerda Frank, "The Enigma of Michelangelo's *Pietà Rondanini:* A Study of Mother-loss in Childhood," *American Imago,* XXIII (1966), 287–315. A less heavy-handed, subtler reading is suggested by Adrian Stokes, *Michelangelo: A Study in the Nature of Art* (London, 1955), 32–33. For a summary of my views on the relevance of Michelangelo's reference to his wet nurse to his images of the *Madonna and Child,* see Erik Erikson, "Play and Actuality," in Robert J. Lifton (ed.), *Explorations in Psychohistory: The Wellfleet Papers* (New York, 1971), 113–14.

NOTES TO TRANSLATED TEXT

1. Condivi collected Michelangelo's poems and his observations on anatomy (see pp. 99, 109), but never published them.

2. Condivi's justification for the quick publication of his biography is primarily a

criticism of Vasari's section on Michelangelo in the first edition (1550) of *Le Vite de' più eccellenti architetti, pittori et scultori italiani* (see Introduction, pp. xvi-xviii).

3. Michelangelo's belief that he was descended from the counts of Canossa derived from a letter of 1520 in which Alessandro da Canossa addresses him as "honored kinsman" and claims that he has discovered an ancestor of the Buonarroti family named Simone da Canossa, who was *podestà* of Florence in the thirteenth century. Michelangelo was intensely concerned with the honor of his family and often referred to it in letters to his nephew Lionardo. "We are citizens descended from a very noble race," he wrote him in 1546, and in a letter of 1549 he reminded Lionardo "that we are old Florentine citizens and as noble as any other family." Bonifazio of Canossa, the father of the Countess Matilda, was invested as margrave of Tuscany by Emperor Conrad II in 1027. After Bonifazio's death his widow Beatrice remarried, and Matilda acceded to the margraviate upon the death of her stepfather in 1069. Known as *la gran contessa*, she was one of the most influential rulers of medieval Italy and a supporter of Pope Gregory VII against Emperor Henry IV. It was at her ancestral home, the castle of Canossa, that in the winter of 1077 the pope had the emperor wait in the cold for three days before admitting him to his presence. In the seventeenth century the remains of Countess Matilda were transferred from S. Benedetto at Polirone to a tomb at St. Peter's in Rome. The tomb was commissioned by Pope Urban VIII from the atelier of Gianlorenzo Bernini. By "the patrimony of St. Peter" Condivi means the Papal States.

4. The administrative division of Florence into sixths (*sestieri*) was replaced in 1343 by the quarters (*quartieri*) of Sta. Croce, S. Giovanni, Sta. Maria Novella and Sto. Spirito.

5. In the terminology of heraldry, *gules, argent, azure*, and *or* designate the colors red, silver, blue, and gold, respectively. The best translation of *rastrello* in the present context is *grate*. A search kindly undertaken at the Bargello (the former Palazzo del Podestà) by Professor Fred Licht has revealed that, although it contains several later coats of arms of the Canossa family, the original Canossa escutcheon described by Condivi has been lost.

6. Leo X (Giovanni de' Medici, the second son of Lorenzo the Magnificent) was pope from 1513 to 1521 (Pl. 2). In December, 1515, he stayed in Florence while meeting with the French King Francis I in Bologna and at that time conferred on the Buonarroti family the title of counts of Palatine. Michelangelo had four brothers: Lionardo (born 1473), Buonarroto (born 1477), Giovansimone (born 1479), and Gismondo (born 1481), among whom Buonarroto was his favorite. The *squitinio* (or *scrutinio*) was the procedure for screening Florentine citizens to determine their eligibility for being elected to public office.

7. Lodovico was in fact *podestà* only of Caprese, a small town near Arezzo today called Caprese Michelangelo. The constitution of Caprese stated that its *podestà* had to be a Florentine and a Guelph. The year of Michelangelo's birth is not 1474 but 1475. By the Florentine Renaissance calendar the year began on March 25, the Feast of the Annunciation.

8. According to the astrological tradition which the Renaissance inherited from the

Greeks, a person's temperament, occupation, and accomplishments were determined by the position of the planets at the time of birth. In Michelangelo's horoscope Mercury and Venus are in the second house and Jupiter is in the first house. But the second house, which is indicative of financial matters, is considered as "the house ruled by Jupiter." The Renaissance, following Marsilio Ficino, believed that artists were born under Saturn. Condivi's interpretation of the time of Michelangelo's birth derives from the Greek view that artists were born under Mercury, since Hermes, the Greek equivalent of Mercury, was venerated as the inventor of the sciences and the arts.

9. Michelangelo's real mother died at the age of twenty-six when he was six. In the entire body of his writings he mentioned her only once: in 1554 he wrote his nephew Lionardo, who had recently married, that if Lionardo were to have a daughter he should call her Francesca, "after our mother." Michelangelo's reference to the power of the nurse's milk rests on the ancient metaphor of drinking at the breasts of Wisdom, popular and heraldic images of which were common in the late Middle Ages and the Renaissance.

10. Michelangelo entered the school in 1482, when he was seven. The curriculum in a Florentine Renaissance grammar school consisted of reading and writing, with elementary training in business correspondence and drafting legal documents.

11. In 1488 Michelangelo was apprenticed by his father to Domenico Ghirlandaio, who with his atelier was at that time working on the frescoes in the choir of Sta. Maria Novella, for a period of three years. However, he remained with Ghirlandaio only until 1490, when Lorenzo the Magnificent took him to live in the Medici Palace. Francesco Granacci was a Florentine painter of the time whose style was later influenced by Michelangelo's early work. In 1508 he went to Rome to be an assistant in the decoration of the Sistine Ceiling, but was dismissed almost at once.

12. The artist whom Condivi calls Martino d'Ollandia—Vasari refers to him more correctly as Martino Tedesco (the German Martin)—is Martin Schongauer. Michelangelo's copy of Schongauer's engraving, *The Temptation of St. Anthony*, has been identified with a small panel in the style of Ghirlandaio sold at Sotheby's in London in December, 1960. See Adam Bartsch, *Le Peintre graveur* (2nd ed.; Würzburg, 1920), VI, 47.

13. According to a contemporary, Domenico Ghirlandaio's brother Benedetto later returned from France "very rich and honored."

14. As is indicated by Michelangelo's remarks to Condivi that his capacity for "gratification" through the chisel had come to him through the milk of his wet nurse and that when he sees his early relief *The Battle of the Centaurs* (Pl. 5) "he realizes what a great wrong he committed against nature by not promptly pursuing the art of sculpture," he believed in his later years—and perhaps always—that he had been destined to be a sculptor. Condivi consequently does not mention Michelangelo's apprenticeship to Ghirlandaio, but rather emphasizes his friendship with Granacci who, by taking Michelangelo to the Medici Garden, set him on the course which nature had ordained for him. Nevertheless, Ghirlandaio's importance for Michelangelo should not be underestimated, for he transmitted to him the Florentine tradition of fresco painting and first introduced him to classical

sculpture. Condivi's reference to Michelangelo's *divinità* reflects the Renaissance concept of the "divine artist," which goes back to Plato's theory of the poet as a divinely inspired creator and to the medieval idea of God as the architect *(artifex)* of the universe. In his treatise *On Painting* (1435) Leon Battista Alberti wrote that the painter Zeuxis (see n. 124) "began to give his works away," because he "did not believe any price could be found to recompense the man who, in modeling or painting living things, behaved like a god among mortals. The virtues of painting, therefore, are that its masters see their works admired and feel themselves to be almost like the Creator [*deo*]." The appellation "divine," first bestowed on Michelangelo in the line *Michel più che mortal Angel divino* of Lodovico Ariosto's *Orlando furioso* (1516), was commonly applied to him by the middle of the sixteenth century. He often responded to such acclaim ironically, as in a letter of 1547 to Luca Martini, a member of the Florentine Academy, in reply to Martini's adulatory praise of one of his sonnets: "I am a poor fellow, and of little worth, plodding along in that art which God has assigned to me, in order to prolong my life as long as I can."

15. The work has been lost. A copy of it appears in a seventeenth-century fresco by Ottavio Vannini, *Michelangelo Presenting the Head of the Faun to Lorenzo the Magnificent*, in the Palazzo Pitti.

16. The Laurentian Library in the cloister of S. Lorenzo (Fig. 1) was designed by Michelangelo beginning in 1524 on the commission of Clement VII. Its famous vestibule was completed by Bartolommeo Ammanati, on designs sent by Michelangelo from Rome, in 1559.

17. By carnelians *(corniole)* Condivi probably means engraved gems, the most prized items in Lorenzo the Magnificent's art collection. In the inventory of his collection drawn up after his death, the engraved gems were valued between four hundred and one thousand florins each, although paintings by masters such as Botticelli were appraised at fifty to one hundred florins.

18. Angelo Poliziano was the tutor of Lorenzo's sons. His principal works are *La Giostra*, which commemorates in octave stanzas a tournament staged in 1475 in honor of Lorenzo's younger brother Giuliano, and *Orfeo*, a lyrical verse drama.

19. The relief is today in the Casa Buonarroti. Its subject is the battle between the Lapiths and the centaurs at the wedding feast of Hippodamia and Pirithous, as told in Book 12 of Ovid's *Metamorphoses*. Condivi confuses this story, in which one of the centaurs attempts to abduct Hippodamia, with the battle between Hercules and the centaur Nessus, who tried to carry away Hercules' bride Deianira.

20. Lorenzo died at his villa in Careggi on April 8, 1492. The over life-sized *Hercules* has been lost. It was acquired from Michelangelo by the Strozzi family and in 1529 was sold by Filippo Strozzi to Francis I. In 1594 Henry IV had the figure installed on a base in the Jardin d'Estang at Fontainebleau, where it is shown in an engraving of 1694 by Israel Silvestre. The statue disappeared when the Jardin d'Estang was destroyed in 1713.

21. Snow is a rarity in Florentine winters; but it is recorded that on January 22, 1494, it snowed for more than a day.

22. The *Crucifix* was moved to the sacristy in the early seventeenth century, when a new main altar was constructed, and was subsequently believed lost. In 1962 it

was rediscovered by Dr. Margrit Lisner in a corridor leading to the kitchen of the monastery of Sto. Spirito and it is now in the Casa Buonarroti. Though the church tended to be touchy about dissection—Pope Leo X forbade Leonardo to continue dissecting corpses during his stay at the Vatican—it did not unequivocally disapprove of it. By the end of the fifteenth century dissection was practiced at universities; and Antonio Pollaiuolo, Andrea del Verrocchio, and Leonardo da Vinci all studied anatomy through dissection.

23. Piero's brother Giovanni became Pope Leo X. Giuliano, the third son of Lorenzo the Magnificent, became duke of Nemours through his marriage into the French royal family. He died in 1516 and is buried in the tomb with the figures *Night* and *Day* in the Medici Chapel at S. Lorenzo (Pl. 34).

24. Bernardo Dovizi da Bibbiena was also the tutor and later chancellor (secretary) of Piero's brother Giovanni de' Medici, who upon his election as Leo X named Bernardo Dovizi cardinal of Sta. Maria in Portico. A copy of Raphael's portrait of Cardinal Bibbiena is in the Uffizi Gallery.

25. Giovanni Bentivoglio was the lord of Bologna from 1462 until 1506, when he was overthrown by papal forces under Julius II (see p. 37).

26. Gianfrancesco Aldovrandi later served Pope Julius II as ambassador to Florence and Ferrara. The Sixteen were a body of citizens formed in 1376 to safeguard the rights of Bologna against papal domination.

27. The Florentines expelled the Medici in November, 1494—two years after Lorenzo's death, when Michelangelo was nineteen—after Piero had surrendered Florence's key fortress towns in Tuscany to Charles VIII, who had invaded Italy with a French army.

28. Michelangelo in fact carved three figures for the tomb of St. Dominic: the *Kneeling Angel*, the *St. Petronius*, and the *St. Proculus*, which has been recognized as a self-portrait of the nineteen-year-old sculptor (Pl. 7). The tomb of St. Dominic was begun by Nicola Pisano and his workshop in the thirteenth century. It was continued in the late fifteenth century by the south Italian sculptor Niccolò dell' Arca, at whose death in March, 1494, three figures were still missing.

29. Lorenzo di Pierfrancesco, a member of the younger branch of the Medici, had sympathized with the revolt of 1494 against Piero. Michelangelo may have lived in his house after his return from Bologna in 1495. The marble *Infant St. John* has not survived.

30. By the term *lapis* Condivi must have meant a stick of chalk. In the introduction to the 1568 edition of the *Vite* Vasari describes among the materials of drawing red and black chalk (*lapis rosso* and *pietra nera*). Both, contrary to Condivi, were used by Italian artists well before 1500. The *lapis* is first listed as a draftsman's instrument in Filippo Baldinucci's *Vocabolario Toscano dell' arte del disegno* of 1681, where it is defined as a *matita* (pencil), but is not described. The modern graphite pencil, which in Italian is called both *lapis* and *matita*, did not come into use until the end of the eighteenth century.

31. The *Sleeping Eros* has been lost. Raffaele Riario, the cardinal of S. Giorgio in Velabro, was the grandnephew of Pope Sixtus IV, one of the early Roman collectors of antiquities and Michelangelo's first patron in Rome. After he returned the *Eros* to the dealer Baldassare del Milanese, from whom he had bought it,

that Bramante was his enemy (see n. 64), though there is no evidence confirming that he was. An architect in the Renaissance was usually apprenticed to a painter or sculptor and received the title master architect only after his first building commission, usually at an advanced age. Bramante was no exception. He knew little about technical matters and made structural miscalculations in the Vatican loggias, the crossing piers of St. Peter's, and the Belvedere Corridor, which collapsed in 1531, nearly killing Pope Clement VII. Bramante never worked at S. Pietro in Vincoli, which Condivi confuses with S. Pietro in Montorio, the site of Bramante's Tempietto.

45. The *Captives* are the *Dying Slave* and the *Rebellious Slave* in the Louvre (Pls. 13,14). They belonged not to the original project of the tomb, which Condivi goes on to describe, but to the second project of 1513 (Fig. 3). There were to be three further projects until the tomb was installed in greatly reduced form at S. Pietro in Vincoli in 1545 (Pl. 39). For a summary of the five projects, see Appendix 2.

46. A *term* is an architectural element consisting of a pedestal tapering toward the base and usually supporting a bust or merging at the top into a figure.

47. By the "upper side" *(banda di sopra)* Condivi must have meant the front of the tomb. According to Vasari's description of the 1505 project in the 1568 edition of his *Vite*, access to the interior chamber of the tomb was "through the ends of the square form of the work in the middle of the niches."

48. The rebuilding of the choir of St. Peter's, begun by Bernardo Rossellino at the order of Nicholas V (1447–1455), was continued during the pontificate of Paul II (1464–1471) under the direction of Giuliano da Sangallo. Giuliano became a friend of Michelangelo's and was the favorite architect of Julius II during the early years of his reign. When Julius commissioned Bramante to "rebuild the whole church anew" he decided to abandon the project of his tomb, and this was the chief reason for Michelangelo's subsequent flight from Rome and for his lifelong hatred of Bramante.

49. Michelangelo left Rome in April, 1506, one day before the cornerstone was laid for the St. Peter's designed by Bramante. Condivi's description of Michelangelo's flight from Rome corresponds closely to Michelangelo's own accounts in letters of May, 1506, to Giuliano da Sangallo and of October–November, 1542, probably to Cardinal Alessandro Farnese.

50. The sultan of Turkey at this time was Bayezid II (1481–1512), the victor over the Venetians at Lepanto and the builder of the Bayezid Mosque in Istanbul. In 1519 Michelangelo received a letter written from Adrianopolis, then the capital of the Ottoman Empire, by Tommaso di Tolfo, an Italian who had been in the service of Bayezid II. Tommaso recalled that in Florence "about fifteen years ago" Michelangelo had spoken of his wish "to come and see this country."

51. Michelangelo had prepared the cartoon for a large mural in the Sala del Consiglio of the Palazzo della Signoria between December, 1504, and his departure for Rome in March, 1505. It was to be opposite Leonardo da Vinci's lost mural *The Battle of Anghiari* and had as its subject *The Battle of Cascina*, an engagement in 1364 between Florentine and Pisan troops. Michelangelo began the fresco before leaving Florence for Bologna in November, 1506, but never worked on it again. The cartoon is described in some detail in both the 1550 and 1568 edi-

tions of Vasari's life of Michelangelo. The Sala del Papa in the convent of Sta. Maria Novella was the residence of the pope when he visited Florence. Between the summer of 1515 and the spring of 1516 Michelangelo's cartoon was moved from the Sala del Papa to the Palazzo della Signoria and cut into sections, none of which have survived. The most reliable copy of the cartoon is a mid-sixteenth-century Florentine grisaille painting in the collection of Lord Leicester at Holkham Hall, Norfolk (Pl. 15).

52. Julius entered Bologna at the head of a papal army composed partly of French troops on November 11, 1506. In a letter of 1523 Michelangelo wrote that he had been forced to go to the pope in Bologna "with a rope around my neck, to ask his pardon." Cardinal Soderini of Volterra was the brother of Michelangelo's friend Piero Soderini, the *gonfaloniere* of Florence. Among the many letters of introduction that Piero furnished Michelangelo when he sent him to Bologna, he addressed one to his brother the cardinal. For "jabs" Condivi uses the now obsolete expression *matti frugoni* (literally, wild sticks), meaning jabs delivered with the fingers held together and straight out so as to come to a point or with the knuckles of the fist.

53. According to Vasari, the figure was installed in a niche above the portal of S. Petronio. In his left hand the pope held not a sword but a key, the emblem of the occupant of the throne of St. Peter. Michelangelo worked on the statue between the end of 1506 and February, 1508. In March he briefly returned to Florence before going to Rome to begin the Sistine Ceiling. The Bentivoglio retook Bologna at the end of December, 1511. According to Vasari, the smashed statue was sold to Duke Alfonso I d'Este of Ferrara, who melted down the bronze to make a cannon called La Giulia.

54. When Julius II decided to have Michelangelo paint the ceiling of the papal chapel built by his uncle Sixtus IV (1471–1484), its walls were already decorated with frescoes of scenes from the lives of Moses and Christ by a group of painters under the direction of Perugino, including Sandro Botticelli, Domenico Ghirlandaio, and Luca Signorelli. At the center of the altar wall was an altarpiece by Perugino, *The Assumption of the Virgin*, and the ceiling showed the blue firmament decorated with gilt stars. Condivi's account of the commissioning of the Sistine Ceiling should be taken in the context of Michelangelo's bitter memories of having had to abandon the Julius Tomb and of his animosity toward Bramante. According to a May, 1506, letter to Michelangelo from Piero Roselli, the master mason in charge of preparing the Sistine Ceiling for painting, Julius already at that time wished to give the commission to Michelangelo, though Bramante advised the pope "that Michelangelo would lack the necessary courage to attack the ceiling because he had not had much experience in figure painting, and in general the figures will be set high and in foreshortening, and this brings up problems which are completely different from those met in painting at ground level." Michelangelo had known Raphael in Florence in 1504 and 1505, and it is not impossible that he could have suggested that the ceiling be given to the young painter whose style he so decisively influenced. Bramante, however, did not know Raphael until his arrival in Rome in the late summer or early autumn of 1508. The statement that Michelangelo "had not yet used colors" is untrue, for he had not only

painted the Doni Tondo and begun *The Battle of Cascina*, but had worked on the murals in the choir of Sta. Maria Novella as an apprentice of Ghirlandaio's. Michelangelo signed the contract for the Sistine Ceiling in May, 1508.

55. The proportions of the plan of the Sistine Chapel are 1:3 (13.41 × 40.23 meters). In giving the proportions of "the whole vault" as 1:2.5, Condivi was calculating its area as far down as the painted brackets below the lunettes on the walls (Pl. 17, Fig. 7).

56. The "head of the chapel" is the altar end of the interior space. Condivi's use of the term "first space" for *The Separation of Light and Darkness* is liturgically accurate and consistent with the chronological sequence of the wall frescoes of the time of Sixtus IV. However, Michelangelo's Genesis scenes on the vault are meant to be read in the opposite direction, from the entrance toward the altar, reversing and thus transcending chronological time. *The Drunkenness of Noah* over the entrance, though the last scene in time, is actually the first in the narrative sequence of the vault; and *The Separation of Light and Darkness*, the first scene of Creation, is the last and culminating composition of the ceiling.

57. In describing the figure of God foreshortened from the back as being "at the left side" of *The Creation of the Sun, Moon, and Planets* Condivi is visualizing it with his back to the entrance and facing the altar wall. Later in his account of the ceiling, when he locates the foreground mountain in *The Flood* at the right of the composition and *The Crucifixion of Haman* at the right of *The Last Judgment*, he assumes the reverse position, with his back to the altar wall and looking toward the entrance.

58. Professor Charles Seymour has pointed out that the gesture of the Almighty has a specific scriptural meaning, familiar to the Renaissance through the words of St. Augustine, "That Holy Spirit, through whom charity which is the fullness of the law is shed abroad in our hearts, is also called in the Gospel the finger of God," and from the third stanza of the medieval hymn sung at vespers on Whitsunday according to the Roman rite:

> The seven-fold gift of grace is thine,
> Thou finger of the hand divine;
> Our Father's promise true, to teach
> Our earthly tongues Thy heavenly speech.

59. The seventh space composition is *The Sacrifice of Noah*, not that of Cain and Abel. Because he needed one of the larger panels on the ceiling for *The Flood*, Michelangelo placed it after *The Sacrifice of Noah*, even though chronologically the sacrifice follows the subsiding of the waters.

60. The alternating Old Testament Prophets and Sibyls of pagan antiquity, the largest figures on the ceiling, are the seers who foretold the coming of a Savior. Their location is determined by the relationship of their prophecies to the compositions on the vault and to the subjects of the fifteenth-century frescoes on the walls.

61. Like the Prophets and the Sibyls the stories in the four corner triangles refer to Christ's mission of salvation: Haman through his crucifixion, the Brazen Serpent through its power to heal, and Judith and David through their salvation of their people by beheading powerful enemies.

62. The medallions supported by the *ignudi* (male nude figures) look like the enlarged reverses of medals. The subjects are for the most part struggles of righteous against unwise rule taken from the First Book of Kings and the Second Book of Samuel. Two medallions near the altar depict Elijah taken to heaven in his chariot of fire and *The Sacrifice of Isaac* (Pl. 18), foretelling the sacrifice and ascension of Christ. By his remark that the subjects of the medallions are "all related . . . to the principal narrative," Condivi clearly implies that there is a unifying concept for the ceiling as a whole. Although scholars disagree in their interpretations of the ceiling, it is evident that such a concept exists; that it embraces not only the ceiling but also the fifteenth-century wall frescoes; and that it is an exposition and orchestration on linked levels of doctrinal reference and symbolism of the plan of man's redemption and of the pentecostal theme of the unfolding of God's "promise . . . to teach our earthly tongues" His "heavenly speech."

63. If Condivi's report that the pope visited the chapel "before the dust raised by the dismantling of the scaffold had settled" is reliable, the first half of the ceiling —probably through *The Creation of Eve*—would have been uncovered prior to August 17, 1510, when the pope left Rome for Bologna. Michelangelo began the second half of the ceiling in February, 1511.

64. It is very improbable that Raphael wanted to finish the Sistine Ceiling. Condivi's references to Raphael as well as to Bramante were motivated by his loyalty to his master and should be taken in the context of Michelangelo's belief, expressed in a letter of 1542, that "all the discords that arose between Pope Julius and me were owing to the envy of Bramante and Raphael of Urbino; and this is the reason why he did not proceed with the tomb in his lifetime, in order to ruin me. And Raphael had good reason to be envious, since what he knew of art he learned from me."

65. The length of time between the signing of the contract and the final unveiling of the ceiling was in fact nearly fifty-four months (May 10, 1508, to October 31, 1512). Condivi's figure of twenty months may refer to the time Michelangelo actually spent on the scaffold. It is quite impossible that Michelangelo could have painted the ceiling without any help whatever. He must have had assistants for preparing cartoons, laying in plaster, and preparing pigments.

66. A *secco* passages (additions in tempera or size after the plaster is dry) and gilt (gold leaf) have in fact been found, though only in the first half of the ceiling. The exchange that Condivi reports between Michelangelo and the pope is a transposition of a conversation concerning the abandoned plan of decorating the ceiling with the Twelve Apostles. In a letter of 1523 Michelangelo wrote, "I told the pope that if the Apostles alone were put there it seemed to me that it would turn out a poor affair. He asked me why. I said 'because they themselves were poor.'" The sum of three thousand ducats was the one stipulated for the Twelve Apostles scheme. For the program that Michelangelo executed he received considerably more, perhaps as much as six thousand ducats.

67. Michelangelo himself described his discomfort in painting the ceiling in a sonnet addressed to his friend Giovanni di Pistoia:

I've got myself a goiter from this strain,
As water gives the cats in Lombardy
Or maybe it is in some other country;
My belly's pushed by force beneath my chin.

My beard toward heaven, I feel the back of my brain
Upon my neck, I grow the breast of a Harpy;
My brush, above my face continually,
Makes it a splendid floor by dripping down.

My loins have penetrated to my paunch,
My rump's a crupper, as a counterweight,
And pointless the unseeing steps I go.

In front of me my skin is being stretched
While it folds up behind and forms a knot,
And I am bending like a Syrian bow.

68. Julius II died on February 21, 1513. He left ten thousand ducats for the completion of his tomb, and in May Michelangelo signed the first contract with Julius' heirs for its continuation (see Appendix 2). Lorenzo Pucci, cardinal of Quattro Santi Coronati, and Leonardo Grosso della Rovere, Cardinal Aginense, were the executors of Julius' estate.

69. Bernardo Bini was the *depositario*, the head cashier, of the papal treasury under Leo X and other popes.

70. S. Lorenzo, the family church of the Medici, was begun in 1421 by Filippo Brunelleschi and with the exception of the façade, which until this day consists only of rough masonry, was finished by the end of the fifteenth century. In 1515 Leo X decided to provide the church with a façade, and according to Vasari there was a competition involving Michelangelo, Giuliano and Antonio da Sangallo the Elder, Baccio d'Agnolo, Andrea and Jacopo Sansovino, Raphael, and others. The contract for the façade was awarded to Michelangelo in January, 1518, although the commission had been his since November, 1516. A wooden model of Michelangelo's design is in the Casa Buonarroti (Pl. 31). In July, 1516, he signed the second contract for the tomb of Julius II (see Appendix 2).

71. Marquis Alberico Malaspina, lord of Carrara, had been a friend of Michelangelo's since the sculptor had first worked at Carrara in 1505.

72. Beset by difficulties and mishaps, Michelangelo spent some thirteen months of 1518 and 1519 at Pietra Santa, at one point writing to his brother Buonarroto, "I have undertaken to raise the dead in trying to domesticate these mountains and bring art to this village." In March, 1520, Leo X inexplicably canceled Michelangelo's S. Lorenzo façade contract.

73. Leo X died in December, 1521. Hadrian VI, born in Utrecht, had been the tutor of Emperor Charles V and regent of Spain and was pope from January, 1522, to September, 1523. He stressed austerity, attended to religious matters, and was indifferent to art.

74. Cardinal Giulio de' Medici, who ruled as Pope Clement VII from 1523 to 1534, was the illegitimate son of Giuliano, the brother of Lorenzo the Magnificent. In 1519 Giulio and Leo X decided to construct the New Sacristy at S. Lorenzo—a

pendant to Brunelleschi's Old Sacristy—as a Medici tomb chapel. Michelangelo submitted his first design for the chapel to the cardinal in November, 1520, but did not begin work on the tombs until 1524.

75. Francesco Maria della Rovere inherited the title of duke of Urbino from his adopted father Guidobaldo da Montefeltro in 1508. In 1516 Leo X drove Francesco Maria out and named as duke of Urbino his nephew Lorenzo de' Medici, who died in 1519 and is buried in the tomb with the figures *Morning* and *Evening* in the Medici Chapel at S. Lorenzo (Pl. 33). Francesco Maria was reinstated as duke of Urbino by Hadrian VI and, following the death of Cardinal Aginense, became the chief executor of the will of his uncle Julius II.

76. The Medici were expelled and Florence was declared a republic in May, 1527, following the sack of Rome by the imperial troops of Charles V.

77. In January, 1529, Michelangelo was appointed to the Council of Nine for the Militia *(nove della milizia)*, and in April he was named governor and procurator general of the Florentine fortifications. The treachery to which Condivi refers was the secret negotiations between the Medicean forces and Malatesta Baglioni, one of the commanders of the Florentine defenses. This led to the capitulation of the city "by agreement," as Condivi puts it, in August, 1530, marking the end of republican institutions and the beginning of hereditary Medici rule. Michelangelo left Florence for Venice accompanied by his pupils Rinaldo Corsini and Antonio Mini in September, 1529, and returned at the end of November.

78. The *corte,* the Florentine military tribunal, was sent to arrest Michelangelo by the papal commissioner Baccio Valori, who immediately after the fall of Florence had ordered Michelangelo's assassination. The sculptor was hidden in the house of the canon of S. Lorenzo. Michelangelo stopped work on the Medici tombs in April, 1527, and resumed after Clement VII had ordered friendly treatment for him in November, 1530—a period of inactivity of three and a half years, not, as Condivi says, of fifteen years. At the time of Michelangelo's final departure from Florence for Rome in September, 1534, some of the statues were still incomplete. They were installed in 1545 by his pupils Niccolò Tribolo and Raffaello da Montelupo.

79. The New Sacristy by Michelangelo is joined to the right transept of S. Lorenzo. Brunelleschi's Old Sacristy is connected to the left transept, on the side of the cloister and the Laurentian Library (Fig. 1). Michelangelo's tombs with portrait statues and the allegorical figures of the times of day—*Night* and *Day, Morning* and *Evening*—commemorate two cousins of Clement VII: Giuliano, duke of Nemours (see n. 23), and Lorenzo, duke of Urbino (see n. 75). Condivi speaks of four monuments because there also was to be a double tomb facing the altar of Clement's father Giuliano and of his uncle Lorenzo the Magnificent. Their bodies were interred in 1559 near the entrance wall in a plain marble sarcophagus (designed by Michelangelo) surmounted by Michelangelo's *Madonna and Child* and the Medici patron saints *Cosmas* by Giovanni Angelo Montorsoli and *Damian* by Raffaello da Montelupo (Pl. 33). In the second printing the phrase, "The tombs are placed in certain chapels," was corrected to read, "The tombs are situated against the side walls."

80. The Greek mathematician and natural philosopher Archimedes of Syracuse constructed various engines of war which during the Second Punic War enabled his

city to hold out for two years against Roman General Claudius Marcellus. When Syracuse was taken in 212 B.C. Archimedes was killed by Roman soldiers, even though Marcellus wished to spare his life.

81. Alessandro, the illegitimate son of Clement VII, was declared ruler of Florence by imperial decree in October, 1530. In May, 1532, his father created him duke of Florence. Justly described by a historian of the time as a "creature who would have disgraced even the deadliest epochs of Roman villainy," Alessandro was assassinated in January, 1537, by his cousin and companion in debauchery, Lorenzino, of the younger branch of the Medici family. Alessandro Vitelli was the captain of the Florentine defense garrison. The fortress whose site Michelangelo declined to inspect is the Fortezza da Basso, built in 1534–1535 by the architect Pier Francesco da Viterbo on the design of Antonio da Sangallo the Younger.

82. In November, 1531, Clement summoned Michelangelo to Rome and forbade him on pain of excommunication to work on anything other than the tombs for the Medici Chapel and the Julius Tomb. His respect for Michelangelo "as something sacred" *(come cosa sacra)* echoed his epoch's veneration of Michelangelo as being "divine" (see n. 14). Clement VII died in September, 1534, two days after Michelangelo's permanent arrival in Rome. He was succeeded by Alessandro Farnese, who was elected on October 13 as Pope Paul III (Pl. 37).

83. Duke Alfonso I d'Este was one of the most eminent authorities of his age on military fortifications. He was succeeded in 1534 by his son Ercole II d'Este. Michelangelo was sent to Ferrara by the Florentine *signoria* to inspect the fortresses at the end of July, 1529. He completed the *Leda* commissioned by Duke Alfonso in October, 1530, and in the following year gave the painting to his pupil Antonio Mini to provide dowries for Mini's sisters. Mini took the work to France in 1532 in order to sell it to Francis I, but died before the negotiations for the sale were concluded. The picture, which remained in France, disappeared after the eighteenth century. Several copies exist, including a canvas in the National Gallery in London.

84. According to a letter written in April, 1531, by Michelangelo's friend Sebastiano del Piombo, who was acting as his go-between with Girolamo Stoccioli, the agent of Duke Francesco Maria della Rovere, the duke was impatient to see the tomb completed according to the terms of the contract signed in 1516 by Michelangelo and the Cardinals Quattro Santi Coronati and Aginense (see Appendix 2). The *datario* was the prelate in charge of conferring papal benefices. Tommaso Cortesi da Prato, bishop of Carriata, was appointed to this post by Clement VII.

85. Julius III, pontiff from 1550 to 1555, was Giovanni Maria Ciocchi del Monte.

86. The negotiations for the third contract for the Julius Tomb began in November, 1531, after Clement VII had called Michelangelo to Rome, and were concluded at the end of April, 1532 (see Appendix 2).

87. The spokesman for the duke of Urbino who made this agreement with Michelangelo was Marquis Alberico Malaspina of Carrara (see n. 71).

88. After signing the new contract for the tomb, Michelangelo divided his time between Florence and Rome. The four months in Florence to which Condivi refers were from June to October, 1533. Michelangelo then remained in Rome until

May or June, 1534. The scaffolding for preparing the altar wall of the Sistine Chapel for the fresco—originally meant to be *The Resurrection of Christ* but subsequently changed to *The Last Judgment*—commissioned by Clement VII was erected in the early spring of 1535, and Michelangelo seems to have completed the cartoons for the mural in September of that year. Among the figures for the Julius Tomb on which Michelangelo worked during the periods he spent in Florence between November, 1530, and September, 1534, are the four *Captives* in the Accademia (Pl. 36), which may have been begun in the early 1520s, and the *Victory* in the Palazzo della Signoria, which the sculptor may have started and largely completed when work on the Medici tombs was stopped between 1527 and 1530 (see Appendix 2).

89. Francesco Pallavicini, bishop of Aleria, had been a friend of Michelangelo's since the days of Julius II.

90. The third contract for the Julius Tomb expired in 1535. In September of that year Paul III named Michelangelo "supreme architect, sculptor, and painter of the Apostolic Palace" and in November, 1536, released him from his obligations to the della Rovere executors until *The Last Judgment* was finished. Michelangelo concluded the mural in November, 1541. In the following February he agreed that three of the six statues for the tomb specified in the 1532 contract be completed by Raffaello da Montelupo: the *Madonna and Child*, the Prophet, and the Sibyl (Pl. 39). The fourth contract for the tomb was signed in August, 1542, and the monument was finished in February, 1545 (see Appendix 2). Ercole Gonzaga, cardinal of Mantua, was the presiding prelate at the Council of Trent from 1561 until his death in 1563.

91. Condivi makes several errors in his description of the tomb. The left hand of the *Moses* does not support his chin but rests on his lap. The *Active Life* holds in her right hand a diadem surmounted by a mask, not a mirror, and in her left hand is a garland not of flowers but of laurel. In Canto 28 of the *Purgatorio* Dante describes how there appeared to him "a lady all alone, who went singing and / culling flower from flower, with which all / her path was painted." She becomes the poet's guide through the Terrestrial Paradise to Beatrice and appears to him three more times. At their last encounter, in Canto 33, he calls her Matelda. Earlier, in Canto 27, he writes:

> [He] seemed to see in a dream a lady young and
> beautiful going through a meadow gather-
> ing flowers and, singing, she was saying,
> "Whoso asks my name, let him know that I
> am Leah, and I go moving my fair hands
> around to make myself a garland. To please
> me at the glass I adorn me here, but my
> sister Rachel never leaves her mirror and sits
> all day. She is fain to behold her fair eyes,
> as I am to deck me with my hands: she with
> seeing, I with doing am satisfied."

Condivi evidently confuses these passages, since the lady whom Dante associates with the Active Life, who is "with doing . . . satisfied," is not Matelda but Leah.

Condivi's mistake may derive from Michelangelo's belief that the Countess Matilda of Canossa, whom Condivi identifies with Dante's Matelda, was an ancestor of the Buonarroti family (see n. 3). Both Condivi and Vasari refer to the two figures flanking the *Moses* only as the *Active Life* and the *Contemplative Life;* but later the statues came to be designated also as *Leah* and *Rachel.*

92. Michelangelo did not begin the actual painting of *The Last Judgment* until the spring or summer of 1536. The mural was unveiled on the eve of All Saints' Day, October 31, 1541, and completed during the following weeks.

93. Engravings of *The Last Judgment* were made by Niccolò Beatrizet a year or two after the fresco was finished and in 1562. Beatrizet's first print was copied in an engraving by Niccolò della Casa issued in 1543 and 1545 and in a second printing in 1548. Four other known engravers copied *The Last Judgment* within two decades of its completion.

94. In Ezekiel's vision in the valley of dry bones God commands him to prophesy: "O ye dry bones, hear the word of the Lord. Thus saith the Lord God unto these bones; Behold, I will cause breath to enter into you, and ye shall live: And I will lay sinews upon you, and will bring up flesh upon you, and cover you with skin, and put breath in you, and ye shall live; and ye shall know that I am the Lord. So I prophesied as I was commanded: and as I prophesied, there was a noise, and behold a shaking, and the bones came together, bone by bone. And when I beheld, lo, the sinews and the flesh came upon them, and the skin covered them above" (Ezekiel 37:4–8).

95. According to a law prevalent in the late Middle Ages, punishment was inflicted on that part of a convicted criminal's body with which he had committed the crime.

96. In Canto 3 of the *Inferno* the poet describes the souls of the damned:

> weeping loudly, all drew to the evil shore that
> awaits every man who fears not God. The demon
> Charon, his eyes like glowing coals, beckons to
> them and collects them all, beating with his
> oar whoever lingers.
>
> As the leaves fall away in autumn, one after
> another, till the bough sees all its spoils upon
> the ground, so there the evil seed of Adam:
> one by one they cast themselves from that
> shore at signals, like a bird at its call. Thus
> they go over the dark water, and before they
> have landed on the other shore, on this side
> a new throng gathers.
>
> "My son," said the courteous master, "those
> who die in the wrath of God all come to-
> gether here from every land; and they are
> eager to cross the stream, for Divine Justice
> so spurs them that their fear is changed to
> desire."

In Canto 5, the poet descends to the second circle of Hell, that of carnal sinners:

> There stands Minos, horrible and snarling:
> upon the entrance he examines their offenses,
> and judges and dispatches them according as
> he entwines. I mean that when the ill-begotten
> soul comes before him, it confesses all; and
> that discerner of sins sees which shall be its
> place in Hell, then girds himself with his tail
> as many times as the grades he wills that it
> be sent down. Always before him
> stands a crowd of them; they go, each in his turn to
> the judgment; they tell, and hear, and then are
> hurled below.

Michelangelo gave to Minos (Pl. 45) the features of the papal master of ceremonies Biagio da Cesena, in revenge for his attacks on the nudity of the figures in *The Last Judgment*.

97. On the skin of St. Bartholomew Michelangelo painted a grim, tormented image of his own face (Pl. 46).

98. The Pauline Chapel, designed by Antonio da Sangallo the Younger, was consecrated by Paul III in 1540. One of Michelangelo's murals, probably *The Conversion of St. Paul*, was begun in November, 1542, and may have been finished when the pope visited the chapel in July, 1545. The other fresco was begun in March, 1546, and was not completed until March, 1550, four months after Paul's death.

99. The monumental *Pietà* has stood since the eighteenth century in the Florentine Duomo. In 1555 Michelangelo abandoned and mutilated the work and in 1561 sold it to his friend Francesco Bandini, a Florentine banker in Rome and one of Michelangelo's supporters at St. Peter's (see p. 102). However, the sculptor kept the left leg of Christ, on which he continued to work and which he never rejoined to the rest of the group. Copies after Michelangelo's model in an engraving by Cherubino Alberti and a painting in the sacristy of St. Peter's by Lorenzo Sabbatini show Christ's left leg placed across the thigh of the Virgin. Bandini had the group restored by Michelangelo's pupil Tiberio Calcagni, but it remained unfinished at Calcagni's death in 1565. The figure of Nicodemus, according to a letter from Vasari to Michelangelo's nephew Lionardo shortly after the artist's death, is a self-portrait. For the *Pietà* that Michelangelo designed for Vittoria Colonna, the marchioness of Pescara, see p. 103.

100. Michelangelo began a figure for *The Risen Christ* in 1514, but cast it aside two years later because of a flaw in the marble block. In 1519 he began a second statue, which was unveiled at Christmas, 1521, in the church of Sta. Maria sopra Minerva in Rome, where it still stands. He began the *St. Matthew* in the Accademia in the winter of 1504–1505 and worked on it again in the summer of 1506, leaving it unfinished in November when he went to Bologna "with a rope around his neck" to meet Julius II. Eight Apostles for the Duomo were carved during the sixteenth century by other sculptors and were installed on the last two piers of the nave and on the entrance walls to the three tribunes. Designs for the Rialto Bridge over the Grand Canal in Venice were commissioned from Michelangelo, Fra

Giacondo, Andrea Palladio, Jacopo Sansovino, Vincenzo Scamozzi, and Giacomo da Vignola. The bridge was built between 1588 and 1591 by the local architect Antonio da Ponte. No traces of Michelangelo's project for the bridge have survived.

101. Michelangelo wished to be buried in Sta. Maria Maggiore in Rome but was actually interred in the Florentine church of Sta. Croce. His tomb was designed by Vasari, who unsuccessfully tried to obtain the Duomo *Pietà* for the tomb from Francesco Bandini's son Pierantonio.

102. Isocrates, the fourth among the Ten Attic Orators, died at the age of ninety-eight in 338 B.C., the same year in which he completed the *Panathenaicus*, a discourse in praise of Athens.

103. Archival research has established that Michelangelo's father actually died in 1531 at the age of eighty-seven.

104. The foregoing sentence in the text occurs only in the second printing. Cardinal Pietro Bembo, a Venetian by birth, was one of the great humanists and literary stylists of his epoch, with close connections to the papal court from the time of his arrival in Rome in 1512 until his death in 1547. Jacopo Sannazaro's *Arcadia*, inspired by the pastoral poetry of Theocritus and Vergil, had a permanent influence on the Renaissance image of classical antiquity. Annibale Caro was the translator of Aristotle's *Rhetorica*, the *Aeneid*, and *Daphnis and Chloë*. Condivi married Caro's daughter Porzia in 1556. Giovanni Guidiccione, bishop of Fossombrone, composed orations and poems deploring the evil times of Italy. For Vittoria Colonna, the marchioness of Pescara and the author of *Rime spirituali*, see n. 120.

105. Raphael's father Giovanni Santi was a court painter to the dukes of Urbino. He died in 1494, when Raphael was eleven, and is traditionally thought to have been his son's first teacher. Between the ages of sixteen and twenty-one Raphael worked with Perugino and assimilated Perugino's style. After his arrival in Florence in 1504 he was strongly influenced by both Michelangelo and Leonardo. Michelangelo wrote of Raphael in a letter of 1542 that "what he knew of art he learned from me" (see n. 64).

106. The Grand Turk was the Sultan Bayezid II (see n. 50). Raguga (spelled "Ragusia" in the second printing) is the Dalmatian port city of Ragusa, which had close economic and cultural ties to Italy until coming under Turkish domination in 1526.

107. In April, 1546, in reply to a letter from Francis I, Michelangelo wrote to the French king that "for a long time I have desired to serve You, but have been unable to do so, because even in Italy I have not had sufficient opportunities to devote myself to my art." Two years earlier Michelangelo had by way of intermediaries promised Francis I a statue in the Piazza della Signoria if he would liberate Florence from the tyranny of the Medici.

108. The Florentine humanist Antonio Brucioli (or Bruccioli), known for his translations of Aristotle, Cicero, and Pliny, lived in Venice during much of the second quarter of the sixteenth century. The *serenissima signoria* of Venice consisted principally of the doge and his cabinet of six councilors.

109. This paragraph and the next were inserted in the second printing. Soon after

his accession in 1550 Julius commissioned Michelangelo to remodel the exedra designed by Bramante at the garden end of the Belvedere Court and assigned to a team of three architects—Bartolommeo Ammanati, Vasari, and Vignola, with Michelangelo as a consultant—the transformation of the Villa Giulia from a modest country house into a sumptuous papal residence. The reconstruction was finished in 1553, and the decoration of the interior was completed by 1554, the same year in which Condivi, who never wrote his projected work on the villa, left Rome.

110. Condivi's informant was Pier Giovanni Alliotti (or Aliotti), who had been master of the wardrobe under Paul III and was appointed bishop of Forlì and chamberlain (*maestro di camera*) by Julius III. The *maestro di camera* was at this time in charge of the pontiff's household and private expenses, including the papal art collections and commissions for works of art and buildings. Vasari reports that, in the construction of the Villa Giulia, "from day to day, the pope had new ideas, which had to be carried out in accordance with the never-ending instructions of the Chamberlain Pier Giovanni Aliotti."

111. The Latin phrase *motu proprio* ("by his own accord") designates a papal brief expressing the pontiff's personal wish. After the death of Bramante in 1514, the rebuilding of St. Peter's proceeded under the direction of Raphael, Fra Giacondo, and Bramante's pupils Baldassare Peruzzi and Antonio da Sangallo the Younger. The central piers of Bramante's plan (Fig. 9), a Greek cross dominated by a dome, were in place before his death, and the vaulting of the interior volumes surrounding the central piers was well under way at the time of Sangallo's death in 1546 (Pl. 49). His post was first offered to Giulio Romano, who died in November of the same year after refusing the position. At this point Paul III compelled Michelangelo to take charge of the work, "under duress and against my will," as Michelangelo later wrote Vasari, and confirmed his appointment in a *motu proprio* of January, 1547. In October, 1549, the pope issued a further *motu proprio* granting Michelangelo "full, free, and complete permission and authority to change, refashion, enlarge, and contract the model and plan and the construction of the building as shall seem best to him" and releasing him "from the power, jurisdiction, and authority of the deputies of the same fabric."

Michelangelo returned to the first plan of Bramante (Fig. 9). He rejected the model of Sangallo, which added a nave to Bramante's design in an attempt to bring about a synthesis between a longitudinal and a centralized structure (Fig. 9), and, very much against the wishes of the deputies, he razed the exterior walls which Sangallo had begun to build (Pl. 49). In January, 1547, Michelangelo wrote the prefect of the deputies that Bramante's plan was "not full of confusion, but clear, simple, luminous and . . . a beautiful design . . . so that anyone who has departed from Bramante's arrangement, as Sangallo has done, has departed from the true course; and that this is so can be seen by anyone who looks at his model with unprejudiced eyes." At the end of 1550 the deputies sought to destroy Julius III's confidence in Michelangelo by charging that they could make no report on the progress of the building, "as everything is kept secret from them, as if they had nothing to do with it. They have several times protested, and are now protesting again to ease their consciences, that they do not approve of the man-

ner in which Michelangelo is proceeding, especially as regards the demolition." In 1551 the pope summoned the deputies to a meeting in which Michelangelo defended himself against their accusations. But their attacks on him continued, and in January, 1553, Julius issued a *motu proprio* confirming Paul III's decree of October, 1549.

112. Michelangelo worked on the design for this palace, which was to be near the church of S. Rocco, in the autumn of 1551. According to Vasari he made a model of the façade, but neither model nor drawings have survived.

113. The foregoing sentence in the text occurs only in the second printing. Albrecht Dürer's *Four Books on Human Proportions* was published shortly after his death in Nuremberg in 1528 and in a Latin translation in 1532.

114. Realdo Colombo da Cremona was Michelangelo's physician and the author of a treatise on anatomy, *De re anatomica libri XV* (Venice, 1559), which was prepared with Michelangelo's collaboration. In 1548 Colombo wrote to his patron Cosimo I de' Medici asking to be permitted to stay in Rome to work on this treatise because, among other advantages, "fortune has presented me with the greatest painter in the world to assist me in this." Professor David Summers has suggested that Condivi may have transmitted his notes on Michelangelo's "ingenious theory" to Vincenzo Danti. In 1567 Danti published the first and only volume of his *Trattato delle perfette proporzioni*, a work which if completed by its remaining fourteen volumes would have been principally a treatise on anatomy. Its central thesis is that "perfect proportion" is based on the use of the parts of the body as revealed through anatomy rather than on measurement—a concept related to Michelangelo's objections to Dürer's theory of proportion on the grounds that it does not take into account "the movements and gestures of human beings." Vincenzo Danti was a member of the Florentine Academy, and in 1565, when he was working on the first volume of his treatise, Condivi also became a member.

115. Condivi links perspective and architecture because perspective was a branch of *disegno*, and by the middle of the sixteenth century the purest expression of *disegno* was thought to be the abstract art of architecture. Perspective was therefore one of the "principal elements of architecture," and Condivi's praise of Michelangelo's success in perspective refers to his architectural designs.

116. Michelangelo worked on the rebuilding of St. Peter's "for the love of God," as he wrote Vasari in 1557, and persisted in rejecting the pope's proffered payments. Condivi describes Alessandro Ruffini as the pope's *cameriere* and *scalco*, ceremonial posts conferred on members of the Roman nobility who attended the pontiff in his private chambers and at his table.

117. Michelangelo's wooden model, constructed between December, 1546, and the autumn of 1547, has been lost. Part of it is shown in a painting of 1620 by Domenico Pasignani now in the Casa Buonarroti. A wooden model of the dome in the Vatican Museo Petriano is a replica of a clay model which Michelangelo made in 1557. A nave was added to Michelangelo's plan by Carlo Maderna in the seventeenth century. Michelangelo's concept of St. Peter's is preserved in two engravings of 1569 by E. Dupérac and, with some alterations, in the building itself as seen from the Vatican gardens (Pl. 50).

118. In the second printing the phrase "continual practice of *virtù*" was changed to

"continual practice of the praiseworthy arts" *(delle virtuose arti)*. Michelangelo was known for his solitary behavior throughout his life. While working on the Sistine Ceiling he wrote his brother Buonarroto, "I am living here in a state of great anxiety and of the greatest physical fatigue; I have no friends and want none." And in a black poem composed when he was in his early seventies he wrote:

> I live shut up here, like the doughy middle
> Inside the bread crust, poor and all alone,
> Like a genie shut up inside a bottle.

Aloofness, depression, and melancholy were also traits of some contemporaries of Michelangelo, notably Jacopo Pontormo and Leonardo da Vinci, and were seen as marks of the artistic temperament and of what Plato had called "divine madness." From Florence in 1525 Michelangelo wrote to Sebastiano del Piombo that some friends "kindly invited me to go and have supper with them, which gave me the greatest pleasure, as I emerged a little from my depression, or rather from my obsession. I not only enjoyed the supper, which was extremely pleasant, but also, and even more than this, the discussions which took place."

"The great Scipio" is Publius Scipius Africanus, the hero of Petrarch's *Africa*, renowned for his magnanimity and clemency and as the conqueror of Hannibal in the concluding battle of the Second Punic War.

119. Condivi's list of thirteen names includes many of the notable personalities of mid-sixteenth-century Rome. A number of them belonged to three discernible groups: the circle of Cardinal Alessandro di Pier Luigi Farnese, the grandson of Pope Paul III (the cardinal of Sta. Croce, Maffei, Claudio Tolomei, Annibal Caro); the friends of Vittoria Colonna (Monsignor Polo, Tolomei); and the Florentine exiles (Cardinal Ridolfi, Lorenzo Ridolfi, Donato Giannotti). The English prelate Reginald Pole (Monsignor Polo), an exponent of reform within the church, was named cardinal of SS. Nereo e Achilleo by Paul III and in 1557 became archbishop of Canterbury. Tiberio Crispo (or Crispi) was constable of the Castel Sant' Angelo under Paul III. Condivi refers to him as "my most reverend patron" because he was the cardinal of Condivi's diocese of S. Agata in Suburra. Marcello Spannocchi Cervini, cardinal of Sta. Croce, was prefect of the Vatican Library, a deputy of St. Peter's, and one of Michelangelo's severest critics in 1550–1551 (see n. 111). In April, 1555, he was elected Pope Marcellus II, but died within three weeks and was succeeded by Paul IV. Bernardino Maffei, cardinal of S. Cirillo, was until his death in 1553 secretary to Cardinal Alessandro di Pier Luigi Farnese. Cervini and Maffei were also members of the Academy of Vitruvius founded by Claudio Tolomei in 1542.

Cristoforo Spiriti da Viterbo, who became patriarch of Jerusalem in 1550 and had until 1545 been bishop of Cesena, was empowered by Julius III's *motu proprio* of 1552 (see n. 111) to safeguard Michelangelo's interests as architect of St. Peter's. Cardinal Niccolò Ridolfi, though a nephew of Pope Leo X, shared Michelangelo's hatred of the Medici yoke imposed on Florence in 1530 and on the suggestion of Donato Giannotti, who became his secretary in 1539, commissioned from Michelangelo the *Brutus* bust in the Bargello, in commemoration of the tyrannicide in 1537 of Duke Alessandro (see n. 81). Claudio Tolomei, bishop

of Corsula, was a humanist and wrote commentaries on Vitruvius. Lorenzo Ridolfi was the youngest brother of Cardinal Niccolò Ridolfi and served for some time as apostolic secretary. Donato Giannotti was one of Michelangelo's closest friends. He had been secretary of state of the last Florentine Republic of 1527–1530 and after its fall continued to espouse the republican cause in his writings. In 1546 he composed the *Dialoghi*, in which Michelangelo, Giannotti, and Michelangelo's friends Luigi del Riccio and Antonio Petroneo discuss the duration of Dante's sojourn in Hell and Purgatory. Lionardo Malespini and Gian Francesco Lottini (Lottino), the agent in Rome of Duke Cosimo I, were humanists.

Tommaso Cavalieri was next to Vittorio Colonna the most important person in Michelangelo's later years. In a discourse to the Florentine Academy in 1547 Benedetto Varchi described him as a young Roman nobleman of "incomparable beauty" and of "such graceful manners, so excellent an endowment and so charming a demeanor that he indeed deserved, and still deserves, the more to be loved the better he is known." He inspired in Michelangelo the most exalted love and friendship. Michelangelo dedicated several sonnets and drawings to Cavalieri and in a letter to him in January, 1533, confessed that since their first meeting some months earlier he had felt "completely overwhelmed." Annibale (or Annibal) Caro, the translator of Vergil's *Aeneid* and Condivi's father-in-law (see n. 104), became secretary to Cardinal Alessandro Farnese after the death of Bernardino Maffei. In 1553 he rendered Michelangelo the service of undertaking negotiations concerning the Julius Tomb with Duke Guidobaldo II of Urbino, who as the grandnephew of Julius II still believed that Michelangelo had not fulfilled his contractual obligations to the pope's heirs.

120. Vittoria Colonna, marchioness of Pescara, was the granddaughter of Duke Federigo da Montefeltro of Urbino and the wife of Ferrante Francesco d'Avalos, marquis of Pescara and a general in the imperial armies of Charles V. After her husband's death in 1525 she consecrated her life to his memory and to pious meditation, the themes of her *Rime spirituali*. Michelangelo and Vittoria Colonna met in the late 1530s. From 1541 until 1544 she lived in the convent of Sta. Caterina at Viterbo, in the company of Reginald Pole (see n. 119) and other learned men and women dedicated to reform within the church by teaching the doctrine of Juan de Valdés that salvation depends on faith in the suffering and death of Christ rather than on the sacraments of the church. She died in February, 1547.

The compositions of the *Pietà* and the *Crucifixion* that Michelangelo made for her are preserved in drawings in the Isabella Stewart Gardner Museum in Boston and in the British Museum. The inscription on the stem of the cross in the *pietà*, "One would not think how much blood it costs," is from a tercet in Canto 29 of Dante's *Paradiso* in which Beatrice alludes to the cost of sowing the true spirit of Divine Scripture in the world. The Bianchi, penitents clad in white linen as a sign of repentance and regeneration, came through Florence in the summer of 1399, not, as Condivi writes, in 1348. At the head of their processions they carried a Y-shaped cross with a horizontal bar at the top. Michelangelo used this form of the cross not only in the *Pietà* for Vittoria Colonna—it appears in engravings of the composition made in 1546 by Giulio Bonasoni and in 1547 by

Niccolò Beatrizet—but also in drawings of the *Crucifixion* made during the last years of his life.

121. Benedetto Varchi, one of the great sixteenth-century Florentine humanists and historians, devoted the first of two discourses he delivered to the Florentine Academy in March, 1547, to the sonnet in which Michelangelo expresses the belief that in carving an image the sculptor is guided by the concept he has of it in his mind and that through the act of carving he liberates the image from the block of stone in which it is imprisoned:

> The best of artists never has a concept
> A single marble block does not contain
> Inside its husk, but to it may attain
> Only if hand follows the intellect.

The two discourses were published under the title *Due lezioni* in January, 1550. In July, 1564, Varchi delivered the principal funeral oration at the memorial service for Michelangelo in S. Lorenzo.

122. Fra Girolamo Savonarola preached in Florence from 1482 to 1484 and again from 1490 until his execution in 1498. The voice of Savonarola echoes in many of the religious drawings and poems of Michelangelo's later years, especially in the sonnet of 1554 containing the lines:

> So that the passionate fantasy, which made
> Of art a monarch for me and an idol,
> Was laden down with sin, now I know well,
> Like what all men against their will desired.

123. Insinuations of promiscuity were directed by contemporaries at adherents of the Neoplatonic doctrine of love in general and at Michelangelo in particular. The major Renaissance theorist of this doctrine—that love awakened by beauty leads to intimations of immortality and perfection if the lover passes from the physical contemplation of beauty to its spiritualized image in his mind—was Marsilio Ficino, a member of the circle of Lorenzo the Magnificent to which Michelangelo was introduced when he lived in the Medici Palace. Neoplatonic love was the dominant theme of Italian lyrical poetry from Petrarch to Michelangelo.

124. Pliny tells the story in Book 35 of his *Natural History* that, when the Greek artist Zeuxis (active in the late fifth and early fourth centuries B.C.) was asked to paint a picture of Helen of Troy for the inhabitants of Croton in southern Italy, "he made an inspection of the virgins of the city, who were nude, and selected five in order that he might represent in the picture that which was the most laudable feature of each." The story was felt to epitomize the classical style and was widely cited by Italian sixteenth-century writers on artistic theory.

125. Michelangelo presented the *Dying Slave* and the *Rebellious Slave* (Pl. 13,14) made for the second project of the tomb of Julius II (see Appendix 2) to Roberto Strozzi, a Florentine exile living in Lyons, in gratitude for having been nursed back to health in the Strozzi Palace in Rome during periods of severe illness in 1544 and 1545. In the second printing the phrase "if it were only those two statues" (*s'altro non fusse che quelle due statue*) was changed to "as befell, as if it

were nothing, with those two statues" *(siccome, si quello non fosse, segui di quelle due statue).*

126. Condivi stresses Michelangelo's interest in teaching to offset the statement in Vasari's 1550 *Vite* that Michelangelo had few pupils and the reference by Paolo Giovio in his biographical sketch written about 1527 to Michelangelo's dislike of receiving visitors—he was in fact notorious for barring visitors from his studio—and instructing students. The phrase "preferring good deeds to the appearance thereof" *(volendo più tosto fare, che parer di far bene)* is derived from the expression *esse quam videri, bonus valebat* in the *Bellum Catilinae,* an account of the conspiracy of Catiline by the first-century historian Sallust.

127. The "bronze statue" is the over life-sized figure of Julius II over the portal of S. Petronio which Michelangelo made between 1506 and 1508 (see p. 38). Francesco Francia was a Bolognese goldsmith and painter whose pictorial style was strongly influenced by Perugino and Raphael. Apelles of Kos, the court painter of Philip of Macedon and Alexander the Great and the most renowned painter of classical antiquity, was known to the Renaissance through descriptions of his works and fame by ancient writers, principally Pliny and Lucian.

128. Michelangelo was seriously ill and close to death in the summer of 1544 and in December, 1545.

129. The Florentine sculptor Pietro Torrigiano had been a companion of Michelangelo's in the Medici Garden. He later told Benvenuto Cellini—who reports the incident in his autobiography—that, when Michelangelo and he were boys, they "used to go into the church of the Carmine, to learn drawing from the chapel of Masaccio. It was Buonarroti's habit to banter all who were drawing there; and one day, when he was annoying me, I got more angry than usual, and, clenching my fist, I gave him such a blow on the nose that I felt bone and cartilage go down like biscuit beneath my knuckles; and this mark of mine he will carry with him to the grave." Torrigiano went to England, where he did the tomb of Henry VII in Westminster Abbey, and ended his days in Seville, starving himself to death in prison in 1528 after having fallen into the hands of the Inquisition.

130. The most memorable among the many portraits of Michelangelo, which include engravings, medals, and paintings, are a drawing by Daniele da Volterra in the Teylers Museum in Haarlem (frontispiece) and seven bronze busts cast by different artists from a model by Volterra, examples of which are in the Accademia, the Bargello, and the Casa Buonarroti (Pl. 53).

131. Michelangelo's poems were first published—in partly rewritten form to protect his memory from the stigma of homosexuality—by his grandnephew and namesake Michelangelo Buonarotti in 1623.

GLOSSARY OF
ITALIAN TERMS
AND MONETARY UNITS

bolognini	The *bolognino* was a silver coin in use throughout Italy, currently equivalent to approximately five cents.
braccia	The *braccio* was the standard Florentine unit of measurement equivalent to 58.36 centimeters.
disegno	Literally, drawing or design. However, by the middle of the sixteenth century, *disegno* was considered the common foundation of the three arts of painting, sculpture, and architecture, and the phrase *arti del disegno* referred to the visual arts in general.
ducat	The *ducato da camera* was the largest gold coin in sixteenth-century Rome, equivalent today to about fifty dollars.
gonfaloniere	Literally, standard-bearer. The formal head of the Florentine government from the middle of the fifteenth century until the end of the republic in 1530.
lire	The lira (*libra* in the Carolingian monetary system) was not a coin but a unit of value, reckoned in the sixteenth century at roughly one-seventh of a ducat, or currently equivalent to seven dollars.
mezzo-rilievo	Literally, half relief. A relief in which the figures stand out but are not detached from the background.
operai	The overseers of the construction, decoration, and maintenance of religious buildings.
palmi	The *palmo* was the standard unit of measurement in Rome, equivalent to 29.18 centimeters.
podestà	The chief administrative officer of a Tuscan commune.
scudi	The *scudo* was the standard gold coin in Rome and Florence after the middle of the sixteenth century. Its value was fixed by Pope Paul III in 1544 at the equivalent today of about fifty-five dollars.
signoria	The chief governing body of Florence from the thirteenth century until the establishment of Medici rule in 1530, empowered with initiating legislation, the conduct of foreign affairs, and the right to issue proclamations. It comprised the *gonfaloniere* and two priors (*priori*) from each of the city's four quarters and was elected every two months.

147

tempietto Literally, little temple. A circular or oval structure surrounded by columns and surmounted by a dome.

virtù The human potential for achievement; the quality which enables men and women to perform great works and deeds; the combination of success, qualities of character, and moral probity that society admires and rewards.

BIBLIOGRAPHICAL NOTE

The complete bibliography on Michelangelo is listed and described in Ernst Steinmann and Rudolf Wittkower (eds.), *Michelangelo Bibliographie, 1510–1926* (Leipzig, 1927); Hans Werner Schmidt, "Nachtrag und Fortsetzung der Michelangelo Bibliographie von Steinmann–Wittkower bis 1930," in Ernst Steinmann, *Michelangelo im Spiegel seiner Zeit*, Römische Forschungen der Bibliotheca Hertziana, VIII (Leipzig, 1930), 67–94; and Luitpold Dussler (ed.), *Michelangelo Bibliographie, 1926–1970* (Wiesbaden, 1974). Listings in all three are alphabetical by author.

In the preparation of this work the editor's indispensable companions were Giorgio Vasari, *La Vita di Michelangelo nelle redazioni del 1550 e del 1568*, ed. Paola Barocchi (5 vols.; Milan and Naples, 1962); Elizabeth Ramsden (ed.), *The Letters of Michelangelo* (2 vols; Stanford, 1963), which is especially valuable for its appendices on Renaissance history, patronage, and economic matters; Steinmann, *Michelangelo im Spiegel seiner Zeit*; and Ludwig Pastor, *The History of the Popes*, ed. Frederick I. Antrobus and Ralph F. Kerr (14 vols; London, 1923–24), V–XIII. For Michelangelo's poems I have used Robert N. Linscott (ed.), *Complete Poems and Selected Letters of Michelangelo*, trans. Creighton Gilbert (New York, 1963). The standard annotated Italian edition of the poetry is Enzo N. Girardi (ed.), *Michelangelo Buonarroti: Rime, scrittori d'Italia* (Bari, 1960).

The most rewarding biographies of Michelangelo remain Herman Grimm, *Leben Michelangelos* (Vienna, 1933), first published 1860–1863, and John A. Symonds, *The Life of Michelangelo Buonarroti* (New York, 1936), first published in 1893.

The fundamental work of archival research on the artist's life is Aurelio Gotti, *Vita di Michelangelo Buonarroti* (2 vols; Florence, 1875). The most exhaustive study of Michelangelo's art, life, and thought is Charles de Tolnay, *Michelangelo* (5 vols; Princeton, 1943–60), which has been published in a one-volume edition by Princeton in 1975. Its conclusions are summarized in Charles de Tolnay, *The Art and Thought of Michelangelo* (New York, 1964), and in biographical form with a catalog of works in Charles de Tolnay, *Michel-Ange* (Paris, 1970). The

149

most reliable one-volume monographs are Herbert von Einem, *Michelangelo*, trans. Ronald Taylor (London, 1973), and Howard Hibbard, *Michelangelo* (London and New York, 1974).

There are numerous comprehensive and easily available works on Michelangelo's painting, drawing, sculpture, architecture, and artistic theory. The paintings as a whole have been discussed by Frederick Hartt, *Michelangelo* (New York and London, 1965), and there are two excellent studies of the Sistine Ceiling: Sydney J. Freedberg, *Painting of the High Renaissance in Rome and Florence* (2 vols.; Cambridge, 1961), I, 92–112; and Charles Seymour, Jr. (ed.), *Michelangelo: The Sistine Chapel Ceiling* (New York and London, 1972).

The pioneer work, first published in 1903, in distinguishing Michelangelo's drawings from those of his followers is Bernard Berenson, *The Drawings of the Florentine Painters* (3 vols; Chicago, 1938), I, 184–237. The most complete recent study of Michelangelo as a draftsman, with a detailed catalog, is Luitpold Dussler, *Die Zeichnungen des Michelangelo* (Berlin, 1959). It is supplemented by the lavishly illustrated volume by Frederick Hartt, *The Drawings of Michelangelo* (New York, 1970). Two exemplary scholarly works dealing with collections rich in drawings by Michelangelo and his atelier are Johannes Wilde, *Italian Drawings in the British Museum: Michelangelo and His Studio* (London, 1953), and Paola Barocchi, *Michelangelo e la sua scuola: I disegni di Casa Buonarroti e degli Uffizi* (2 vols; Florence, 1962).

The major monographs on the sculpture are Friedrich Kriegbaum, *Michelangelo Buonarroti: Die Bildwerke* (Berlin, 1940), Frederick Hartt, *Michelangelo: The Complete Sculpture* (New York, 1968), and Martin Weinberger, *Michelangelo, the Sculptor* (2 vols; London, 1967). A convenient workmanlike survey of Michelangelo's activity as a sculptor is provided by John Pope-Hennessy, *Italian High Renaissance and Baroque Sculpture* (London, 1970), 3–39, 299–339. There are notable studies on the *David*, the Julius Tomb, and the Medici Chapel: Charles Seymour, Jr., *Michelangelo's "David": A Search for Identity* (Pittsburgh, 1967); Erwin Panofsky, "The First Two Projects of Michelangelo's Tomb of Julius II," *Art Bulletin*, XIX (1937), 561–79; Johannes Wilde, "Michelangelo's Designs for the Medici Tombs," *Journal of the Warburg and Courtauld Institutes*, XVIII (1955), 54–66; and Frederick Hartt, "The Meaning of Michelangelo's Medici Chapel," in *Festschrift für Georg Swarzenski* (Berlin and Chicago, 1951), 145–55.

Michelangelo's contributions to Renaissance architecture have been investigated with great care and insight in the magisterial work by James S. Ackerman, *The Architecture of Michelangelo* (2 vols; London, 1961), and in Paolo Portoghesi and Bruno Zevi (eds.), *Michelangelo architetto* (Turin, 1964), a series of essays

accompanied by a catalog of buildings, projects, and architectural drawings and by stunning photographic documentation.

Illuminating discussions of the theoretical aspects of Michelangelo's art are found in Erwin Panofsky, "The Neoplatonic Movement and Michelangelo," in *Studies in Iconology* (New York, 1962), 171–233, and in David Summers, "Michelangelo on Architecture," *Art Bulletin,* LIV (1972), 146–57. The general work on this subject is Robert J. Clements, *Michelangelo's Theory of Art* (New York, 1961). Considerable space is also devoted to Michelangelo's ideas on art in Robert J. Clements, *The Poetry of Michelangelo* (New York, 1965). Among the psychological interpretations of Michelangelo the man and the artist, the most admirable and judicious is Adrian Stokes, *Michelangelo: A Study in the Nature of Art* (London 1955).

INDEX

Charles I (king of England), 128n
Charles V (Holy Roman emperor), 134n, 135n, 144n
Charles VIII (king of France), 127n, 128n, 129n
Cicero, 93, 140n
Ciocchi del Monte, Giovanni Maria. *See* Julius III, Pope
Clement VII, Pope (Giulio de' Medici), 12, 63, 67, 69–75, 77, 83, 94, 126n, 130n, 134n, 135n, 136n, 137n
Colombo, Realdo, 99, 142n
Colonna, Vittoria (marchioness of Pescara), xix, 90, 93, 103, 139n, 140n, 143n, 144n
Condivi, Ascanio: relationship of, to Michelangelo, xiii, xv–xvii, xix, 1, 3–4, 106; career of, xiii, 142n; editions of *Life of Michelangelo* of, xiv–xv; projected writings of, 3, 95, 99, 108–109, 123n, 141n, 142n
Conrad II (Holy Roman emperor), 124n
Corsini, Rinaldo, 135n
Crispo, Tiberio (cardinal of S. Agata in Suburra), 102, 143n

Dante Alighieri: his *Purgatorio*, 79, 137n; his *Inferno*, 84, 138n–39n; his *Paradiso*, 128n, 144n; mentioned, 19
Danti, Vincenzo, 142n
D'Avalos, Ferrante Francesco (marquis of Pescara), 144n
Della Casa, Niccolò, 138n
Dell'Arca, Niccolò, 127n
Della Rovere, Francesco Maria (duke of Urbino), xvii, 63, 71–72, 75, 77, 135n, 136n
Della Rovere, Giuliano. *See* Julius II, Pope
Della Rovere, Leonardo Grosso. *See* Aginense, Cardinal
Del Riccio, Luigi, xix, 144n
Demosthenes, 93
Dinocrates, 129n
Donatello, 28, 129n
Doni, Angelo, 28, 129n
Dupérac, Étienne, 142n
Dürer, Albrecht, xiv, 99, 114, 142n

Este, Alfonso I, d' (duke of Ferrara), 70, 131n, 136n
Este, Ercole II, d' (duke of Ferrara), 70, 136n
Este, Isabella, d' (marchioness of Mantua), 21, 128n
Euclid, 93
Ezekiel, 84, 138n

Farnese, Alessandro. *See* Paul III, Pope
Farnese, Alessandro di Pier Luigi, 102, 130n, 143n
Ficino, Marsilio, 125n, 145n

Florence: administration of, 5, 124n; Palazzo del Podestà in, 5, 124n; Medici Garden in, 10, 125n, 146n; S. Lorenzo in, 11–12, 59–63, 67, 69–70, 126n, 127n, 134n, 135n, 145n; Sto. Spirito in, 17, 126n–28n; Palazzo della Signoria in, 27, 37, 117, 129n, 130n, 137n; Sta. Maria del Fiore in, 27, 90, 100, 128n–29n; Sta. Maria Novella in, 37, 125n, 131n, 132n; S. Miniato in, 64–65; and siege of 1529–1530, pp. 64–65, 135n; Florentine Academy in, 124n, 142n, 145n; Palazzo Pitti in, 126n; Fortezza da Basso in, 136n; Piazza della Signoria in, 140n; Sta. Maria del Carmine in, 146n
Fra Giacondo, 139n–40n, 141n
Francia, Francesc, 107, 146n
Francis I (king of France), 71, 94, 124n, 126n, 136n, 140n

Galen, 93
Galli, Jacopo, 23–24, 128n
Ghiberti, Lorenzo, xvi
Ghirlandaio, Benedetto, 10, 125n
Ghirlandaio, Domenico, xvi, 9–10, 125n–26n, 132n
Giannotti, Donato, xix, 102, 143n, 144n
Giotto, xvi
Giovio, Paolo: his *Life of Michelangelo*, xiv, xvi, 128n, 146n
Gonzaga, Ercole (cardinal of Mantua), 77, 137n
Granacci, Francesco, 9, 12, 125n
Gregory VII, Pope, 124n
Guidiccione, Giovanni (bishop of Fossombrone), 93, 140n

Hadrian VI, Pope, 62, 134n, 135n
Henry IV (Holy Roman emperor), 124n
Henry VII (king of England), 146n
Hippocrates, 93
Homer, 93, 95

Inquisition, 146n
Isocrates, 90, 140n

John the Evangelist, St., 83
Julius II, Pope (Giuliano della Rovere), xvii, 28–30, 34–35, 37–39, 57–59, 63, 72, 77, 83, 94, 99, 107, 116, 129n, 130n, 131n, 133n, 134n, 135n, 137n, 139n
Julius III, Pope (Giovanni Maria Ciocchi del Monte), xiii, 1, 72, 95, 97, 101, 136n, 140n, 141n–42n

Leo X, Pope (Giovanni de' Medici), 6, 17, 59–61, 63, 94, 127n, 129n, 134n, 135n
Leonardo da Vinci. *See* Vinci, Leonardo da
Lottini, Gian Francesco, 144n
Lucian, 146n

Maderna, Carlo, 142*n*

Maffei, Bernardino (cardinal of S. Cirillo), 102, 143*n*

Malaspina, Alberico (marquis of Carrara), 61, 63, 134*n*, 136*n*

Malespini, Lionardo, 144*n*

Marcellus, Claudius, 67, 136*n*

Martini, Luca, 126*n*

Medici, Alessandro de' (duke of Florence), 69, 71, 36*n*

Medici, Cosimo de', 59

Medici, Cosimo de' (duke of Florence), 142*n*, 144*n*

Medici, Giovanni de'. *See* Leo X, Pope

Medici, Giuliano de', 126*n*, 134*n*, 135*n*

Medici, Giuliano de' (duke of Nemours), 17, 67, 127*n*, 135*n*

Medici, Giulio de'. *See* Clement VII, Pope

Medici, Lorenzino de', 136*n*

Medici, Lorenzo de' (the Magnificent), xix, 10–15, 125*n*, 127*n*, 135*n*, 145*n*; art collection of, 126*n*

Medici, Lorenzo de' (duke of Urbino), 135*n*

Medici, Lorenzo di Pierfrancesco de', 19, 127*n*

Medici, Piero de', 15, 17, 127*n*

Medici family, xvi–xvii, 18–19, 64, 71, 127*n*, 135*n*

Michelangelo: character and temperament of, xvii–xviii, 90, 93, 95, 97, 102–103, 105–107, 143*n*; wet nurse of, xviii, 6–7, 125*n*; his approach to sculpture, xviii, 15, 28, 145*n*; poetry of, xx, 3, 103, 105, 123*n*, 143*n*, 145*n*, 146*n*; achievement and fame of, 1, 3, 93–95, 97; ancestry of, 5–6, 124*n*; horoscope of, 6, 124*n*–25*n*; education of, 9, 125*n*; apprenticeship of, 9–10, 14, 125*n*; his *divinità*, 10, 126*n*, 136*n*; study of anatomy by, 17, 90, 93, 97, 99, 126*n*–27*n*, 142*n*; flight to Bologna by, 18–19; flight of, from Rome in 1506, pp. 34–35; directs fortification of Florence, 64–65, 135*n*; flight of, from Florence in 1529, pp. 64–65, 135*n*; inspects fortifications at Ferrara, 70; his approach to architecture, 99, 101, 142*n*; his love of beauty, 105; his attitude toward pupils, 106–107, 146*n*; physical appearance of, 108; psychoanalytic interpretation of, 123*n*; mother of, 125*n*; self-portraits of, 127*n*, 139*n*

—Works: rebuilding of St. Peter's, xiii–xiv, xvii, 34, 97, 101–102, 137*n*, 139*n*, 141*n*–42*n*; Sistine Ceiling, xvi, xvii, xix, 39, 42, 47–48, 57–58, 99, 101, 125*n*, 131*n*–34*n*, 143*n*; *Sleeping Eros* (lost), xvi, 19, 21, 127*n*–28*n*; *David* of 1501–1504, xvi, 27–28, 128*n*–29*n*; tomb of Julius II, xvii, xix, 28–30, 33–34, 59–61, 71–72, 75, 77, 79, 83, 113–18, 130*n*, 131*n*, 134*n*, 136*n*, 137*n*; *The Battle of the Centaurs*, xviii, 15, 125*n*; *Moses*, xviii, 33, 77,

79, 115–16, 138*n*; Laurentian Library, 11–12, 63, 126*n*, 135*n*; *Head of a Faun* (lost), 11–12, 126*n*; *Hercules* (lost), 15, 126*n*; *Crucifix* for Sto. Spirito, 17, 126*n*–27*n*; *Infant St. John* (lost), 19, 127*n*; statues for tomb of St. Dominic, 19, 127*n*; *Eros* for Jacopo Galli (lost), 24; St. Peter's *Pietà*, 24, 27, 90, 128*n*; *Bacchus*, 24, 128*n*; *The Contemplative Life*, 28, 79, 117, 138*n*; bronze *David* (lost), 28, 129*n*; Bruges *Madonna*, 28, 129*n*; Doni Tondo, 28, 129*n*, 132*n*; *Dying Slave*, 33, 115, 130*n*, 145*n*; *Rebellious Slave*, 33, 115, 130*n*, 145*n*; *The Battle of Cascina*, 37, 130*n*–31*n*, 132*n*; bronze *Julius II* (lost), 38–39, 107, 131*n*, 146*n*; *The Last Judgment*, 48, 75, 83–84, 87, 137*n*, 138*n*–39*n*; design for façade of S. Lorenzo, 59–63, 134*n*; Medici Chapel, 67, 69–70, 127*n*, 134*n*–35*n*, 135*n*; *Leda and the Swan* (lost), 70–71, 136*n*; *The Active Life*, 79, 117, 137*n*–38*n*; *Pietà* in Sta. Maria del Fiore, 87, 90, 139*n*; Pauline Chapel, 87, 139*n*; *Pietà* for Vittoria Colonna, 90, 103, 144*n*–45*n*; *The Risen Christ*, 90, 130*n*; *St. Matthew*, 90, 139*n*; design for Rialto Bridge, 90, 139*n*–40*n*; design of palace for Julius III, 97, 142*n*; *Crucifixion* for Vittoria Colonna, 103, 144*n*–45*n*; *Captives* for the tomb of Julius II, 117, 137*n*; *Victory*, 117, 137*n*

Mini, Antonio, 135*n*–36*n*

Montefeltro, Federigo da (duke of Urbino), 144*n*

Montefeltro, Guidobaldo da (duke of Urbino), 128*n*, 135*n*

Montelupo, Raffaello da, 117, 135*n*, 137*n*

Montorsoli, Giovanni Angelo, 135*n*

Moscheroni family, 28

Nicholas V, Pope, 34, 130*n*

Ovid: his *Metamorphoses*, 126*n*

Palladio, Andrea, 140*n*

Pallavicini, Francesco (bishop of Aleria), 75, 137*n*

Pasignani, Domenico, 142*n*

Paul II, Pope, 130*n*

Paul III, Pope (Alessandro Farnese), xvii, 75, 77, 83, 87, 97, 101, 136*n*, 137*n*, 139*n*, 141*n*, 142*n*

Perugino, 94, 131*n*, 140*n*, 146*n*

Peruzzi, Baldassare, 141*n*

Petrarch, 19, 93, 103, 145*n*

Petroneo, Antonio, 144*n*

Philip of Macedon, 145*n*

Pietra Santa, 63, 134*n*

Pisano, Nicola, 127*n*

5